PRINT INDEX

Recent titles in the Art Reference Collection:

Book Illustration and Decoration: A Guide to Research
Compiled by Vito J. Brenni

American Ceramics Before 1930: A Bibliography
Compiled by Ruth Irwin Weidner

Modern Latin American Art: A Bibliography
Compiled by James A. Findlay

PRINT INDEX

A GUIDE TO REPRODUCTIONS

Compiled by Pamela Jeffcott Parry
and Kathe Chipman

Art Reference Collection, Number 4

Greenwood Press
Westport, Connecticut • London, England

Library of Congress Cataloging in Publication Data

Parry, Pamela Jeffcott.
 Print index.

 (Art reference collection, ISSN 0193-6867 ; no. 4)

 1. Prints—Indexes. 2. Prints—18th century—
Indexes. 3. Prints—19th century—Indexes. 4. Prints—
20th century—Indexes. 5. Printmakers—Indexes.
I. Chipman, Kathe. II. Title.
NE90.P17 1983 769'.016 83-12824
ISBN 0-313-22063-8 (lib. bdg.)

Library of Congress Catalog Card Number: 83-12824
ISBN: 0-313-22063-8
ISSN: 0193-6867

First published in 1983

Greenwood Press
A division of Congressional Information Service, Inc.
88 Post Road West, Westport, Connecticut 06881

Printed in the United States of America

10 9 8 7 6 5 4 3 2 1

For
Janna, Evan,
Jonathan, and Peter

Contents

About the Compilers

PAMELA JEFFCOTT PARRY is the Executive Director of the Art Libraries Society of North America (ARLIS/NA). She is also the compiler of *Contemporary Art and Artists: An Index to Reproductions* (Greenwood Press, 1978) and *Photography Index: A Guide to Reproductions* (Greenwood Press, 1979).

KATHIE CHIPMAN is the former book editor of *RILA* (*International Repertory of the Literature of Art*). In 1982 she contributed a glossary of architectural terms to the *Macmillan Encyclopedia of Architects*.

Preface

Print Index: A Guide to Reproductions is a reference tool intended to aid the user in locating illustrations of prints dating from the early eighteenth century through the mid-1970s. The format of this volume is similar to that of two earlier compilations by Pamela J. Parry, *Contemporary Art and Artists* (Greenwood, 1978) and *Photography Index* (Greenwood, 1979), the intention being that researchers familiar with the earlier indexes will use *Print Index* in much the same way. *Print Index* compiles data and provides access to illustrations contained in one hundred English-language monographs, exhibition catalogs, and collection catalogs (see List of Books Indexed). The body of the work consists of a list of many thousands of prints by more than twenty-one hundred printmakers, some of whom achieved prominence in other media as well (e.g., Degas, Picasso) and some of whom had only modest careers and therefore are not listed in the major art reference books. Nationality and lifedates are given for the artist where known, and at least one reproduction source is noted for each print. All printmaking techniques in use by Western graphic artists who were active in the last three centuries are represented. (The Abbreviations list reflects this variety of media.)

Books Indexed

The publications indexed were selected primarily on the basis of their being current, authoritative, and well illustrated. In some cases, other qualities dictated inclusion: Books were chosen to round out the listings of a nationality, medium, or century; to introduce new prints rather than repeat a selection of frequently illustrated prints; or in recognition of their widespread availability and use, as is the case with Mayor's *Prints & People*. Periodicals were excluded because they are indexed on a regular basis by *Art Index* and *International Repertory of the Literature of Art (RILA)*. The publications indexed are available at most museum, college, or large public libraries with art book holdings.

Information Given in Part I: Artist Index

Prints are listed alphabetically by title under the artist or artists. A brief anonymous section precedes the main alphabetical listing of artists. Foreign accent marks are excluded. Entries include the following information:

1. Printmaker—Name, alternative names, plus nationality and dates in most cases. Names are cross-referenced as necessary.
2. Title of Work—Alternative, foreign, and explanatory titles, as well as series or suite information, are given in parentheses following the first title, with the most complete or most frequently cited title given priority. Works with the same title and those labeled "Untitled" are arranged by date, or by number if they are part of a numbered series.
3. Date
4. Print Technique(s) Used—An abbreviation for technique is used (e.g., etch, litho). Color is indicated as "col" (e.g., col litho); otherwise the original print is assumed to be black and white.
5. Publications—Books or catalogs in which a reproduction of the print appears are indicated by a brief code (usually the author's last name), which is amplified in the List of Books Indexed. Also given are the page, plate, or figure number and, when appropriate, an indication that the reproduction is in color or is a detail. Users are advised that reproductions of prints may have been cropped for publication without this being so noted in the text or captions. As *Print Index* has its foundations in the information supplied in the books indexed, the compilers recognize that in a few instances a misstatement as to medium, date, or title of a print inadvertently may have been perpetuated.

Information Given in Part II: Subject and Title Index

This section serves as an aid in locating works that depict a particular person, place, event, or theme. A few works are indexed under title, where the title is distinctive or expressive. Abstract prints and those with unidentifiable or sketchy subjects have not been indexed by subject. Under each subject heading, entries are alphabetical by artist, and the title follows. Under the general heading "Portraits," identified subjects are listed alphabetically by sitter, with artist noted; unidentified portraits follow. Group portraits are entered under the heading "Portraits, Group," and self-portraits under "Self-Portraits." Researchers should refer back to Part I for further information and reproduction sources. A List of Subject Headings Used is included in the frontmatter following the Abbreviations.

Acknowledgments

We wish to express our thanks to three libraries and a regional library system, which we utilized in the course of four years' work: The University of Iowa Art Library (Iowa City), The Clark Art Institute Library (Williamstown, Mass.), Columbia University's Avery Architectural and Fine Arts Library (New York City), and the Ramapo-Catskill Library System (New York State). The cooperation and assistance received in all four locations has been much appreciated. David Chipman graciously provided computer expertise, which eased some of the tedium of production and editing.

It is our hope that the *Print Index* will be enthusiastically used by members of the Art Libraries Society of North America's Cataloging/Indexing Systems Special Interest Group (CISSIG), for it was this dedicated group of art librarians that several years ago initiated the idea of an index to print illustrations.

<div align="right">

PAMELA JEFFCOTT PARRY
KATHE CHIPMAN

</div>

June 1983

List of Books Indexed

Ad-1 Adhemar, Jean. Twentieth-Century Graphics. New
 York, Praeger, c1971.

Ad-2 Adhemar, Jean. Graphic Art of the 18th Century.
 New York, McGraw-Hill, 1964.

Baro Baro, Gene. 30 Years of American Printmaking.
 New York, Universe Books, 1976.

Bauman Bauman, Hans F.S. (Felix H. Man). 150 Years of
 Artists' Lithographs, 1803-1953. London,
 W.Heinemann, 1953.

Boston Boston Museum of Fine Arts. An Exhibition of
 Lithographs: 527 Examples...from 1799 to 1937...
 Boston, 1937.

Bowdoin Bowdoin College, Museum of Art. Language of the
 Print; a Selection from the Donald H. Karshan
 Collection. Brunswick, Chanticleer Press, distrib.
 by Random House, 1968.

Brown Brown University, Department of Art. Early
 Lithography, 1800-1840: Exhibition, March 26
 Through April 19, 1968. Providence, 1968.

Chase Chase, Edward T. The Etchings of the French
 Impressionists and Their Contemporaries. Paris,
 Hyperion; distrib. by Crown, New York, 1946.

Clark Clark, Charles. German Graphics of the Sixties.
 Catalogue of an Exhibition, February 17-March 24,
 1974, University Art Museum. Austin, University of
 Texas at Austin, 1974.

Blumenthal. Madison, University of Wisconsin, 1972.

MGA Museum of Graphic Art. American Printmaking: the First 150 Years. Text by Wendy J. Shadwell. Washington, published for the Museum of Graphic Art by the Smithsonian Institution Press, 1969.

Minn Minneapolis Institute of Arts. Prints 1800-1945; a Loan Exhibition from Museums and Private Collections. Minneapolis, 1966.

MMA Metropolitan Museum of Art. The Painterly Print: Monotypes from the Seventeenth to the Twentieth Century. Exhibition...by Colta Ives, et al. New York, Metropolitan Museum of Art, distrib. by Rizzoli International, 1980.

MOMA Museum of Modern Art. Contemporary Painters and Sculptors as Printmakers. By Elaine L. Johnson; Catalogue of an Exhibition...New York, 1966.

Ontario Art Gallery of Ontario. Prints: Bochner, LeWitt, Mangold, Marden, Martin, Renouf, Rockburne, Ryman. Toronto, 1975.

Pass-1 Passeron, Roger. French Prints of the 20th Century. New York, Praeger, 1970.

Pass-2 Passeron, Roger. Impressionist Prints. New York, Dutton, 1974.

Pennell Pennell, Joseph. Etchers and Etching; Chapters in the History of the Art... 3d ed. New York, Macmillan, 1925.

Pet-1 Peterdi, Gabor. Great Prints of the World. New York, Macmillan, 1969.

Pet-2 Peterdi, Gabor. Printmaking: Methods Old and New. Rev. ed. New York, Macmillan; London, Collier-Macmillan, 1973.

Portland Portland Art Museum. Masterworks in Wood: the Woodcut Print from the 15th to the early 20th Century. Portland, Oregon, 1976.

RC-1 Castleman, Riva. American Prints, 1913-1963. An Exhibition Circulated by the International Council of the Museum of Modern Art. Brussels, Bibliotheque Royale Albert 1er, 1976.

RC-2 Castleman, Riva. Modern Art in Prints. New York, Museum of Modern Art, 1973.

WPA Smithsonian Institution. WPA/FAP Graphics.
 Exhibition, by Francis V. O'Connor. Washington,
 S.I.P., 1976.

Yale Yale Center for British Art, New Haven. Color
 Printing in England, 1486-1870. By Joan M.
 Friedman. An Exhibition...20 April to 25 June
 1978. New Haven, 1978.

Z1 Zigrosser, Carl. Prints and Their Creators: a
 World History. 2d rev. ed. New York, Crown,
 1974.

Z2 Zigrosser, Carl. The Expressionists; a Survey of
 Their Graphic Art. New York, Braziller, 1957.

Z3 Zigrosser, Carl, ed. Prints; Thirteen
 Illustrated Essays on the Art of the Print. New
 York, Holt, Rinehart and Winston, 1962.

Z4 Zigrosser, Carl. The Artist in America;
 Twenty-four Closeups of Contemporary Printmakers.
 New York, Knopf, 1942.

Z5 Zigrosser, Carl. The Appeal of Prints.
 Philadelphia, Leary's Book Co., 1970.

Abbreviations

anon.	anonymous
attrib.	attributed
aqua	aquatint
b.	born
bet.	between
c.	circa; century
col.	color
d.	died
det.	detail
dp	drypoint
engr	engraving
etch	etching
f.p.	frontispiece
fig.,figs.	figure, figures
fol.	following
ill., ills.	illustration, illustration
intag	intaglio
linocut	linoleum cut
lino engr	linoleum engraving
litho	lithograph
mezzo	mezzotint
mono	monotype
n.d.	no date
no.	number
opp.	opposite
p., pp.	page, pages
pl., pls.	plate, plates
pub.	published
seri	serigraph
sg etch	soft ground etching
ss	silkscreen
st., sts.	state, states
tech	technique
vol.	volume
w.	with
wc	woodcut
wengr	wood engraving

List of Subject Headings Used

Acrobats
Actors and Actresses
Airplanes, Helicopters, etc.
American Revolution
Animals
Art
Art Dealers
Artists
Automobiles

Bathers and Swimmers
Beggars
Biblical and Religious Themes
Birds
Bookplates
Boxers and Wrestlers
Bridges
British Royal Family
Bullfights and Bullfighters

Carnival
Carriages
Cats
Cattle
Children
Christmas
Churches and Other Religious
 Buildings
Cigars, Cigarettes and Pipes
Circuses
Cities
Clothing
Clowns
Couples
Cows

Dancers and Dancing
Death

Diners and Dining
Doctors
Dogs
Doors

Equestrians
Eskimos

Family Members
Farms and Farming
Fish
Fishermen and Fishing
Flags
Flowers
Food and Drink
French and Indian War
Fruits
Funerals
Furniture and Furnishings

Games and Sports
Gardens
Gas Stations
Graves and Graveyards
Gypsies

Historical Themes
Horse-Racing
Horses
Hospitals
Hotels, Restaurants, etc.
Houses
Human Body
Hunters and Hunting

Ice
Illness
Indians (American)
Industry

PART I
Artist Index

ANONYMOUS: American
 Brewster Top Buggy, c.1890,
 wengr
 Mayor, ill.561
 Parrot Gun Aboard a Monitor (In
 the Turret), early to mid 19th
 c., steel engr
 Mayor, ill.635
 A Rattan Chair (ill. in cata-
 logue of Wakefield Reed and
 Rattan Furniture Co., Wake-
 field, Mass.), c.1890, wengr
 Mayor, ill.393
 Veneered Furniture, 1833, litho
 Mayor, ill.560

ANONYMOUS: Austrian
 Kaiser Franz II's Bedroom at
 Laxenburg (ill. for "Bildliche
 Darstellung von Laxenburg"),
 1826, litho
 Mayor, ill.543

ANONYMOUS: British
 Algiers (pl.2 of M.Wagner, "The
 Tricolor on the Atlas; or,
 Algeria and the French Con-
 quest"), 1854, rainbow litho
 Yale, pl.LXVIII
 Billiard Tables (pl.190 of vol.2
 of J.B.Waring, "Masterpieces
 of Industrial Art & Sculpture
 at the International Exhibi-
 tion, 1862"), 1863, chromo-
 litho
 Yale, pl.LXXI
 Book cover in the possession of
 Thos.Willement, Esq. F.S.A.,
 Date about the middle of the
 16th century (pl.41 of H.Shaw,
 "The Decorative Arts Ecclesi-
 astical and Civil of the Mid-
 dle Ages"), 1851, chromolitho
 Yale, pl.LX
 Book of Kells (pl.11 of J.O.
 Westwood, "Palaeographia sacra
 pictoria..."), 1843-45,
 chromolitho
 Yale, pl.LVIII
 Broadside: Bishop's House of
 Murder (John Bishop and Thomas
 Williams, Murderers), 1831,
 wengr
 Mayor, ill.650
 The Earl of Derby's Drawing
 Room, Grosvenor Square, London
 (ill. for R.Adam, "The works
 in architecture"), 1778, etch
 Mayor, ill.541
 George III and His Family View-
 ing the Royal Academy Exhibi-
 tion at Somerset House, 1789,
 engr
 Mayor, ill.536
 George Washington's bookplate,
 1765-75, engr
 Mayor, ill.536
 Weit, opp.p.294
 Sconces, Drawer Pulls, and Sa-
 bots (ill. in brassware cata-
 logue, Birmingham), c.1790,
 engr
 Mayor, ill.558
 Sugar Basin in Catalogue of Shef-
 field Plate, 1780s, engr
 Mayor, ill.557
 Trade Card for Metalwares, 18th
 c., engr

Mayor, ill.556
Wallpaper fragment with classi-
cal frieze, c.1760?, chiaro-
scuro wc
Yale, pl.XXVII

ANONYMOUS: Chinese
Pavilion of Harmony, Strangeness
and Delight, designed by
Giuseppe Castiglione, Summer
Palace, Peking, after 1747,
engr
Mayor, ill.365

ANONYMOUS: French
The Gobelins Tapestry Works (ill
for Diderot, "Encyclopedie"),
pub.1751-72, engr
Mayor, ill.449
Ill. for "Galerie des Modes et
Costumes Francais", 1778-88,
etch
Mayor, ill.382
The Library at Malmaison (ill.
for C.Percier and P.Fontaine,
"Recueil de Decorations Inter-
ieures"), 1812, etch
Mayor, ill.542
Louis-Philippe, Queen Victoria,
and Prince Albert (ill. for
"Voyage de S.M.Louis-Philippe
a Windsor"), 1846, litho
Mayor, ill.258
Plate with three images: Figures
in a Cottage Interior; River
Landscape with Three Trees;
Figures in a Forest Landscape,
glass print
Detroit, p.201

ANONYMOUS: German
Mechanical and Electrical Toys
(ill. for G.H.Bestelmeier,
"Magazin von verschiedene
Kunst- und andern nutzlichen
Sachen"), 1803, etch
Mayor, ill.559

ANONYMOUS: Greek
New Russian Monastery on Mt.
Athos, 1849, etch
Mayor, ill.646

ANONYMOUS: Italian
Stage set by Giuseppe Galli
Bibiena (ill. for "Architet-

ture e Prospettive"), 1740,
engr
Mayor, ill.548

ANONYMOUS: Mexican
Ballad sheet for All Souls' Day,
1890s?, metal cut
Mayor, ill.652

ANONYMOUS: Russian
Sirin Sings of the Paradise of
the Faithful (copy of engr in
Rovinski, "Russian Fairy
Tales"), 1881, litho
Mayor, ill.647

ANONYMOUS: School of Arras
Tree Trunks, glass print
Detroit, p.201

ABBE, Solomon van (British, 1883-
1955)
The Gossip Page, etch
Guichard pl.2

ABBOTT, E.E. (Australian, 20th c.)
A Bush Road, etch
Guichard, pl.79

ABRAMO, Livio (Brazilian, 1903-)
Macumba, 1957, wc
Hayter-1, pl.2

ABULARACH, Rudolfo (Guatemalan,
1933-)
Shrine, 1966, litho
Tamarind-2, p.15
Untitled, 1966, litho
Tamarind-1, p.23
Untitled, Nov.1967, litho
Johnson-2, ill.133

ACCONCI, Vito (American, 1940-)
Kiss Off, litho
Knigin, p. 120

ACHENER, Maurice
Canal pres Strasbourg, etch
Leipnik, pl.83
Pont de la Tournelle, etch
Leipnik, pl.82

ACKERMANN, Rudolph (German, 1764-
1834)
Ackermann's Gallery (ill. for

ALBERS, Josef (American, 1888-
1976)
Aquarium, 1934, wc
Z1, ill.660
Birthday Pair: pl.LXXIIIA, 1973,
col ss
Rosen, col pl.14
Day and Night portfolio: pl.I,
1963, col litho
Tamarind-1, p.35
Day and Night portfolio: pl.X,
1963, col litho
RC-1, pl.71
Embossed Linear Construction,
1969, engr
RC-3, p.149
Embossed Linear Construction
2-A (from series of eight
prints), inkless embossed
print
Johnson-2, ill.99
Rosen, fig.197
Encircled, 1933, wc
Pet-2, p.280
Graphic Tectonic series: Ascen-
sion, 1942, litho
RC-1, pl.69
RC-3, p.147
Graphic Tectonic series: Seclu-
sion, 1942, litho
SLAM, fig.73
Gray Instrumentation Ie, 1974,
ss
Baro, p.15
Homage to the Square: orange
plate, 1964, col seri
Siblik, p.145 (col)
Homage to the Square: pl.VII,
1967, col ss
RC-3, p.151 (col)
Intaglio Duo B, 1958, inkless
intag
RC-4, p.193
Midnight and Noon suite: pl.IV,
1964, col litho
Tamarind-2, p.18
Midnight and Noon suite: pl.V,
1964, col litho
RC-4, p.188 (col)
Multiplex A, 1947, wc
RC-1, pl.70
Never Before f, 1976, ss
Baro, p.16
Self-Portrait, 1917, crayon
litho
RC-4, p.61

Self-Portrait, c.1918, litho
Eich, pl.542
Six Variants portfolio: Variant
4, 1969, seri
GM, p.10
Ten Variants portfolio: no.VII,
1967, col ss
Eich, col pl.70
Ten Variants portfolio: no.IX,
1967, col ss
Johnson-2, col ill.11
Ten Variants portfolio: no.X,
1967, col ss
Eich, col pl.70
White Line Square IV, 1966, col
litho
RC-2, p.62

ALBERT, Prince (British, 1819-
1861)
Eos and Cairnach (after drawing
by E.Landseer), pub.1843, etch
Engen, p.36
Old Woman in a Cloak (after
drawing by E. Landseer), pub.
1844, etch
Engen, p.36

ALBRIGHT, Ivan Le Lorraine (Amer-
ican, 1897-)
"Heavy the Oar to Him Who is
Tired", c.1942, litho
Z1, ill.613
Into the World There Came a
Soul Called Ida, 1940, litho
RC-1, pl.52
Self-Portrait: 55 East Division
Street, 1947, litho
Baro, p.16
Eich, pl.587
Johnson-2, ill.73

ALBRIGHT, Ripley F. (1951-)
Coffee by the Pool, 1975, litho
w. hand coloring
Baro, p.16

ALDIN, Cecil Charles Windsor
(British, 1870-1935)
A Temporary Partnership, etch
Guichard, pl.2

ALECHINSKY, Pierre (Belgian, 1927
-)
Ill. from pp.148-49 of W.Ting,
"1 Cent Life", 1964, litho

RC-4, p.149
The Moon, 1969, litho and aqua
RC-2, p.36
No Rattle (Sans Sonette), 1971,
col aqua and litho
RC-3, p.79 (col)
Quelque Chose d'un Monde, 1952-
53, etch and engr
RC-3, p.77
Sur les 12 Coups de Minuit,
1970, col litho
Knigin, p.202 (col)

ALEXEIEFF, Alexander (1901-)
Ill. for Gogol, "Journal d'un
Fou", pub.1927, engr and aqua
Hayter-2, p.36
The Name in the Wind, 1928, etch
and aqua
Ad-1, p.149

ALKEN, Henry Thomas (British,
1785-1851)
Running into a Fox, sg etch
Sparrow, opp.p.134
Study of Racehorses, sg etch
Laver, pl.XVIII

ALKEN, Samuel (British, active c.
1780-1798)
Manager and Spouter (after T.
Rowlandson(?) and H.Wigstead,
1784, col etch w.aqua
Colnaghi-1, pl.LVIII

ALLEN, Anne (active mid 18th c.)
Chinoiserie Design (after J.
Pillemont), c.1760, col etch
Z1, ill.279
Fleurs Ideales (after J. Pille-
mont; from "Nouvelle Suite de
Cahiers de Fleurs Ideales"),
col etch
Z1, ill.280

ALLEN, F.E. (British, active
1920s)
Mersey Side, Storm, c.1922-25,
etch
Guichard, pl.2

ALLEN, Terry (American, 1943-)
Pinto to Paradise, 1970, col
litho
Baro, p.16
Knigin, p.65 (col)

ALPS, Glen (American, 1914-)
Collagraph No.12, 1958, colla-
graph w.crushed walnut shells,
plastic wood, matboard
Eich, pl.452
White Necklace, 1969, col colla-
graph w.crushed walnut shells,
white lacquer, cardboard
Eich, pl.453

ALT, Otmar (German, 1940-)
Die Spielzeug Kuh, col ss
Clark, no.2

ALTENBOURG, Gerhard (German, 1926-
)
Etwa: Johannes Mohnd, litho
Clark, no.3

ALTMAN, Harold (American, 1924-)
Luxembourg November, 1965, litho
Johnson-2, ill.125

ALTOON, John (American, 1925-1969)
Untitled, 1965, col litho
Knigin, p.156 (col)
Untitled, 1968, col litho
Tamarind-2, p.19

AMAN, Jane (1943-)
Untitled, 1975, seri
Baro, p.17

AMAN, Theodore (Romanian, 1831-
1891)
La Ceinture, etch
Leipnik, pl.45

AMANO, Kazumi (1927-)
Color Ring, 1968, wc
Rosen, col pl.2

AMSHEWITZ, John Henry (British,
1882-1942)
Don Quixote, etch
Guichard, pl.3
The Fortune Teller, dp
Laver, pl.LIX

AMSTEL, Cornelis Ploos van
River with Town in Distance,
mid-19th c., col aqua and etch
Eich, p.304 (etched st), col
pl.33

ANDERSON, Alexander (1775-1870)
 Creation, wengr
 Eich, pl.105

ANDERSON, Stanley (British, 1884-
 1966)
 Les Arcades, Dieppe, etch
 Guichard, pl.3
 The Cathedral, Segovia, dp
 Laver, pl.XLIII
 The Fallen Star, 1929, engr
 Furst, p.365
 Hyden, the Old Shepherd, etch
 Guichard, pl.3

ANDRE, Johann (1775-1842)
 Suite d'avis connu...par Mozart,
 1799, litho
 Boston, p.63

ANGUIANO, Raul (1915-)
 Executed, 1940, litho
 Haab, pl.70
 Na K'in, 1951, litho
 Haab, pl.72
 Woman with Leprosy, 1940, litho
 Haab, pl.71

ANGUS, Stanley (Scottish, 20th c.)
 Lindesfarne, etch
 Guichard, pl.3

ANQUETIN, Louis (French, 1861-
 1932)
 The Horseman and the Beggar,
 1893, litho
 Stein, pl.1

ANSDELL, Richard (British, 1815-
 1885) See also H.T.Ryall; F.
 Stacpoole
 The Park, pub.1865, etch
 Sparrow, opp.p.183
 The Stag Sentinel, etch
 Guichard, pl.3

ANTES, Horst (German, 1936-)
 Couple, 1964, etch
 Sotriffer-2, p.118
 Figure with Ladder and Funnel
 (Figur mit Leiter und Rohr)
 1971, col litho
 RC-3, p.107 (col)
 Figure with Red P-Hat with Flag,
 1967, litho
 RC-4, p.160

Head with Angle, 1966, etch
 RC-2, p.54
Interior with Male Figure (Mann-
 liche Figur im Raum), 1964,
 etch and dp
 RC-3, p.105
Olympic Games in Munich 1972,
 1971, col litho
 Knigin, p.257 (col)
Untitled, col offset litho
 Clark, no.4

ANTREASIAN, Garo (American, 1922-
)
 New Mexico I, col litho
 Eich, pl.647
 Quantum Suite portfolio: pl.VII,
 1966, col litho
 Tamarind-1, p.37 (col)
 Silver Suite: pl.IX, 1968, col
 litho
 Tamarind-2, p.20
 Specimen, 1960, col litho
 RC-1, pl.94
 Untitled (78.2-Ia+b), 1978, col
 litho
 Johnson-2, col ill.22
 View, 1959, litho
 Baro, p.17

ANUSZKIEWICZ, Richard (American,
 1930-)
 Largo, 1973, litho
 Baro, p.18
 Plate 3 for W. Blake, "The In-
 ward Eye", 1970, col seri
 RC-4, p.189 (col)
 Sequential: pl.5, 1972, col seri
 Rosen, col pl.15
 Soft Lime, 1976, photo ss
 Baro, p.18

APPEL, Karel (Dutch, 1921-)
 Les Anges Noirs, 1961, col litho
 Fogg, pl.161
 Two Heads (Deux Tetes), 1965,
 col litho
 Siblik, p.27 (col)
 Woman, 1960, col litho w. ink
 and chalk
 Sotriffer-1, p.127

APPIAN, Jacques Barthelemy, called
 Adolphe (French, 1818-1898)
 Artemare, etch
 Leipnik, pl.44

Weisberg-2, no.25
Gerona, Spain, 1925, etch
 Weisberg-2, no.26
Gothic Glory, Sens, 1929, etch
 Weisberg-2, no.35
The Gothic Spirit (Gargoyle
 series, no.8), 1922, etch
 Johnson-2, ill.24
Grim Orvieto, 1926, etch
 Weisberg-2, no.8
In Memoriam, Chartres, etch
 Z4, fol.p.24
In the Gothic Spirit, 1922,
 etch
 RC-1, pl.15
Lace in Stone, etch
 Z4, fol.p.24
Limoges, 1932, etch
 Eich, pl.370
Old Corner, Rouen, 1925, etch
 Weisberg-2, no.38
Old Saumur, Houses in the Rue
 Dacier, 1916, etch
 Weisberg-2, no.39
Out of My Window, 1916, etch
 Weisberg-2, no.28
The Red Mill, 1921, etch
 Weisberg-2, no.43
Rodez, 1926, etch
 Laver, pl.LXVI
Saint Paul, Alpes Maritimes,
 1927, etch
 Weisberg-2, no.9
Stockholm, 1940, etch
 Weisberg-2, no.27
Street in Blois, 1927, etch
 Weisberg-2, no.49
Sunshine on Stone, etch
 Haas, p.129
A Tower of Saint Front, Peri-
 gueux, 1928, etch
 Weisberg-2, no.41
Triangular Bridge, Crowland,
 1941, engr
 Schmeck, p.54
Via Facchini, Pisa, 1927, etch
 Weisberg-2, no.40
Watching the People Below,
 Amiens, 1921, etch
 Weisberg-2, no.33

ARMSTRONG, Elizabeth (British,
 1859-1912)
 Dorothea, 1880s, etch
 Guichard, pl.4

ARP, Jean (Hans) (German-French,
 1887-1966)
 Bust of Navel, 1963, seri
 Siblik, p.147
 Christ on the Cross, white-line
 wc
 Eich, pl.122
 Configuration, 1951, col litho
 RC-2, p.26
 RC-3, p.43 (col)
 Ill. for "Dreams and Projects",
 pub.1952, wengr
 Z1, ill.492
 Navel Bottle (from "Arpaden"
 portfolio), 1923, litho
 RC-4, p.69
 Untitled, 1963, col litho
 Knigin, p.207 (col)
 Vers le Blanc Infini: pl.III,
 1960, etch
 RC-3, p.45

ASAWA, Ruth (1926-)
 Chair, 1965, litho
 Tamarind-2, p.21

ATKINSON, John Augustus (1775-
 after 1833)
 A Baggage Wagon in the Year
 1809, etch and aqua
 Sparrow, opp.p.123
 A Carrier's Wagon in the Year
 1807, etch and aqua
 Sparrow, opp.p.122

ATKINSON, Thomas Lewis (1817-c.
 1889)
 Flora (after V.W.Bromley), pub.
 1876, mezzo
 Engen, p.73

ATLAN, Jean (French, 1913-)
 Astarte, 1958, col litho
 Siblik, p.31 (col)
 Moonbird, 1954, col litho
 Ad-1, p.180

AUBERT, Georges (1886-1961)
 Figure of Christ (from A.Saures,
 "The Passion"; after G.
 Rouault), pub.1939, wc
 Portland, no.83
 Head of Christ (from A.Saures,
 "The Passion"; after G.
 Rouault), pub. 1939, wc
 Portland, no.82

Two Figures (from "Le Cirque de
l'Etoile Filante"; after G.
Rouault), pub.1938, wc
Portland, no.81

AUDSLEY, George Ashdown (British,
1838-1925) See also W.R.Tymms
The Art of Chromolithography
Popularly Explained and Illus-
trated...: pl.XXIII, Twelfth
printing alone, 1883, chromo-
litho
Yale, pl.LXVII
The Art of Chromolithography...:
pl.XLIV, First to twenty-
second printings combined,
1883, chromolitho
Yale, pl.LXVII
Octagonal Coffer or Panel De-
signs (pl.XXXIII of "The Prac-
tical Decorator and Ornament-
ist..."; w.M.A.Audsley), 1892,
chromolitho
Yale, pl.LXXII

AUDUBON, John James (American,
1785-1851) See also R.Havell,
Jr.
Wood Ibis, c.1825, col aqua
Sal, p.246

AUER, Alois (Austrian, 1813-1869)
Iris (?) (pl.13 of "Die Entdeck-
ung des Naturselbstdruckes"),
1854, nature print
Yale, pl.XXII (col)

AUERBACH-LEVY, William (1889-
before 1982)
Devotion, 1931, etch
Schmeck, p.56
Padraic, 1920, etch
Schmeck, p.55

AURIOL, Georges (French, 1863-
1938)
Trembling Woods, 1893, col litho
Stein, pl.11

AUSTEN, Winifred (British, 1876-
1964)
Lapwing, etch
Guichard, pl.4
Sheltering from the Wind (Little
Owls), 1920, dp
Guichard, pl.4

AUSTIN, Robert Sargent (British,
1895-1973)
Bed Time, etch
Guichard, pl.4
Deer, etch
Guichard, pl.4
Mother & Child with Lilies, etch
Guichard, pl.5
Sisters of Assisi, 1924, engr
Furst, p.393

AVATI, Mario (1921-)
The Butterflies of Nagasaki,
1962, aqua
Ad-1, p.236
Les Coquillages d'Amagansett,
mezzo
Pet-2, p.71
Il est 3 Heures, Madame, 1969,
col mezzo
Eich, col pl.53
Six Running Zebras..., 1957,
aqua
Pass-1, p.151 (4th st)
Still Life, 1961, mezzo
Sotriffer-1, p.86
Still Life with Artichokes,
1959, mezzo
Pass-1, p.153 (4th st)
Still Life with Garlic, mezzo
Pass-1, p.18
Still Life with Olives, 1956,
mezzo
Wechsler, fig.25

AVELINE, Pierre Alexander (French,
1710-1760)
The Anxious Sweetheart (after
Watteau), engr
Ad-2, p.18
The Shop of Gersaint (after
Watteau; from "Receuil
Jullienne"), 1732 (pub.1735),
engr
Z1, ill.273

AVERY, Milton (American, 1893-
1965)
Birds and Ruffled Sea, 1951,
mono in gray
MMA, p.224
The Dancer, wc
Eich, pl.140
Edge of the Forest, 1951, col
mono
MMA, p.225 (col)

Head of a Man, 1935, etch
 Johnson-2, ill.44
Myself in Blue Beret, 1950, col
 mono
 MMA, p.221 (col)
Nude with Long Torso, 1948, dp
 Baro, p.19
 Johnson-2, ill.76
Pink Nude, 1950, col mono
 MMA, p.223
Sailboat, 1954, wc
 Baro, p.19

AVILA, Abelardo (1907-)
 To the Churchyard, 1938, wc
 Haab, pl.74

AZUMA, Norio (American, 1928-)
 Image E, 1969, col ss
 Eich, col pl.73
 Image of a City, 1962, screen
 print
 Johnson-2, ill.117
 Interior, ss on canvas
 Pet-2, p.224

BAADER, Johannes (1876-1955)
 The Author in His Home, c.1920,
 collage of photographs
 Rosen, fig.40

BACHER, Otto Henry
 Venice, etch
 Laver, pl.LXII

BACKHUYSEN, Ludolf (Dutch, 1631-
 1708)
 Distant View of Amsterdam, etch
 Salaman, p.125
 Marine with Distant View of Am-
 sterdam, 1701, etch
 Z1, ill.244

BACON, Peggy (American, 1895-)
 Aesthetic Pleasure, etch
 Craven, pl.3
 Antique Beauty, 1933
 Craven, pl.5
 The Bellows Class, 1919, dp
 Johnson-2, ill.31
 Frenzied Effort (The Whitney
 Studio Club), 1925, etch & dp
 WISC, no.47
 Patroness, 1927, litho

 Getlein, p.258
 Laver, pl.LXXXIII
Pity the Blind, 1933
 Craven, pl.2
The Rival Ragmen, etch
 Craven, pl.4
The Social Graces, 1935
 Craven, pl.1

BACQUES
 Madona, 1968, litho
 Knigin, p.297

BADELEY, H.J.F. (British, 1874-
 1951)
 Bookplate for J.R.Abbey, etch
 Guichard, pl.5

BADMIN, Stanley R. (British, 1906-
)
 Burford, Oxfordshire, etch
 Guichard, pl.5
 Fallen Mill Sails, etch
 Guichard, pl.5
 Shepton Mallet, etch
 Furst, p.403

BAERISWYL, Bruno
 Untitled, 1970, litho
 Knigin, p.244

BAILEY, Peter
 Bandits (Banditti), 1802, poly-
 autograph
 Bauman, pl.4

BAJ, Enrico (Italian, 1924-)
 The Archduke Charles at the Bat-
 tle of Aspern-Essling, 1965,
 col etch
 RC-4, p.177
 Personaggio, 1968, col litho
 Knigin, p.287 (col)

BAKOF, Julius (German, 1819-1857)
 Cottage (Chaumiere), c.1857
 Detroit, p.46

BANGEMANN, Oscar
 Lovis Corinth (after a self-
 portrait by Corinth), wc
 Sotriffer-1, p.16

BAQUOY, C.
 It's a Boy, Monsieur! (after
 Moreau le Jeune), engr

Ad-2, p.170

BARATHIER
The Three Witches (ill. from
"Macbeth"; after H.Fuseli),
c.1783, engr
L-S, pl.145

BARKER, Anthony Raine (British,
1880-1963)
The Pavement Artist, etch
Guichard, pl.6

BARKER, J.J.
Horizontorium (after W.Mason),
1832, litho
Z1, ill.581

BARKER, K.F. (British, 20th c.)
The End of the Day, etch
Guichard, pl.5

BARKER, Thomas (Barker of Bath)
(British, 1769-1847)
Frontispiece to H.Bankes, "Li-
thography, or The Art of Mak-
ing Drawings on Stone", pub.
1813, litho
Weber, p.18
Rest (Group of Three Figures),
1803, pen litho
Brown, no.4
Rhaiadr Cynant y Vuch upon the
Etilia, near Festiniog, Mer-
ioneth (ill. for "Thirty-Two
Lithographic Impressions from
Pen Drawings of Landscape
Scenery"), 1814, pen litho
Godfrey, pl.87
Rustic Figure, 1813, litho
Bauman, pl.7B

BARLACH, Ernst (German, 1870-1938)
Away with the Word Cannibalism
(Fort mit dem Wort vom Mensch-
enfrass), 1922, wc
Houston, ill.20
Burial, 1919, wc
Eich, pl.121
Christ on Mount of Olives, 1920,
wc
Z1, ill.504
Z2, pl.84
Dead Children, 1919, wc
Sotriffer-2, p.73
The Dog Snatcher, 1915, wc

Ad-1, p.85
Portland, no.125
"Dona nobis pacem" (front page
ill. for "Die Bildermann"),
1916, litho
Weber, p.108
The Giant Image (ill. for
Goethe, "Ausgewahlte Ge-
dichte"), 1924, litho
Weber, p.195
Ill. to Schiller, "Ode to Joy"
(An die Freude): Freude
schoner Gotterfunken, 1927, wc
Houston, ill.28
Sachs, p.125
Ill. for Reinhold von Walter,
"Der Kopf", pub.1919, wc
Portland, no.123
Judgment Day, 1932, litho
Z2, pl.86
Metamorphic Creations of God
(Die Wandlungen Gottes): The
First Day, 1921, wc
RC-4, p.31
Metamorphic Creations of God
(Die Wandlungen Gottes): God
Over the City (The Cathe-
drals), 1921, wc
Fogg, pl.56
Getlein, p.21
Pet-1, p.224
Pet-2, p.262
Metamorphic Creations of God
(Die Wandlungen Gottes): ill.,
1922, wc
Portland, no.124
Peasant Woman (from "Der Tote
Tag"), 1912, litho
Sachs, pl.131
Rebellion: the Prophet Elijah
(from "Die Ausgestossenen"),
1922, litho
Fogg, pl.57
Z2, pl.85
The Rocks, 1921, wc
Ad-1, p.90
Self-Portrait I, 1928, litho
Z3, p.22
To Joy, 1927, wc
Z2, pl.83
Traveling Death (Wandering
Death; Wandernder Tod), 1923,
litho
Eich, pl.533
Houston, ill.21

BARLOW, Inigo (active 1780-1800)
View of the West Bank of the
Hudson's River, 1789, line
engr
MGA, pl.53

BARLOW, Thomas Oldham (British,
1824-1889)
Awake! (after J.E.Millais), c.
1867, mezzo
Engen, p.18
The Bride of Lammermoor (The
Parting of Edgar and Lucy of
Lammermoor) (after J.E.
Millais), pub.1881, mixed
media
Engen, p.80

BARNET, Will (American, 1911-)
Enfant, 1951, col litho
RC-1, pl.86
Figure, 1955, litho
Weber, p.229
Labor, c.1936-37, aqua and etch
WPA, p.9
Singular Image, 1964, col wc
Baro, p.19
Johnson-2, col ill.18
Waiting, 1976, litho and screen
print
Johnson-2, ill.119
Woman and Cats, 1962, wc
Z1, ill.632

BARON, Bernard (French, 1696-1762)
Marriage a la Mode (after
Hogarth): pl.1, The Contract,
1745, engr
Getlein, p.155
Marriage a la Mode: pl.2, The
Morning After (Breakfast
Scene)
Getlein, p.155
Long, pl.55
Z1, ill.338
Marriage a la Mode: pl.3, The
Quack Doctor (A Visit to the
Quack)
Getlein, p.157
Long, pl.56
Marriage a la Mode: pl.4, The
Levee
Getlein, p.157
Marriage a la Mode: pl.5, Wound-
ed Nobleman
Getlein, p.159

BARRY, James (Irish, 1741-1806)
Eastern Patriarch, 1803, pen and
tusche litho
Man, pl.11
Z3, p.117
Elysium, 1791, etch and engr
Godfrey, pl.67

BARTH, Johann August (German,
1765-1818)
Persice (pl.45 of "Pacis annis
MDCCCXV foederatis armis rest-
itutae monumentum..."), 1818,
letterpress and 6-col litho
Yale, pl.LIV

BARTOLOZZI, Francesco (Italian,
1727-1815)
Cupids (ill. for G.B.Piazzetta,
"Studj di Pittura"), 1760, etch
Mayor, ill.323
The Duchess of Suffolk (pl.2 of
part I of J.Chamberlaine, "Im-
itations of Original Drawings
by Hans Holbein..."), 1792-
1800, col stipple engr
Yale, pl.XXVIII
Four Putti (ill. for "Eighty-two
Prints...from Original Draw-
ings of Guercino"), 1764-84,
etch
Mayor, ill.345
Honora Sneyd (after T.H.Ben-
well), 1784, stipple engr
Mayor, ill.226
The Lady Parker (after H.
Holbein), 1812, stipple engr
Wechsler, fig.26
Lady Smythe and Children (after
Reynolds), 1789, stipple engr
Godfrey, pl.48, fig.6 (det)
Mrs.Abington as Thalia (Alle-
gory) (after R.Cosway),
stipple engr
Hayter-2, p.193
Ivins, p.136
The Shrimp Girl (after Hogarth),
1782, stipple engr
Z1, ill.343
Title page for "La Reggia di
Calipso", c.1763, etch
Mayor, ill.563
Venus Chiding Cupid (after Rey-
nolds), stipple engr
Hind, p.292
Venus Recommending Hymen to Cupid

Ad-2, p.222

BARTSCH, Adam von (Austrian, 1757-
1821)
Self-Portrait, 1785, etch & engr
Z1, ill.320

BARYE, Antoine-Louis (French, 1796
-1875)
A Lion and Her Young, 1832 (?),
crayon litho
Bauman, pl.36
Brown, no.5
Mississippi Bear, c.1835, crayon
litho
Minn, pl.6
RM-1, p.55

BASCHANG, Hans (1937-)
Composition, col ss
Clark, no.8

BASKETT, Charles Henry (British,
1872-1953)
The Harvest Moon, etch
Guichard, pl.6

BASKIN, Leonard (American, 1922-)
The Anatomist (Anatomical Man),
1952, wc
Ad-1, p.189
Fogg, pl.75
Pet-2, p.263
RC-2, p.31
Angel of Death, 1959, wc
Johnson-2, ill.70
Children and Still Life, wengr
Eich, pl.147
Crazy Horse, 1974, litho
Baro, p.20
Death of the Laureate, 1959,
wengr
Eich, pl.149
Sotriffer-1, p.38
Eve, 1976, litho
Baro, p.20
Goya, 1963-64, etch
MOMA, p.25
RC-3, p.101
Haman, 1956, wc
Sotriffer-2, p.117
Hydrogen Man, 1954, wc
Z5, p.123
Man of Peace, 1952, wc
Johnson, p.13
Johnson-2, ill.69

RC-3, p.99
RC-4, p.133
Man with Forsythia, 1953, wengr
Getlein, p.261
Pet-2, p.303
Poet Laureate, 1955, wc
Z1, ill.654
Porcupine, 1951, wc
Sachs, p.208
Torment, 1958, wc
RC-1, pl.68

BASTIEN-LEPAGE, Jules (French,
1848-1884)
Mower Sharpening his Scythe
(Faucheur Aiguisant sa Faux),
1878, etch
Weisberg-1, p.49
Return from the Fields (Retour
des Champs), c.1878, etch
Weisberg-1, p.48

BAUER, Marius Alexander Jacques
(Dutch, 1867-1932)
Elephants, etch
Furst, p.319
The Entry of a Queen, etch
Lumsden, p.315
Mecca Pilgrims, etch
Lumsden, p.327
A Sultan, etch
Lumsden, p.316
The West Front, Amiens, etch
Wedmore, opp.p.24

BAUER, Rudolf (German, 1889-1953)
Bantama (from Bauhaus Portfolio
3), c.1921, litho
Wingler, pl.29

BAUERLE, Amelia (Bowerley)
(British, d.1916)
The Goblin Market, etch
Guichard, pl.6

BAUMEISTER, Willi (German, 1889-
1955)
Abstract Seated Figure (from
Bauhaus Portfolio 3), c.1921,
litho
Wingler, pl.30
Apoll II, 1921, litho
Rosen, fig.78
Tennis Players, litho
Ad-1, p.175

BAUMER, Lewis C. (British, 1870–
1963)
The Mirror, etch
Guichard, pl.6

BAWDEN, Edward (British, 1903–)
The Bibliolaters Relaxed (menu
for The Double Crown Club 16th
dinner), 1928, letterpress w.
stenciled color
Gilmour, pl.14
Calendar in "Review of Revues",
pub.1930, letterpress and col
line
Gilmour, pl.14
Smithfield Market (from "Six
London Markets"), 1967, col
litho
Gilmour, pl.32 (col)
That's What We Want! Dried Beef
Pulp, pub.1930, litho
Gilmour, pl.15

BAXTER, George (British, 1804–
1867)
Avalanche at Lewes (f.p. of R.
Mudie, "Winter"; after W.West-
all), 1837, col wengr
Yale, pl.XXXVI
The Belle of the Village, 1854,
col wengr w.key plate
Yale, pl.XXXIX
Cattle Drinking (f.p. of B.F.
Gandee, "The Artist or, Young
Ladies Instructor"; after T.
Gainsborough), 1835, col wengr
Yale, pl.XXXV
Chimborazo (f.p. of A.von Hum-
boldt, "Views of Nature: or,
Contemplations..."; after
drawing by A.von H.), 1850,
col wengr w.key plate
Yale, pl.XXXVII
Dippers and Nest (title page
vignette of vol.I of R.Mudie,
"The Feathered Tribes of the
British Isles"), 1834, col
wengr
Yale, pl.XXXIV
Evening on the Sea (f.p. of R.
Mudie, "The Sea"), 1835, col
wengr w. key plate
Yale, pl.XXXVI
Funeral of the late Duke of
Wellington, 1853, col wengr w.
key plate

Yale, pl.XXXIX
Gems of the Great Exhibition:
pl.2, Portion of the Belgian
Department, 1854, col wengr w.
key plate
Yale, pl.XXXVIII
Gems of the Great Exhibition:
pl.8, General View of the Ex-
terior from the Southeast,
1854, col wengr w.key plate
Yale, pl.XXXVIII
Hiram Powers' Greek Slave at the
Crystal Palace, Hyde Park,
1851, col mixed method
Mayor, ill.537
Parsonage at Ovingham (pl. opp.
p.713 of J.Jackson, "A Trea-
tise on Wood Engraving...";
after drawing by E.Swinburne),
1839, chiaroscuro wengr
Yale, pl.XL
Polar Sky (f.p. of R.Mudie, "The
Heavens"), 1835, col wengr w.
key plate
Yale, pl.XXXVI
The Reception of the Rev. John
Williams, at Tanna, in the
South Seas (pl.1 of "Two Spec-
mens of Printing in Oil Col-
ours"), 1841, col wengr w.key
plate
Yale, pl.XXXVII
South Down Sheep (f.p. to "Bax-
ter's Agricultural and Horti-
cultural Gleaner"), 1836, col
wengr w.key plate
Yale, pl.XXXVI
Verona (pl.4 of "The Pictorial
Album; or, Cabinet of Paint-
ings"; after S.Prout), 1837,
col wengr
Yale, pl.VIII (col)

BAYER, Herbert
Structure on Yellow, 1965, col
litho
Tamarind-2, p.22

BEAL, Jack (American, 1931–)
Self-Portrait, 1974, litho
Baro, p.20

BEARDEN, Romare (American, 1914–)
Prevalence of Ritual, 1974–75,
screen print
Johnson-2, ill.124

etch
Laver, pl.XLV

BELL, Charles (Scottish, 1774-
1842)
Plate from "A Series of Engrav-
ings Explaining the Course of
the Nerves", pub. 1803, engr
L-S, pl.170

BELL, John (British, 1811-1895)
Comus and his Rout, etch
Guichard, pl.7

BELLMER, Hans (German, 1902-1975)
Rose ou Verte la Nuit, 1966,
etch
RC-4, p.84
Untitled, 1968, engr
RC-3, p.93

BELLOTTO, Bernardo (Italian, 1721-
1780)
Konigstein Castle with the
Lilienstein, c.1765, etch
Sopher, p.20
View of the Bridge at Dresden on
the Elbe, 1748, etch
Sal, p.53 (I/IV)

BELLOWS, George (American, 1882-
1925)
Allan Donn Puts to Sea (ill.
from Donn Byrne, "The Wind
Bloweth"), 1923, litho
Cleveland, pl.XLVII
Anne in a Spotted Dress, litho
Haas, p.118
Counted Out (no.2), 1921, litho
WISC, no.40
Dempsey and Firpo, 1924, litho
RC-1, pl.19
Hungry Dogs, 1916, litho
Eich, pl.579
In the Park, 1916, litho
RC-1, pl.18
Jean in a Black Hat, c.1920,
litho
Wechsler, fig.28
Murder of Edith Cavell, 1918,
litho
Johnson-2, ill.27
Nude on a Bed, Evening, 1921,
litho
Minn, pl.36
The Sawdust Trail, 1917, litho

WISC, no.39
Splinter Beach, 1917, litho
Bowdoin, pl.11
Lockhart, p.202
Stag at Sharkey's, 1917, litho
Cleveland, pl.XLVII
Fogg, pl.77
Johnson-2, ill.28
Knigin, p.129
Rosen, fig.84
Sachs, pl.184
SLAM, fig.81
Weber, p.135
Z1, ill.611

BELTRAN, Alberto (1923-)
Francisco Villa, Leader of the
Insurgents (1877-1923) (from a
Taller de Grafica Popular
portfolio "Estampas de la
Revolucion"), 1946, linocut
Haab, pl.49

BELTRAND, Camille
The Ploughman, wc
RM-2, pl.85

BEN-ZION (Ukrainian-American,
1897-)
In the Grip of the Five Senses
(pl.14 from "In Search of One-
self"), 1967, etch
Johnson-2, ill.74

BENCOVICH, Federico (Italian, 1677
-1756)
St. Peter of Pisa, after 1724,
etch
Sopher, p.31

BENGSTON, Billy Al (American,
1934-)
Cockatoo AAA Dracula, 1968, col
litho
Tamarind-2, p.23

BENNETT, William James (British,
1787-1844)
South Street from Maiden Lane,
1828, col aqua
Z1, ill.575

BENSON, Frank Weston (American,
1862-1951)
Broadbills, 1919, etch and dp
Z1, ill.605

Canoe Man, etch
 Schmeck, p.58
Flight of Blue Bills, 1915, etch
 Schmeck, p.57
Herons at Rest, etch
 Lumsden, p.329
Portsmouth Harbor, 1916, dp
 Schmeck, p.58
Rippling Water, etch
 Laver, pl.LXIX
Summer Yellow-Legs, dp
 Lumsden, p.330

BENTLEY, Alfred (British, 1879-
1923)
Silent River, etch
 Guichard, pl.7
The Wayfarers, etch
 Guichard, pl.7

BENTON, Thomas Hart (American,
1889-1975)
Coming Round the Mountain, litho
 Z4, fol.p.176
Cradling Wheat, 1939, litho
 Eich, pl.588
 Johnson-2, ill.45
 Z4, fol.p.176
Frankie and Johnny, litho
 Craven, pl.8
Going West, 1929, litho
 Z1, ill.642
 Z4, fol.p.176
I Got a Gal on Sourwood Mountain
 Craven, pl.7
In the Ozarks, 1938, litho
 Craven, pl.9
 Getlein, p.257
 RC-1, pl.45
Jesse James, 1936, litho
 Knigin, p.129
 Lockhart, p.206
Lonesome Road, litho
 Craven, pl.6
Sunday Morning, litho
 Craven, pl.10

BENY, W. Roloff (Canadian, 1924-)
A Time of War and a Time of
 Peace, 1947, etch, aqua,
 litho, engr
 Baro, p.22

BERCKELAERS, Ferdinand Louis
See SEUPHOR, Michel

BERDECIO, Roberto (1910-)
Mexican Girl, 1947, litho
 Haab, pl.76

BERDICH, Vera (American, 1915-)
Fabricated Mirror, 1957, aqua,
 dp, mezzo
 Johnson-2, ill.135
Lunar Eclipse, 1959, glass print
 Detroit, p.124

BERG, Werner (1904-)
Courtship, c.1960, wc
 Sotriffer-2, p.111

BERGER, L.
Interieur d'une Chambre Mili-
 taire, early 19th c., litho
 Eich, pl.484

BERGERET, Pierre-Nolasque (French,
1782-1863)
The Burning of Troy (Der Brand
 von Troja; L'Incendie de
 Troie), 1803, pen litho
 Brown, no.7
 Man, pl.53
Lamentation for the Dead (adver-
 tisement for Mr.Belland, "The
 Louvre Pictures"), 1803, litho
 Bauman, pl.11B
 Weber, p.46 (det)
 Z3, p.119

BERGMAN, Anna Eva (Swedish, 1909-
 -)
Norwegian Sea (Mer de Norvege),
 1964, litho
 Siblik, p.105

BERNARD, Emile (French, 1868-1941)
Christ (Crucifixion), 1894, wc
 Stein, pl.42

BERNIK, Janez (Yugoslavian, 1933
 -)
Script 218, 1963, aqua
 Siblik, p.141 (col)

BERTHAULT, P.-G.
Revolutionary Committee under
 the Terror (from "Tableaux
 Historiques de la Revolution
 Francaise"; after Fragonard),
 pub.1802, engr
 Ad-2, p.184

Z1, ill.326

BERTHAUX, F.
A View of West Point, c.1810,
litho
MGA, pl.114

BERTOIA, Harry (American, 1915-
1978)
Composition, 1943, col mono-
print
RC-1, pl.81

BERTON, Armand (d.1918)
L'Espiegle, etch
Leipnik, pl.95

BERVIC, Charles-Clement Balvay
(French, 1756-1822)
The Laocoon group, as restored
in 1533 by G.A.da Montorsoli,
1809, engr
Mayor, ill.343

BESNARD, Paul Albert (French,
1849-1934)
Dans les Cendres, etch
Leipnik, pl.66
The End of it All, c.1880, etch
Chase, pl.47
RM-1, p.155
RM-2, pl.48
L'Indifferente (from the series
"Elle"), pub.1900, etch
Furst, p.285
The Intruder (The Visitor),
1893, litho
Stein, pl.21
La Liseuse, etch
Leipnik, pl.67
Madame Besnard, 1884, etch and
dp
Kovler, p.23
The Sick Mother, 1889, etch
RM-1, p.158
The Silk Dress (La Robe de Soie)
1887, etch
Chase, pl.49
Kovler, p.24 (III/III)
RM-2, pl.49
The Swim (Bathing at Talloires),
1888 (pub.1894), etch and aqua
Stein, pl.71
Woman Reading (Before the Win-
dow), 1888 (pub.1895), etch
Stein, pl.82

BEURDSLEY, Jacques (b.1874)
Avignon a Travers les Arbres,
etch
Leipnik, pl.77
The Footbridge to the Washhouse,
1927, etch
Ad-1, p.162
Landscape at Provins, etch
RM-2, pl.90
Route Dans la Plaine, etch
Leipnik, pl.76

BEUYS, Joseph (German, 1921-)
Ohne Rosen, col offset screen
Clark, no.12

BEVAN, Robert (British, 1865-1925)
Horses in a Stable, before 1894,
etch
Guichard, pl.7

BEVERLOO, Cornelis van
See CORNEILLE

BEWICK, Thomas (British, 1753-
1828)
British Water Birds: Kingfisher,
1804, wengr
Eich, pl.95
British Water Birds: Skaters,
1804, wengr
Mayor, ill.636
Rosen, fig.70
British Water Birds: tailpiece,
A Man Fishing, 1804, wengr
Godfrey, pl.69
The Cadger's Trot, 1823, litho
Bauman, pl.26 (I/III), pl.27
(II/III)
A General History of Quadrupeds:
ill., pub.1790, wengr
Portland, no.76
A General History of Quadrupeds:
Leopard, 1790, wengr
Ad-2, p.226
A General History of Quadrupeds:
Wild Bull, 1790, wengr
Eich, pl.94
History of British Birds: Female
Horned Owl, 1797, wengr
Wechsler, fig.9
History of British Birds: Fisher-
man, 1797, wengr
Z1, ill.414
History of British Birds: fisher-
man and goose lady, pub.1797-

1804, wengr
Ivins, p.138
History of British Birds: Sea
Eagle, 1797, wengr
Ad-2, p.227
History of British Birds: Way-
farers, 1797, wengr
Z1, ill.413
Waiting for Death, 1828 (?),
wengr
Z5, p.37

BEYER (German or Swiss, 19th c.)
In the Forest of Fontainebleau,
etch
Hamerton, opp.p.128

BHATT, Jyoti
Baroda, 1967, intag on brass
sheet
Eich, pl.404
Untitled, 1966, etch
Eich, col pl.93

BIBIENA, Ferdinando Galli (Ital-
ian, 1657-1743)
How to Draw a Backdrop (ill. for
F.B., "L'Architettura Civile")
1711, etch
Mayor, ill.178

BICKHAM, George, the elder (Eng-
lish, 1684?-1758?)
English Names for the Muscles
(pl.25 for "The Museum of the
Arts; or, the Curious Reposi-
tory"), c.1745?, line engr w.
col line engr superimposed
Yale, pl.XXVI

BIDDLE, George (American, 1885-
1973)
Cows and Sugar Cane, litho
Z4, fol.p.96
Europa, litho
Z4, fol.p.96
George Santayana, 1952, litho
Sachs, p.237
In Memoriam Spain, litho
Z4, fol.p.96
Self-Portrait, litho
Z4, fol.p.96

BIERMANN, Ed
Finstermunz (after E.B.; from
the album of Berlin Artists),

1855, col oleograph
Weber, p.149 (col)

BIRCH, S.J.Lamorna (British, 1869-
1955)
The Mersey, Cheshire, etch
Guichard, pl.8

BIRCH, William (American, 1755-
1834)
Pennsylvania Hospital, in Pine
Street, Philadelphia, 1799,
line engr
MGA, pl.89
Preparation for War to Defend
Commerce, 1800, line engr
MGA, pl.88

BIRMELIN, Robert (American, 1933
-)
Monkey, 1956, etch and dp
Pet-2, p.112

BIRRELL (British, late 18th c.)
Isabella e Manfredi (pl.2 for
H.Walpole, "Jeffery's edition
of the Castle of Otranto, a
Gothic story"; after "Una
Dama"), 1796, col stipple engr
Yale, pl.XXX

BISHOP, Isabel (American, 1902-)
Encounter, 1939, etch
Johnson-2, ill.33
Little Nude, 1964, etch and aqua
Johnson-2, ill.128
Office Girls, etch
Craven, pl.11
Schoolgirls, etch
Craven, pl.12

BISSIERE, Roger (French, 1886-
1964)
Autumn, 1955, col litho
Weber, p.215 (col)

BJORKLAND, Marc R. (1949-)
Void V/VI, 1975, etch and seri
w. hand coloring
Baro, p.22

BLACHE, Philippe-Charles
Twilight, 1894, col litho
Stein, pl.61

BLACKBURN, Robert (American, 1920
 -)
 Girl in Red, 1950, litho
 Baro, p.23

BLAKE, William (British, 1757-
 1827)
 An Agitated Group Gazing into
 Space (after R.Blake), relief
 etch
 Lumsden, p.268
 Albion's Angel (from "Europe--a
 Prophecy"), 1794, relief etch
 Eich, pl.292
 America: The Door of Death, engr
 Hind, p.221
 America: f.p., relief etch
 Long, pl.113
 The Book of Loth: page, relief
 etch
 Hayter-2, p.209
 The Book of Urizen, I, copy D,
 pl.II, 1794, col relief etch
 Godfrey, fig.5 (col)
 The Book of Urizen: title page,
 1794, hand-col relief etch
 Mayor, ill.609
 Canterbury Pilgrims, 1810, engr
 Eich, pl.291 (4th st; det)
 Dante, "The Inferno": canto XXV,
 engr
 Pet-2, p.30
 Dante, "The Inferno": canto
 XXXII, 1, 79, "Wherefore dost
 bruise me?" (pl.7), c.1826, engr
 Colnaghi-1, pl.LXI
 Dante, "The Inferno": Circle of
 the Falsifiers, 1826, engr
 Eich, pl.290
 Long, pl.111
 Dante, "The Inferno": Circle of
 the Lovers (Circle of the
 Lustful; Paola and Francesca;
 Whirlwind of Lovers), 1826,
 engr
 Eich, pl.289
 Long, pl.110
 Minn, pl.4
 Pet-1, p.165
 Dante, "The Inferno": Circle of
 Thieves, unfinished engr
 Hayter-2, p.208
 Dante, "The Inferno": Head of
 One of the Damned (after
 Fuseli), c.1790-92, engr
 Godfrey, pl.71

 Dante, "The Inferno": The Male-
 branche Tormenting Ciampolo,
 engr
 Long, pl.109
 Ezekiel, 1794, engr
 Godfrey, pl.72
 Sal, p.187
 Gates of Paradise: ill.
 Long, p.164
 Glad Day (Morning), 1780, engr
 Wechsler, pl.49
 The House of Death, 1795, col
 mono
 Sal, opp.p.64 (col)
 Illustrations of the Book of
 Job: pl.2, When the Almighty
 Was Yet With Me, When My Chil-
 dren Were About Me, 1825, engr
 Bowdoin, pl.30
 Illustrations of the Book of
 Job: pl.3, Thy Sons & Thy
 Daughters Were Eating & Drink-
 ing Wine, 1825, engr
 Bowdoin, pl.31
 Illustrations of the Book of
 Job: pl.9, Then a Spirit Pass-
 ed Before My Face, engr
 Lockhart, p.180
 Illustrations of the Book of
 Job: pl.14, When the Morning
 Stars Sang Together, 1825,
 engr
 Bowdoin, pl.32
 Ivins, p.146
 Long, pl.106
 Z1, ill.423
 Z5, p.29
 Illustrations of the Book of
 Job: pl.15, Behemoth and Levi-
 athan (Behold now Behemoth),
 1825, engr
 Bowdoin, pl.33
 Long, pl.107
 L-S, pl.151
 Illustrations of the Book of
 Job: Job's Evil Dream, pub.
 1825, engr
 L-S, pl.150
 Illustrations of the Book of
 Job: Satan Smiting Job, engr
 Haas, p.42
 Illustrations of the Book of
 Job: Then the Lord Answered
 Job Out of the Whirlwind, pub.
 1825, engr
 Furst, p.203

BOCHNER, Mel (American, 1940-)
 Rules of Interference (from an
 untitled series), 1975, aqua
 Ontario, p.15
 Untitled (from "Apices"), 1974,
 aqua
 Ontario, p.12

BOEL, Coryn
 The Caterwaulers' Concert (after
 D.Teniers), engr
 L-S, pl.116

BOHRMANN, Karl (1928-)
 Messblatt, etch
 Clark, no.14

BOHROD, Aaron (American, 1907-)
 New Orleans Street, litho
 Craven, pl.15
 Reflections in a Shop Window,
 1948, litho
 WISC, no.62

BOILLY, Julien-Leopold (Jules)
 (1796-1874)
 Portrait of Thenard (Louis-
 Jacques), member of the Legion
 of Honor, 1822, crayon litho
 Baro, no.8

BOILVIN, Emile (French, 1845-
 1899)
 Vespertina Quies (after E.C.
 Burne-Jones), pub.1897, etch
 Engen, p.70

BOISSIEU, Jean-Jacques de (French,
 1736-1810)
 The School-Master
 Ad-2, p.116
 Self-Portrait, 1796, etch and dp
 SLAM, fig.27

BOLDINI, Giovanni (Italian, 1842-
 1931)
 Portrait of Paul Helleu, c.1900,
 sg etch
 Kovler, p.28
 Sal, p.281
 Whistler Dozing, 1897, dp
 Mayor, ill.715

BOLOTOWSKY, Ilya (American, 1907
 -)
 Rectangle Red, Yellow, 1974,
 screen print
 Johnson-2, col ill.7

BONANNI, F.
 Plate from A.Kircher, "Museum
 Kircheriarum", pub.1709
 L-S, pl.129

BONAPARTE, Louis, King of Holland
 (1778-1846)
 Four Men of the Imperial Guard
 in Conversation, 1805, litho
 Weber, p.47

BONE, David Muirhead (British,
 1876-1953)
 The Art Gallery, Glasgow, 1901,
 etch
 Guichard, pl.9
 Ayr Prison, 1904, dp
 Guichard, pl.9
 Knoedler, p.91
 Lumsden, p.333
 Building
 Guichard, pl.9
 Knoedler, p.92
 Canal and Bridge of SS.Apostoli,
 Venice
 Knoedler, p.107
 Conrad Listening to Music
 Knoedler, p.105
 Demolition of St.James's Hall--
 Exterior
 Knoedler, p.96 (4th st)
 Demolition of St.James's Hall--
 Interior, dp
 Lumsden, p.331
 Evening, Port of Genoa
 Knoedler, p.100
 The Fishmarket, Venice, No.1
 Knoedler, p.98
 The Fosse, Lincoln
 Knoedler, p.93 (III/IV)
 The Great Gantry, Charing Cross
 Station, etch and dp
 Knoedler, p.95
 Schmeck, p.60
 Leeds
 Knoedler, p.94 (1st st)
 Leeds Warehouses, etch
 Wedmore, opp.p.166
 Manhattan Excavation, 1928, dp
 Knoedler, p.108
 WISC, no.53
 Mike, the Dynamiter, dp
 Furst, p.341

Laundry Girl (La Petite Blanch-
 isseuse), 1896, col litho
 Ives, p.59
 RM-2, col pl.XV
 Sachs, pl.57
 Sal, opp.p.208 (col)
Municipal Guard, 1893, litho
 Bauman, pl.67
Portrait en Famille, 1893-94,
 col litho
 Eich, col pl.56
Portrait of Ambroise Vollard,
 1914 (?), etch
 Eich, pl.338
 Sachs, pl.58
Portrait of A.Renoir, 1914, etch
 and dp
 Pet-1, p.247
 Pet-2, p.117
Poster for France-Champagne,
 1889, col litho
 Bowdoin, pl.52
 Ives, p.56
Poster for "La Revue Blanche",
 1894, col litho
 Knigin, p.20
 Mayor, ill.642
Poster for the exhibition "Les
 Peintres Graveurs", 1896, col
 litho
 Weber, p.187
Promenade of Nursemaids; Frieze
 of Horse Cabs, 1899, col litho
 for a 4-panel folding screen
 Ives, p.65
 Sal, p.198
Some Aspects of Paris Life:
 (Quelques Aspects de la Vie de
 Paris): Boulevard, pub.1895,
 col litho
 Cleveland, pl.XLIII
Some Aspects of Paris Life: The
 Bridge (Pont des Arts), 1899,
 col litho
 Ives, pl.63
Some Aspects of Paris Life: f.p.
 1898-99, col litho
 Pass-2, p.195 (col)
Some Aspects of Paris Life: The
 Kitchen, 1895, col litho
 Mayor, ill.720
Some Aspects of Paris Life:
 Rainy Street at Evening (Rue
 le Soir sous la Pluie), 1895,
 col litho
 Ives, p.63 (col)

Troche, p.52
 Z1, ill.448
Some Aspects of Paris Life:
 sheet 12, The Arc de Triomphe
 Seen from the Porte Dauphine,
 1895, col litho
 Pass-2, p.197 (col)
 Sotriffer-1, p.97 (col)
Some Aspects of Paris Life:
 Street Corner, 1899, col litho
 Ives, p.60
Some Aspects of Paris Life:
 Street Seen from Above, 1899,
 col litho
 Fogg, pl.9
 Ives, p.64
The Street, col litho
 RM-2, col pl.XIV
La Toilette Assise, 1925, litho
 Weber, p.101
The Yard, col litho
 RM-2, pl.81
Young Woman with Umbrella, 1895,
 litho
 Weber, p.99
Woman Sitting in Her Bath, 1942,
 col litho
 Bauman, pl.69

BONNET, Louis Marin (French, 1736-
 1793)
A Bust of a Young Girl (after F.
 Boucher), c.1765, col engr in
 crayon manner
 Colnaghi-1, pl.LV (III/IV)
The Charms of the Morning, c.
 1775, col print in imitation
 of pastel
 Sal, opp.p.112 (col)
Head of a Woman (after F.Bouch-
 er), 1767, col engr in crayon
 manner
 Ad-2, p.44 (col)
 Wechsler, fig.27
Portrait of Mme.du Barry (after
 design by F.-H.Drouais), c.
 1770, engr in crayon manner
 Z1, ill.323

BONTECOU, Lee (American, 1931-)
First Stone, 1962, litho
 Eich, pl.648
 Johnson-2, ill.94
 Knigin, p.175
 MOMA, p.28
Fourth Stone, 1963, col litho

BRADBURY, Henry (British, 1829-
 1860)
 Fucus nodosus, Linn (pl.CXXXIX
 of vol.3 of W.G.Johnstone and
 A.Croall, "The Nature-Printed
 British Sea-Weeds"), 1859-60,
 nature print in 2 colors
 Yale, pl.LXV
 Gracilaria multipartita, J.Ag
 (pl.LVII of vol.1 of "The Na-
 ture-Printed British Sea-
 Weeds"), 1859-60, nature
 print
 Yale, pl.LXV

BRADBURY & EVANS (British, mid-
 19th c.)
 Arcesilaus, King of Cyrene,
 Weighing Silphium...(f.p. of
 vol.1 of S.Birch, "History of
 Ancient Pottery"; after draw-
 ing by S.B.), 1858, col wengr
 Yale, pl.LIII
 Entrance to the Garden from the
 Council-Room (p.89 of A.Mur-
 ray, "The Book of the Royal
 Horticultural Society, 1862-
 63"), 1863, letterpress and
 col wengr
 Yale, pl.LIII
 The Exhibition-Room of the Royal
 Academy in 1780 (p.13 of vol.1
 of A.E.Bray, "Life of Thomas
 Stothard, R.A..."; after draw-
 ing by T.S.), 1851, letter-
 press and col wengr
 Yale, pl.LIII

BRADSHAW and BLACKLOCK (British,
 1850s)
 St.Paul Preaching at Athens, c.
 1854, col wengr
 Yale, pl.XLI

BRAMMER, Leonard Griffith (Brit-
 ish, 1906-)
 The Potteries, etch
 Guichard, pl.10

BRANDON, Jacques-Emile-Edouard
 (French, 1831-1897)
 Souvenir of Nice--Young Mother
 Giving her Child a Drink
 (Souvenir de Nice--Jeune Mere
 Fait Boire son Enfant), Jan.
 1854, glass print

Detroit, p.47

BRANGWYN, Frank (British, 1867-
 1956)
 The Bridge, 1904, etch
 Ad-1, p.67
 The Bridge, Espalion, etch
 Furst, p.321
 Building the Victoria and Albert
 Museum, etch
 Wedmore, opp.p.190
 Cannon St.Station, Exterior,
 etch and dp
 Schmeck, p.61
 Church of St.Walburgh, Furness,
 etch
 Guichard, pl.10
 The Feast of Lazarus, etch
 Lumsden, p.347
 Interior of the Church at Air-
 vault, etch
 Furst, p.323
 The Old Bridge at Pavia, dp
 Laver, pl.XXXI

BRANSTON, Allen Robert (British,
 1778-1827)
 Female Street Sweeper and Child
 (pl.4 of W.Savage, "Practical
 Hints on Decorative Printing";
 after design by W.M.Craig),
 1818-23, col wengr
 Yale, pl.XXXII (1st & 5th sts)

BRAQUE, Georges (French, 1882-
 1963) See also J.Villon
 Athena, 1932, col litho
 Fogg, pl.102
 Z1, ill.477
 Bass (Still Life: Wine Glasses,
 Bottles, Cigarettes), 1911/12,
 etch
 Bowdoin, pl.64
 Melamed, p.13
 Sachs, pl.91
 Bird No.7, 1954, col litho
 Siblik, p.25
 Chariot II, 1953, col litho
 Fogg, pl.104
 Chariot III (The Varnished Char-
 iot; Char III; Le Char Verni),
 1955, embossed col litho
 Eich, col pl.61
 RC-3, p.37 (col)
 RC-4, p.100 (col)
 Composition (Still Life with

litho
Rosen, fig.207
Not Wanting to Say Anything
about Marcel--Litho A, 1969,
litho
Knigin, p.97
Not Wanting to Say Anything
about Marcel--Plexigram I,
1969, screen on plastic panels
Johnson-2, ill.104
Plexigram I, 1970, col litho on
Plexiglas
Eich, pl.650

CAIN, Charles William (British,
1893-1962)
Irrawaddy Night, etch
Guichard, pl.13
The Shamal, Mesopotamia, 1924,
etch
Guichard, pl.13

CALAME, Alexandre (Swiss, 1810-
1864)
Alpine Stream, litho
Cleveland, pl.XIX
Souvenir of the Lake, litho and
"chine colle"
Kovler, p.58

CALDER, Alexander (American, 1898-
1976)
The Big I, 1944, hard and sg etch
Hayter-1, p.80
RC-1, pl.60
Flying Saucers, 1968, litho
Johnson-2, ill.82
Ill. for R.L.'Estrange, "The
Fables of Aesop": horse and
lion, 1931
Mayor, ill.99
Le Mousson, 1965, litho
Knigin, p.251
Red Sun, 1965, col litho
RC-4, p.196
Untitled, 1946, col litho
RC-1, pl.87

CALDERON DE LA BARCA, Celia (1921-
)
The Patient, 1950, dp
Haab, pl.55

CALVERT, Edward (British, 1799-
1883)
The Bride, 1828, engr

Eich, pl.293
Chamber Idyll II, 1831, wengr
Godfrey, pl.78
Z1, ill.427
The Flood, 1829, litho
Cleveland, pl.XVI
Ideal Pastoral Life, 1829, litho
Cleveland, pl.XVII
The Ploughman--Christian Plough-
ing the Last Furrow of Life,
1827, wengr
Godfrey, pl.76

CAMERON, David Young (Scottish,
1865-1945)
Afterglow (or Evening) on the
Findhorn
Knoedler, p.84 (2d st)
Beaufort's Tower, St.Cross, 1902
etch
Weisberg-2, no.32
Beauvais
Knoedler, p.86 (VIII/X)
Ben Ledi, 1911, etch
Guichard, pl.14
Ben Lomond, 1923, etch
Guichard, pl.14
Knoedler, p.89
A Border Tower
Knoedler, p.78 (2d st)
Chartres
Knoedler, p.81 (I/V)
The Chimera of Amiens, 1910,
etch and dp
Guichard, pl.14
Lumsden, p.337
Le Cour des Bons Enfants, 1897,
etch
Furst, p.315
Craigievar
Knoedler, p.85 (3d st)
The Devil's Hole, Stanley on the
Tay
Knoedler, p.88
The Five Sisters of York, etch
Wedmore, opp.p.162
The Gargoyles, Stirling Castle
Knoedler, p.79 (2d st)
Harfleur
Guichard, pl.13
Knoedler, p.83 (5th st)
Joannis Darius, Venice
Guichard, pl.13
Knoedler, p.80
Kingsgate, Winchester, 1902,
etch

Weisberg-2, no.48
Landscape, etch
 Weisberg-2, no.7
The Mosque Doorway, Cairo, etch
 Guichard, pl.12
 Schmeck, p.66
Place Plumereau, Tours
 Knoedler, p.82 (II/III)
The Rialto, Venice, 1900, etch
 and dp
 Furst, p.317
 Weisberg-2, no.47
Royal Scottish Academy, etch and
 dp
 Rosen, fig.4
Saint Germain-en-Auxerrois, 1904
 etch and dp
 Weisberg-2, no.31
Thermae of Caracalla, etch and
 dp
 Laver, pl.XXX
 Lumsden, p.338
Valley of the Tay, etch
 Guichard, pl.13
The Wingless Chimera
 Knoedler, p.87 (VII/VIII)

CAMNITZER, Luis (Uruguayan, 1937-)
Portrait of Johnny, 1965, wc and
 polyester mold, printed on
 surgical plaster bandage
 Eich, pl.397

CAMPENDONK, Heinrich (German, 1889
-1957)
Animal Group, 1916, wc
 Portland, no.129
Beggars (Die Bettler), 1922, wc
 Houston, ill.18
Composition, col wc
 Eich, col pl.19
Female Nude in Front of Farmyard
 (Weiblicher Akt von Bauernhof)
 (from Bauhaus Portfolio 3), c.
 1921, wc
 Wingler, pl.31
Interior with Two Nudes, 1918,
 wc
 IFCR, no.14
Nude, 1920, wc
 Ad-1, p.115
Seated Harlequin (Carnival;
 Seated Woman with Animals),
 1916, wc
 IFCR, no.15
 Portland, no.130

22, pl.67
Two Female Nudes, Seated
 1918, wc
 Sotriffer-2, p.61

CAMPIGLI, Massimo (Italian, b.
1895)
In the Rice-Fields, 1958, col
 chalk litho
 Sotriffer-1, p.23 (col)
The Necklace, 1952, col litho
 Bauman, pl.115
Women at the Window (Femmes a la
 Fenetre), 1965, col litho
 Siblik, p.41 (col)

CANALETTO (Giovanni Antonio Canal)
(Italian, 1697-1768)
The Equestrian Monument, etch
 Sopher, p.14
Fantastic View of Padua, c.1742,
 etch
 Troche, p.50
The House with a Date, 1741,
 etch
 Eich, pl.267 (1 of 3 impress-
 ions before plate was cut)
Imaginary View of Venice, c.
 1743, etch
 Sal, p.146 (I/II, undivided
 pl.)
Landscape with Five Bridges,
 etch
 Sopher, p.13
The Lock of Dolo (The Porta del
 Dolo), c.1740-45, etch
 Furst, p.173
 Salaman, p.148
 Wechsler, pl.42
The Market in the Piazzetta,
 Venice
 Ad-2, p.72
Mestre, etch
 Fenton, no.30
 Salaman, p.146
La Piera del Bando V.(enezia),
 c.1743, etch
 Ad-2, p.74
 Sal, p.92
Le Pilier Isole, etch
 Wedmore, opp.p.106
Portico with a Lantern, etch
 Ad-2, p.75
 Colnaghi-1, pl.LIII (II/III)
 Lockhart, p.166
 Salaman, p.147

The Prison (La Preson V.), c.
 1743, etch
 Ad-2, p.76
 Sa1, p.93
 Salaman, p.149
 Z5, p.109
The Terrace, c.1741-42, etch
 Bowdoin, pl.20
 Z1, ill.348
Tower Near Mestre (Torre di Mal-
 ghera), c.1741-42, etch
 Ad-2, p.73
 Hind, p.228 (det)
 Ivins, p.120
 Mayor, ill.576
 Pet-1, pp.145-46
 Salaman, p.145
 Z1, ill.347
Town on a Riverbank, c.1743,
 etch
 Sa1, p.48 (I/II)
Various Pieces of Sculpture
 (from "Vedute ideate"), etch
 Sotriffer-1, p.80
View of a Town with a Tomb of a
 Bishop, etch
 SLAM, fig.25

CANOGAR, Rafael (Spanish, 1934-)
 Cordon de Policia, 1969, col
 litho
 Tamarind-2, p.28

CANTATORE, Domenico (Italian, b.
 1906)
 Odalisca, 1968, col litho
 Knigin, p.290 (col)

CAPEK, Josef (1887-1945)
 Praying (Betende), 1918, linocut
 Houston, ill.49

CAPOBIANCO, David (1928-)
 B.A.L.L.& S., 1976, col litho
 and seri
 Baro, p.26

CAPOGROSSI, Giuseppe (Italian,
 1900-1972)
 Xerigrafia 26, 1963, col seri
 Siblik, p.135 (col)

CARDON, Antoine (Flemish, 1772-
 1813)
 Round, and Sound Five Pence a
 Pound Duke Cherrys! (pl.8 of

F.Wheatley, "The Itinerant
 Trades of London..."; after
 F.W. design), 1793-97, col
 stipple engr
 Yale, pl.XXXI

CARRA, Carlo (Italian, 1881-1966)
 The Acrobats (Artistes; I Salt-
 imbanchi) (pl.3 of Bauhaus
 Portfolio 4), 1922, litho
 Weber, p.119
 Wingler, pl.50

CARRIERE, Eugene (French, 1849-
 1906)
 Auguste Rodin, 1897, litho
 Jordan, p.14
 The Founder (Le Fondeur), 1900,
 litho
 Weisberg-1, p.49
 Head of a Woman (Nelly Carriere)
 1895, litho
 Stein, pl.83
 Head (The Venetian Model), 1893,
 litho
 Stein, pl.32
 Planche a Trois Croquis, etch
 Leipnik, pl.68
 Portrait of Marguerite Carriere,
 c.1895, litho
 Bauman, pl.54
 Chase, pl.46
 Man, pl.151
 RM-1, p.196
 RM-2, pl.47
 Portrait of Paul Verlaine, 1896,
 litho
 Chase, pl.45
 RM-1, p.197
 RM-2, pl.46
 Sleep, 1897, litho (scraping
 technique)
 Eich, pl.524
 Minn, pl.24

CARS, Laurent (French, 1699-1771)
 Fetes Venitiennes (after Watt-
 eau; from "Recueil Julienne")
 1732 (pub.1735), engr
 Z1, ill.274
 La Malade Imaginaire (after F.
 Boucher; from "Theatre de
 Moliere"), pub.1734, engr
 Z1, ill.287
 Les Precieuses Ridicules (after
 F.Boucher; ill. for Moliere),

Weit, opp.p.34
Mother and Child, 1891, dp
 Wechsler, pl.73
Mother and Child, col dp
 Chase, pl.51
 RM-2, pl.51
Mother Rose Nursing Her Child,
 1899, dp
 Pass-2, p.146
Repose, 1890, dp
 Pass-2, p.137 (IV/IV)
Sarah Wearing a Bonnet and
 Coat, c.1904, transfer litho
 Johnson-2, ill.7
 Wechsler, fig.30
La Toilette (Woman Bathing)
 (from a series of 10), 1891,
 col aqua and dp
 Ives, p.55 (V/V; col)
 Minn, cover (col)
 Pass-2, p.143 (V/V; col)
 RM-1, p.163
 Rosen, fig.63 (V/V)
 Sachs, pl.26
Under the Horse Chestnut Tree,
 c.1895-98, col aqua and dp
 Pass-2, p.149 (IV/IV; col)

CASTAN, Gustave-Eugene (Swiss,
 1823-1892)
 At La Belotte, Lake Geneva (A
 La Belotte, Lac de Geneve),
 glass print
 Detroit, p.183 (1979 impress-
 ion)
 Country Road, glass print
 Detroit, p.183
 Landscape with Two Figures Be-
 side a Campfire, glass print
 Detroit, p.183 (1979 impress-
 ion)
 Road in the Wood at Cernay (Le
 Chemin de Bois a Cernay),
 glass print
 Detroit, p.183 (1979 impress-
 ion)
 View of River with Fisherman,
 glass print
 Detroit, p.183 (1979 impress-
 ion)

CASTELLANOS, Julio (1905-1947)
 The Injured Eye, 1935, litho
 Sachs, pl.179

CASTELLON, Federico (American,
 1914-1971)
 China portfolio: title page, c.
 1946, etch
 Baro, p.27
 It was a Voluptuous Scene, That
 Masquerade, 1968, col litho
 Knigin, p.212 (col)
 Memories, litho
 Z4, fol.p.104
 Mimi as a Florentine, 1965, etch
 Johnson-2, ill.134
 Of Land and Sea, c.1940, litho
 Weber, p.211
 Z4, fol.p.104
 Rendezvous in a Landscape, 1938,
 litho in 2 tones
 RC-1, pl.48
 Z1, ill.645
 Z4, fol.p.104
 Roman Urchins, 1953, etch
 Baro, p.27
 Self-Portrait, etch
 Z4, fol.p.104
 Spanish Landscape, 1938, litho
 Johnson-2, ill.53
 The Traveler, litho
 Eich, pl.612
 Two Figures, 1949, etch
 Johnson, p.6

CASTILLO, Jorge
 The Circus, 1962, litho
 Knigin, p.283

CASTRO PACHECO, Fernando (1918-)
 On the Way, 1948, litho
 Haab, pl.68
 The Plundered Cutter of Sisals,
 1947, linocut
 Haab, pl.64
 The Seridan Family Gives the
 Sign for Battle of Puebla, 18.
 Dec.1910 (from Taller de Graf-
 ica Popular portfolio "Estamp-
 as de la Revolucion"), 1946,
 linocut
 Haab, pl.65
 Woman Resting, 1954, litho
 Haab, pl.67
 Woman Striding, litho
 Haab, pl.66

CATLETT, Elizabeth (1919-)
 Head of a Negress, 1947, litho
 Haab, pl.94

Mother and Child, 1947, litho
Haab, pl.93
Negress, 1946, litho
Haab, pl.92

CATLIN, George (American, 1796-
1872)
Buffalo Hunt: Chasing Back (from
"North American Indian Port-
folio"), pub.1844, col litho
Z1, ill.588
Buffalo Hunt on Snowshoes, 1844,
col litho
Weber, p.169

CAULFIELD, Patrick (British, 1936
-)
White Pot, 1976, screenprint
Godfrey, pl.145

CAYLUS, Anne Claude Philippe de
Tubieres, comte de (French, 1692
-1765)
Untitled (after sketch by Leo-
nardo da Vinci), etch
Leipnik, pl.8
Untitled (after sketch by
Titian), etch
Leipnik, pl.8

CELIC, Stojan (Yugoslavian, 1925-)
Malediction de Thesee, 1965,
etch
Siblik, p.67

CELMINS, Vija (American, 1939-)
Untitled, 1970, col litho
Tamarind-2, p.29
Untitled, 1975, col litho
Baro, p.27

CEZANNE, Paul (French, 1839-1906)
See also E.Vuillard
Barges on the Seine at Bercy
(Peniches sur la Seine a
Bercy), 1873, etch
Leymarie, pl.C1
The Bathers (Les Baigneurs; small
version), 1897, col litho
Chase, pl.66 (col)
Eich, col pl.58
Grunwald, p.47
Haas, p.65
Leymarie, pl.C8 (col)
Pass-2, p.107 (col)
RM-2, col pl.IX

The Bathers (Les Baigneurs;
large version), 1898-99, col
litho
Bowdoin, pl.56
Leymarie, pl.C6
Lockhart, p.152
Mayor, ill.719
Pass-2, pp.110-11 (col)
RM-1, p.81 (col)
Sachs, pl.32
Wechsler, pl.68
Z1, ill.403
Girl's Head (Tete de Jeune
Fille), 1873, etch
Leymarie, pl.C4
Pass-2, p.105 (I/II)
Landscape at Anvers (Paysage a
Anvers), 1873, etch
Leymarie, pl.C5
Pass-2, p.106
The Picnic (Le Dejeuner sur l'
Herbe), col litho
Leymarie, pl.C9 (col)
Portrait of the Artist A.Guill-
aumin at the "Hanged Man",
1873, etch
Leymarie, pl.C2
Self-Portrait at the Easel,
1890s, litho
Bauman, pl.61
Chase, pl.65
Eich, pl.520
Leymarie, pl.C7
Pass-2, p.109
Sachs, p.35
View from a Garden in Bicetre,
1873, etch
Leymarie, pl.C3

CHADWICK, Lynn (British, 1914-)
Encounter, 1958, col litho
Weber, p.243

CHAGALL, Marc (Russian-French,
1887-)
Acrobat with Violin, 1924, etch
and dp
Bowdoin, pl.25
Fogg, pl.145
Haas, p.130
Hayter-2, p.106
The Acrobats, 1953, col litho
Ad-1, p.137 (col)
At the Easel (from "Mein Leben"
(My Life) series), 1922, dp
Eich, pl.343

Weber, p.54

CHARLOT, Jean (American, 1898-)
 First Steps, 1936, litho
 Haas, p.133
 Z1, ill.562
 Grinding Maize, 1947, col litho
 Haab, pl.89
 Mexican Kitchen, 1947, col litho
 Haab, pl.88
 Motherly Care (ill. for Claudel,
 "Picture Book"), pub.1933, col
 litho
 Boston, p.80
 Seated Nude, wc
 Eich, pl.136

CHARLTON, E.W. (British, 1859-
 1935)
 Low Tide, etch
 Guichard, pl.15

CHARPENTIER, Alexandre (French,
 1856-1909)
 The Girl with a Violin, 1894,
 col embossed litho
 Stein, pl.62

CHARPENTIER, F.P.
 La Culbute (after Fragonard),
 1766, engr
 Ad-2, p.99

CHASE, William Merritt (American,
 1849-1916)
 Reverie: Portrait of a Woman,
 c.1890-95, mono
 MMA, p.149
 Self-Portrait, c.1911, mono
 MMA, p.153
 Woodland Scene, c.1895, mono
 MMA, p.151

CHASSERIAU, Theodore (French,
 1819-1856)
 Apollo and Daphne, 1844, litho
 Bauman, pl.41
 Jordan, p.19
 Othello: The Death of Desdemona,
 1844, etch
 Mayor, ill.621
 RM-1, p.26
 Venus Anadyomene, 1839, litho
 Boston, p.79
 Man, pl.98
 RM-1, p.79

Z1, ill.396 (1st st)

CHATTOCK, Richard Samuel (British,
 1825-1906)
 Eton College from the River,
 1893, etch
 Hamerton, opp.p.275
 On Hardraw Beck, etch
 Guichard, pl.15

CHAVEZ MORADO, Jose (1909-)
 Corpse in Sitting Posture, 1939,
 litho
 Haab, pl.83
 Giant Leaves, 1950, litho
 Haab, pl.86
 Telegraph Wires, 1938, litho
 Haab, pl.84
 The Three Dancers, 1940, litho
 Haab, pl.85

CHEDEL
 The Frogs Who Wanted a King
 (after J.-B.Oudry; ill. for La
 Fontaine, "Fables"), engr
 Ad-2, p.31

CHEESMAN, Thomas (British, 1760-
 c.1834)
 Two Heads of Apostles (pl.1 for
 P.W.Tomkins, "The British Gal-
 lery of Pictures, Selected
 from the Most Admired Produc-
 tions of the Old Masters in
 Great Britain"; after drawing
 by Satchwell after painting by
 Giotto), 1818, col stipple
 engr
 Yale, pl.XXX

CHERET, Jules (French, 1836-1931)
 The Bridge of Sighs (poster for
 comic opera by J.Offenbach),
 c.1870, litho
 Weber, p.87
 Cleveland Cycles poster, c.1890-
 1910, col litho
 Z1, ill.455
 The Dance, 1893, col litho
 Stein, pl.33
 Fantasy, col litho
 Kovler, p.68
 Folies Bergeres: Fleur de Lotus
 (poster), 1893, col litho
 Kovler, p.69
 Latin Quarter, col litho

MOMA (Front) (from "Some Not
Realized Projects"), 1971,
photo litho and collage
RC-4, p.190
Whitney Museum Wrapped, 1971,
col litho and collage
Baro, p.29
Knigin, p.115

CIRY, Michel (1919-)
Every Man in His Night, 1961,
etch
Pass-1, p.149 (9th st)
The Fourteenth of July Banquet,
1940, etch and aqua
Ad-1, p.172
Houseboat at Rueil, 1950, etch
Ad-1, p.204
Jesus, 1949, etch
Pass-1, p.147 (12th st)
The Pity of Our Lady, 1950, etch
Ad-1, p.195
Saint Sebastian, 1950, etch
Ad-1, p.196 .

CISSE, Joseph de
Ill. for C.A.Seurat, "The Ana-
tomical Man" or "The Living
Skeleton", pub.1827
L-S, pl.171

CLARKE, Geoffrey (British, 1924-)
Warrior III, 1956, sugar aqua
Ad-1, p.204

CLAUSEN, George (British, 1852-
1944)
Filling Sacks, etch
Lumsden, p.335
Ricks by Moonlight, etch
Guichard, pl.16

CLAVE, Antoni (1913-)
Feuille Band Bleu, 1963, col
litho
Siblik, p.89 (col)
The Knight Hunting, 1950, col
litho
Pass-1, p.145 (col)
The Painter, 1955, col litho
Weber, p.217 (col)

CLAY, Edward W. (1799-1857)
The Times, 1837, litho
Z1, ill.582

CLEMENS, Paul Louis
Baseball Argument, litho
Craven, pl.23

CLENNELL, Luke (British, 1781-
1840)
Ill. for Rogers, "The Pleasures
of Memory" (after T.Stothard),
pub.1810, wengr
Ivins, p.140

CLERK, John, of Eldin (British,
1728-1812)
Boghall from Biggar, etch
Lockhart, p.176
Borthwick Castle, etch and dp
Lumsden, p.195
Dalkeith from the Northwest,
etch
Lumsden, p.199
Durham, etch
Furst, p.189
Laver, pl.4
Lumsden, p.194 (1st st)
Hill-Head, Near Lasswade, etch
Lumsden, p.198
The Hill of Arthur's Seat and
Town of Edinburgh from Loch
End, etch
Furst, p.187
A View of Edinburgh, c.1772-73,
etch
Godfrey, pl.64

CLILVERD, Graham Barry (British,
b.1883)
Gypsies, etch
Guichard, pl.16

CLOSE, Chuck (American, 1940-)
Keith, 1972, mezzo
RC-4, p.201
Self-Portrait, 1977-78, etch and
aqua
Johnson-2, ill.145

COCHIN, Charles-Nicolas, I
(French, 1688-1754)
Dans cette Aimable Solitude
(after N.Lancret), engr
Ad-2, p.21
Le Jeu du Pied de Boeuf (after
de Troy), engr
Ad-2, p.22

Negro Praying, 1936, litho
 Haab, pl.95
Street Scene in Mexico, litho
 Haab, pl.96

COWHAM, Hilda (British, d.1964)
 Ballet, etch
 Guichard, pl.18

COX, Alan
 Marble Steps, 1969, col litho
 Knigin, p.230 (col)

COZENS, Alexander (English, c.1717
 -1786)
 A Blot (from "A New Method of
 Assisting the Invention in
 Drawing Original Compositions
 of Landscape"), 1785, lift-
 ground technique
 Eich, pl.284
 A Blot Landscape (from "A New
 Method of Assisting the Inven-
 tion in Drawing Original Com-
 positions of Landscape"),
 1784/85, aqua
 Mayor, ill.531
 Castel Angelo, c.1745, etch
 Godfrey, pl.63
 Landscape, etch
 Laver, pl.II

COZENS, John Robert (British, 1752
 -1799)
 The Oak (from the series "Forest
 Trees"), 1789, sg etch w.
 India ink
 Godfrey, pl.65

CRAIG, Edward Gordon (British,
 1872-1966)
 Landscape and Moon, 1907, wengr
 Godfrey, fig.1
 Stage Design, etch
 Guichard, pl.17
 The Tragedie of Hamlet: Act III,
 Scene II, white-line wengr
 Leighton, p.83

CRANE, Walter (British, 1845-1915)
 See also E.Evans
 Dancer with Cymbals, 1894, litho
 Stein, pl.84

CRAWFORD, Ralston (American, 1906-
 1978)

Cologne Landscape, no.8, 1951,
 col litho
 RC-1, pl.84
Cologne Landscape, no.12, 1951,
 litho
 Johnson-2, ill.63

CREMEAN, Robert (American, 1932-)
 The Four Stations of the Cross:
 pl.4, 1967, col litho
 Tamarind-2, p.30
 The Four Stations of the Cross:
 pl.12, 1967, col litho
 Tamarind-2, p.31

CREMONINI, Leonardo (Italian,
 1925-)
 The Blind Fly, 1968, litho
 Knigin, p.183

CRESWICK, Thomas (British, 1811-
 1869)
 An Evening Walk, etch
 Guichard, pl.17

CRODEL, Carl (German, 1894-1973)
 Curve, 1920, wc
 Sotriffer-2, p.82

CROME, John (British, 1768-1821)
 At Bawburgh, 1813, etch
 Salaman, p.172 (2d st)
 Bridge at Cringleford, etch
 Sparrow, opp.p.152
 A Composition, etch
 Salaman, p.175 (2d st)
 Etchings of Views in Norfolk:
 plate, pub.1838, etch
 Furst, p.205
 The Hall Moor Road Near Hingham,
 1812, etch
 Colnaghi-1, pl.LXIII (I/IV)
 Mousehold Heath, c.1810, etch
 Lumsden, p.258 (II/IV)
 Salaman, p.173 (II/IV)
 Sparrow, opp.p.153
 Wedmore, opp.p.130
 21, ill.411
 Near Hingham, etch
 Laver, pl.X
 Road Scene, Trowse Hall, 1813,
 etch
 Godfrey, pl.97 (touched proof)
 Tree (Study of Tree Trunks), sg
 etch
 Fenton, no.42

Mayor, ill.651

CURRY, John Steuart (American, 1897-1946)
Ajax, litho
Craven, pl.29
Corn, 1935, litho
Craven, pl.32
Hounds and Coyote, 1931, litho
Craven, pl.33
The Line Storm, litho
Craven, pl.30
Man Hunt, 1934, litho
RC-1, pl.50
The Plainsman, 1945, litho
Eich, pl.584
Prize Stallions, 1938, litho
Craven, pl.31
WISC, no.56

CUTNER, Herbert (British, 1881-1969)
Saturday Night, Market, etch
Guichard, pl.18

CUVELIER, Eugene (French, c.1830-1900)
Forest Path (Allee en Foret), c. 1859/62, glass print
Detroit, p.70

DAGLISH, Eric
The Bullfinch (ill. for "Wood-cuts of British Birds"), white-line wengr
Leighton, p.65
Nightingale, white-line wengr
Leighton, p.43

D'AGOTY, Jacques Fabian Gauthier (French, 1711-1785)
L'Aneurisme d'apres l'Operation de M.Faget (pl.opp.p.93 of vol.II, part V of "Observa-tions sur l'histoire naturelle ..."), 1752, col mezzo
Yale, pl.IV (col)

DAHMEN, Karl Fred (German, 1917-)
Untitled, col etch
Clark, no.18

DALI, Salvador (Spanish, 1904-)
Bull Fight no.3, 1966, col litho

Siblik, p.39 (col)
Les Chants de Maldorer: ill., pub.1934, etch
Z1, ill.493
Les Chants de Maldorer: pl.XIV, pub.1934, etch
RC-4, p.79
Christ Crucified, 1951, etch
Ad-1, p.221
Don Quixote: ill., 1957, col litho
Ad-1, p.128 (col)
Dragon and Pears, 1970, litho
Knigin, p.260
Place des Vosges, 1958, etch and aqua
Pass-1, p.139
Portrait of Dante, c.1966, litho
Eich, pl.553
St.George and the Dragon, 1947, etch
Eich, pl.350

DALLMANN, Daniel (1942-)
Bath, 1974, col litho
Baro, p.32
Sunbather, 1973, col litho
Baro, p.32

DALZIEL Brothers (British, 19th c)
Ill. for L.Carroll, "Through the Looking Glass" (after J. Tenniel), 1872, wengr
Eich, pl.103
The Lady of Shalott (ill. for "Moxon's Tennyson"; after D.G. Rossetti), pub.1857, wengr
Ivins, p.166
"Shake the reed, and curl the stream/Silver'd o'er with Cynthia's beam" (ill. for S. Johnson, "Evening Ode"; after drawing by B.Foster), 1859, tinted wengr
Yale, pl.XLVIII

DANA, William Parsons Winchester (American, 1833-1927)
The Seashore (pl.10 of J.W. Ehninger, "Autograph Etchings by American Artists"), pub. 1859, glass print
Detroit, fig.3

DANIEL, Henry Wilkinson (British, active 1930s)

The Old Customs House, Kings
Lyn, etch
Guichard, pl.18

DANIELL, Edward Thomas (1804-1842)
Burough Bridge, etch
Sparrow, opp.p.153
Landscape, etch
Laver, pl.XVI
View of Whitlingham, Norfolk,
1827, etch
Salaman, p.180 (1st st)

DANIELL, Thomas (British, 1749-
1840)
The Ruins of the Palace, Madura
(w.William Daniell; pl. for
"Oriental Scenery"), 1798, col
aqua
Godfrey, fig.8 (col)

DANIELL, William (British, 1769-
1837)
The Ruins of the Palace, Madura
(w.Thomas Daniell); pl. for
"Oriental Scenery"), 1798, col
aqua
Godfrey, fig. 8 (col)

DARBY, M. (active mid 18th c.)
Design for Desk and Bookcase
(from "Gentleman and Cabinet-
maker's Director"; after T.
Chippendale), pub.1755, engr
Z1, ill.281

DARLEY, Felix Octavius Carr
(American, 1822-1888)
Ill. for Cooper, "Leather Stock-
ing Tales" (anon after F.O.C.
D.), steel engr
Weit, opp.p.210
Ill. for Dickens, "Oliver Twist"
(anon after F.O.C.D.), steel
engr
Weit, opp.p.210
Noon (pl.4 of J.W.Ehninger,
"Autograph Etchings by Ameri-
can Artists..."), pub.1859,
glass print
Detroit, p.192

DAUBIGNY, Charles-Francois
(French, 1817-1878)
L'Arbre aux Corbeaux, etch
Leipnik, pl.16

Le Bouquet d'Aunes, glass print
Salaman, p.191
Brook in a Clearing (Le Ruisseau
dans la Clairiere), 1862,
glass print
Detroit, p.74
Claire de Lune a Valmondes, etch
Leipnik, pl.17
Cluster of Alders (Le Bouquet d'
Aunes), 1862, glass print
Detroit, p.79
Comment Naissent les Villes,
1840, etch
Weisberg-3, p.8
Cows at a Watering Place (Vaches
a l'Abreuvoir), 1862, glass
print
Detroit, p.79
Cows in the Woods (Vaches sous
Bois), 1862, glass print
Detroit, p.81
Donkey in a Field (L'Ane au
Pre), 1862, glass print
Detroit, p.77
The Ferry at Bezons (Le Bac de
Bezons), 1850, etch
Weisberg-3, p.62
The Ford (Le Gue), 1862, glass
print
Detroit, p.76
The Ford (Le Gue), 1865, etch
Weisberg-3, p.64
Frontispiece for "Eaux-fortes
par Daubigny", c.1870, etch
and "chine colle"
Kovler, p.86 (IX/X)
The Houseboat, 1861, etch
Mayor, ill.676
Ill. for "Chants et Chansons
Populaires de la France", pub.
1843, etch
Ivins, p.164
The Large Sheep Pasture (Le
Grand Parc a Moutons), 1862,
glass print
Detroit, p.75
The Marsh, 1851?, etch
SLAM, fig.34
Moonrise on the Banks of the
Oise (Lever de Lune sur les
Bords de l'Oise), 1875, etch
Weisberg-3, p.65
Night Impression (Effet de Nuit)
1862, glass print
Detroit, p.78
Pollard Willows (Souvenir of

Ad-2, p.199

DAVIE, Alan (British, 1920-)
Bird Noises, 1964, col litho
 Knigin, p.195 (col)
Celtic Dreamboat I, 1965, col
 litho
 Gilmour, pl.26 (col)
Zurich Improvisation X, 1965,
 litho
 Weber, p.244

DAVIES, Arthur Bowen (American,
1862-1928)
Doorway to Illusion, 1910, sg
 etch and aqua
 RC-1, pl.17
 SLAM, fig.80
Figure in Glass, 1910, dp
 Johnson-2, ill.13
Figure of a Young Girl in a
 Landscape, c.1895-1905, mono
 w. col ink
 MMA, p.169
Release at the Gates, 1923, col
 litho and lithotint
 WISC, no.44
Torment, etch and aqua
 Eich, pl.376
Up-Rising, 1919, sg etch and
 aqua
 Z1, ill.615

DAVIS, Gene (American, 1920-)
Halifax, 1970, col litho
 Knigin, p.119 (col)

DAVIS, Ronald (American, 1937-)
Pinwheel, Diamond and Stripe,
 1975, intag on col paper
 Baro, p.33

DAVIS, Stuart (American, 1894-
1964)
Barbershop Chord, 1931, litho
 Knigin, p.30
 RC-1, pl.25
 Z1, ill.616
Sixth Avenue El, 1931, litho
 Bowdoin, pl.69
 Johnson-2, ill.18
 RC-1, pl.32
 RC-4, p.106

DAVIS, William David Brockman
(British, b.1892)

The Prawn, 1932, etch
 Guichard, pl.18

DAVISON, Bill (American, 1941-)
Decoy--Providence Island, 1976,
 col screen print
 Baro, p.33

DAVOINE
Nightmare, 1859, litho
 L-S, pl.176

DAWE, Philip (active 1750-1785)
(attrib. to)
The Alternative of Williamsburg,
 1775, mezzo
 MGA, pl.44
(attrib. to)
The Bostonians in Distress,
 1774, mezzo
 MGA, pl.43
(attrib. to)
The Bostonians Paying the Excise
 -Man, or Tarring & Feathering,
 1774, mezzo
 MGA, pl.41

DAWKINS, Henry (active c.1753-
1786)
The Paxton Expedition, 1764,
 line engr
 MGA, pl.27
A South-East Prospect of the
 Pennsylvania Hospital, with
 the Elevation of the Intended
 Plan, 1761, line engr
 MGA, pl.26 (1st st)

DAWSON, Nelson (British, 1859-
1941)
A Fair Wind, etch
 Guichard, pl.18

DAY, Gary (1950-)
Fishing is Another 9-to-5 Job,
 1974, col litho
 Baro, p.34

DAY, Worden (American, 1916-)
Burning Bush, 1954, wc
 Johnson-2, ill.57
Mandala II, 1957, col wc
 Johnson-2, col ill.3
Marginal Periphery, wc and
 linocut
 Johnson, p.18

DEBENJAK, Riko (1908-)
 L'Arbre, l'Ecorce, le Resinage,
 no.2, 1965, col etch and aqua
 Siblik, p.117 (col)

DEBUCOURT, Philibert-Louis
 (French, 1755-1832) See also
 A.Legrand
 Les Courses du Matin, ou La
 Porte d'un Riche, 1805, aqua
 Eich, pl.295
 The Ill-guarded Rose (La Rose
 mal dedendue), 1791, col aqua
 Ad-2, p.162 (col)
 Colnaghi-1, pl.LVI
 La Promenade Publique, 1792, col
 aqua
 Bowdoin, pl.22 (III/III)
 Mayor, ill.606
 Sal, p.277
 Z1, ill.324
 The Two Kisses, 1786
 Ad-2, p.171

DECAMPS, Alexandre-Gabriel
 (French, 1803-1860)
 Children Frightened by a Dog
 (Enfants Effrayes par une
 Chienne) (pl.7 from "Sujets de
 Chasse"), c.1829, litho
 Kovler, p.79
 The Chimney-Sweep and the Monkey
 (Le Savoyard et le Singe),
 1823, crayon litho
 Brown, no.30
 Return from the Hunt (Retour de
 la Chasse (pl.4 from "Sujets
 de Chasse"), pub.1829, crayon
 litho
 Brown, no.31
 Turkish Bodyguards, 1834, litho
 RM-1, p.25

DECH, Gertrud J.
 The Hunter from Kurpfalz, 1968,
 stone etch
 Eich, pl.611

DEGAS, Edgar (French, 1834-1917)
 After the Bath, 1885, litho
 Bauman, pl.60
 Z5, p.73
 After the Bath, smaller version
 (Coming Out of the Bath; La
 Sortie du Bain), c.1890, litho
 Cleveland, pl.XXXIII

 Colnaghi-1, pl.LXIX (II/II)
 Eich, pl.516 (I/II)
 Pass-2, p.72 (I/II)
 Sal, p.168 (I/II)
 SLAM, fig.47 (II/II)
 After the Bath, larger version
 (Sortie du Bain), c.1890-91,
 litho
 Pass-2, p.73 (V/V)
 Wechsler, pl.67
 After the Bath (Sortie du Bain),
 1882, etch, dp, aqua, crayon
 electrique
 Haas, p.62
 Ives, p.39 (8th st)
 Pet-1, p.201
 Z1, ill.398
 After the Bath (Standing Nude
 Dressing; Standing Female Nude
 at Her Toilet; Femme Nue
 debout, a sa Toilette)
 c.1890, litho
 Chase, pl.29
 Grunwald, p.44 (IV/IV)
 Ives, p.40 (III/IV)
 Pass-2, p.75 (III/IV)
 RM-1, p.139
 RM-2, pl.29
 Sachs, pl.24
 Weber, p.177
 Wechsler, pl.66
 At Les Ambassadeurs, c.1875,
 etch
 RM-1, p.111
 Rosen, fig.12
 At Les Ambassadeurs: Mlle Becat
 (Aux Ambassadeurs, Mlle Becat)
 1875-77, litho
 Ivins, p.172
 Knigin, p.19
 Mayor, ill.687
 Pass-2, p.66
 Z1, ill.443
 At Les Ambassadeurs: Mademois-
 elle Becat, c.1875-77, litho
 (3 subjects)
 Pass-2, p.67
 At the Louvre (Mary Cassatt; Au
 Louvre), 1876, aqua
 Z1, ill.444 (VI/VI)
 At the Louvre: Mary Cassatt in
 the Etruscan Gallery, 1879-80,
 etch, aqua, crayon electrique
 Ives, p.36 (3d st)
 The Ballet Master, c.1874-75,
 mono

(crayon technique)
Eich, pl.279
Venus Desarmee par les Amours
(after Boucher), 1773, crayon
engr in red and black
Z1, ill.276

DE MARTELLY, John S.
Blue Valley Fox Hunt, litho
Craven, pl.74
Give Us This Day, litho
Craven, pl.73

DENES, Agnes (Hungarian-American,
1941-)
Plate from Map Projections suite
1974, litho
Baro, p.34
Probability Pyramid, 1978, litho
w.flocking
Johnson-2, ill.147

DENIS, Maurice (French, 1870-1943)
Ce Fut un Religieux Mystere,
1898, col litho
Eich, pl.510
Christ at Emmaus, 1895, col
!itho
RM-2, pl.73
Douze lithographies d'Amour:
cover, 1898, col litho
Ad-1, p.28 (col)
Madeleine (two heads) (Tender-
ness), 1893, col litho
Stein, pl.3
Mother and Child (Mere et En-
fant), 1897, litho
Bauman, pl.72
Our Souls in Languid Motions
(Nos Ames, en des Gestes
Lentes) (pl.9 from "L'Amour")
1898, col litho
Bowdoin, pl.55
The Postures Are Easy and
Chaste (Les Attitudes sont
Faciles et Chastes), after
1900, col litho
RM-1, p.210
Weber, p.171 (col)
Reflection in a Fountain
(Bather at the Pool), 1899,
col litho
Pass-1, p.57 (col; II/IV)
RM-2, col pl.XI

DENON, Dominique-Vivant, Baron
(French, 1747-1825) See also
Nee and Masquelier; E.Vernier
Allegory of Time (with self-
portraits), 1818, litho
Eich, pl.479
Denon Drawing a Portrait (Denon
Making a Drawing of Friends;
Self-Portrait of Denon with
Two Ladies; Denon Dessinant
ses Amis), 1816, litho
Bauman, pl.14
Man, pl.56b
Weber, p.50
Z1, ill.375
The Holy Family in Egypt, 1809,
litho
Cleveland, pl.I
Weber, p.49
Madonna with Child and St.John
(after Egaroff), 1810, litho
Brown, no.52
Weber, p.144
Portrait of a Girl, 1817, litho
Weber, p.48
Portrait of Comte Charles de
Lasteyrie, 1816, litho
Weber, p.44
Self-Portrait
Ad-2, p.119

DENT, Robert Stanley Gonell
(British, 1909-)
The Hospital Ward, 1930s?, etch
Guichard, pl.19

DERAIN, Andre (French, 1880-1954)
The Bridge at Cagnes, c.1910,
etch
Ad-1, p.82
Bunch of Flowers in a Vase 1940,
col wc
Pass-1, p.89 (col)
Face, litho
RM-2, pl.126
Face (Visage) (from the series
"Visages"), c.1925, litho
Bauman, pl.99
Figure in Landscape (ill. for
Apollinaire, "L'Enchanteur
Pourrissant"), 1909, wc
Z1, ill.486
Four Women Bathing, c.1913, engr
Sotriffer-2, p.44
Head of a Girl (Figure, les
Mains derriere la Tete), litho

Minn, pl.9
The Wandering Jew, 1856, wc
 RM-1, p.230

DORMAN, Fay
 Pastiche from Gauguin's "Yellow
 Christ", 1969, deep-bite intag
 w.color
 Eich, col pl.42

DOSAMANTES, Francisco (1911-)
 Fishwives, 1940, litho
 Haab, pl.46
 Hanging Up the Washing, 1946,
 litho
 Haab, pl.45
 Maya Village, 1942, litho
 Haab, pl.47
 Three Girls (Yalaltecas), 1940,
 litho
 Haab, pl.44
 Women of Oaxaca, c.1940, litho
 Fogg, pl.84

LE DOUANIER
 See ROUSSEAU, Henri

DOUGHERTY, Paul (American, 1877-
 1947)
 Antique Theme, Classical Figures
 in a Landscape, c.1919, col
 mono
 MMA, p.183

DOUGHTY, William (active 1773-
 1780)
 Portrait of Samuel Johnson
 (after J.Reynolds), 1793,
 mezzo
 Colnaghi-2, pl.XVI (IV/VII)
 Z1, ill.336 (V/VII)

DOW, Arthur W. (American, 1857-
 1922)
 Rain in May, c.1907, wc
 Johnson-2, ill.8

DOWD, James Henry (British, 1883-
 1956)
 The Morning Dip, etch
 Guichard, pl.21

DOWELL, John E., Jr. (American,
 1941-)
 Free Form for Ten, 1973, etch
 Johnson-2, ill.132

Letter to My Betty I and II,
 1970, col litho
 Baro, p.37
Sound Thoughts of Tomorrow,
 1973, etch and aqua
 Baro, p.37

DRASITES, Roy R. (1945-)
 Leaf-Like Chessboard, 1976,
 litho
 Baro, p.38

DREVET, Pierre-Imbert (1663-1738)
 Bousset (after H.Rigaud), engr
 Ad-2, p.56
 Portrait of Hyacinthe Rigaud
 (after H.Rigaud), engr
 Hind, p.149 (det)
 Portrait of Robert de Cotte
 (after H.Rigaud), 1722, engr
 Z1, ill.270

DREW, Roseann
 Untitled diptych, sg etch and
 aqua
 Eich, pl.419

DREWES, Werner (German-American,
 1899-)
 Untitled (from "It Can't Happen
 Here" portfolio), 1934, wc
 Johnson-2, ill.47

DRUMMOND, Malcolm (British, 1880-
 1945)
 The Hanging Committee, etch
 Guichard, pl.21

DRURY, Paul (British, 1903-)
 After Work, 1926, etch
 Guichard, pl.22
 Evening, etch
 Guichard, pl.22
 Nicol's Farm, 1925, etch
 Guichard, pl.22
 Old Man Reading, 1932, etch
 Guichard, pl.22
 September, 1928, etch
 Guichard, pl.22

DUBUFFET, Jean (French, 1901-)
 Bottom of the Sea (Fond de Mer)
 (from "Phenomena" album 1),
 1958, litho
 Siblik, p.99
 Carrot Nose, 1962, col litho

Eich, pl.600
Ill. for Dostoevski, "The Grand
Inquisitor", 1948, wengr
Eich, pl.156
The Night Watch, 1962, wc
Eich, pl.154

EICHLER, Gottfried, II
Terror (ill. for C.Ripa, "Sinn-
bilder"; anon after G.E.), c.
1760, etch
Mayor, ill.236

EKEMANN-ALESSON, Lorenz (Swedish,
1791-1828)
Herdsman and Herd (after M.J.
Wagenbauer), 1817, tinted
litho
Weber, p.153

ELLIOTT, Aileen Mary (British, b.
1896)
Poplars, etch
Guichard, pl.23

EMMES, Thomas
Increase Mather (1639-1723),
1702, line engr
MGA, pl.6 (2d st)

ENFANTIN, Augustin (1793-1827)
Stream with Trees (from "Croquis
Progressifs de Paysage"), pub.
1824, crayon litho
Brown, no.66

ENGEL, Jules
Untitled, 1969, col litho
Tamarind-2, p.36

ENSOR, James (Belgian, 1860-1949)
Barques Echouees, etch
Furst, p.303
The Battle of the Golden Spurs,
1895, etch
Pet-1, p.218
Cathedral, 1886, etch on zinc
Haas, p.82
Minn, pl.20
Pet-1, p.219
RM-1, p.178
Sachs, pl.119
Sal, p.282
Christ in Agony, 1895, etch and
dp
Sotriffer-2, p.35

Christ in Hell, 1895, etch
Rosen, fig.14
The Deadly Sins Dominated by
Death, 1904, etch
Rosen, fig.15
Death Pursuing the Human Hoarde
(The Triumph of Death), 1896,
etch
Eich, pl.331
L-S, pl.215
Z1, ill.432 (I/II)
Z2, pl.9
Demons Torment Me (Demons me
turlupinant), 1895, etch
Bowdoin, pl.3
Les Diables Dzitts et Hohanox
Conduisant le Christ aux
Envers, etch
Furst, p.305
The Entry of Christ into
Brussels in 1889, 1898, etch
Bowdoin, pl.51 (II/II)
Pet-1, p.216
Pet-2, p.115
Fantastic Musicians (Musiciens
Fantastiques), 1888, etch
Ad-1, p.36
Sotriffer-1, p.85
Mariakerche, 1887, etch
RM-1, p.180
My Portrait in 1960, 1886, etch
RM-1, p.179
Odd Insects, engr
L-S, pl.213
Odd Little Figures, 1888
L-S, pl.214
The Scavenger, 1896, hand-col
etch
Sachs, pl.117
Self-Portrait with Demons, 1898,
col litho
Mayor, ill.135
Sachs, pl.118
Stars at the Cemetery, etch and
aqua
Pet-1, p.217
Pet-2, p.130

ERNI, Hans (Swiss, 1909-)
The Dog, 1963, col litho
Ad-1, p.239

ERNST, Max (German, 1891-1976)
Composition, 1950, col litho
Bauman, pl.111
Composition, 1967, etch

Pass-1, p.129

Dangerous Communications (Les
Liaisons Dangereuses) (from
Brunidor Portfolio 1), 1947,
etch
RC-3, p.47

Forest and Sun, 1957, col litho
Weber, p.225 (col)

The Fugitive (pl.30 from
"Histoire Naturelle"), 1926,
collotype after frottage
Rosen, fig.72

Homage to Rimbaud (from "Arthur
Rimbaud Vu Par des Peintres
Contemporains"), 1961 (pub.
1962), etch
RC-3, p.49

Ill. for R.Crevel, "Mr.Knife
Miss Fork": pl.1, opp. title
page, 1931, glass print
Detroit, p.135

Ill. for R.Crevel, "Mr.Knife
Miss Fork": pl.IV, Death is
Something Like Cousin Cynthia,
1931, glass print
Detroit, p.136

Ill. for R.Crevel, "Mr Knife
Miss Fork": pl.X, A Bird Comes
Flying (Kommt ein Vogel ge-
flogen...), 1931, glass print
Detroit, figs.12-13

Ill. for R.Crevel, "Mr.Knife
Miss Fork": pl.XIX, Cynthia,
Her Pearls, Her Feather, Her
Miracles, 1931, glass print
Detroit, p.136

Ill. for "Une Semaine de Bonte,
ou les Sept Elements Capitaux"
pub.1934, collage of wengrs
Eich, pl.157

Ill. for "Une Semaine de Bonte
...": vol.4, pl.25, 1934, line
block
RC-4, p.73

Masks, 1955, aqua and sg etch
Hayter-1, pl.65

Plate from "Let There Be Fash-
ion, Down with Art" (Fiat
Modes, Pereat Ars) album,
1919, litho
RC-4, p.68
Rosen, fig.191

The Sap Rises, 1929, collage
Ad-1, p.142

Sea Star (L'Etoile de Mer),
1950, col litho

Troche, p.62

Two Silhouettes in a Marine
Landscape, c.1950, col litho
Ad-1, p.143

ERRO, Gudmundur (Icelandic, 1932-)
Pop's History, 1969, col litho
Knigin, p.200 (col)

ESCHER, Maurits Cornelis (Dutch,
1898-1972)
Drawing Hands, 1948, litho
Eich, pl.562
Hand with Reflecting Globe
(Self-Portrait), 1935, litho
Eich, pl.565
Order and Chaos, 1950, litho
Z1, ill.542
Other World, 1947, wengr
RC-4, p.161
Print Gallery, 1956, litho
Rosen, fig.1
Relativity, 1953, litho
Knigin, p.35
Rosen, fig.221
Tetrahedral Planetoid, 1954,
wengr
Eich, pl.126

ESCOBAR, Marisol
See MARISOL

ESCOBEDO, Jesus (1918-)
Zapata, 1951, litho
Haab, pl.56

ESCOTT, Diane (American, active
1970s)
Untitled Landscape, 1973, glass
print
Detroit, p.21 (col), p.137
(artist's proof)
Untitled Landscape, 1973, glass
print
Detroit, p.138

ESTES, Richard (American, 1936-)
Nass Linoleum, 1972, screen
print
Johnson-2, ill.140

ESTEVE, Maurice (French, 1904-)
Composition, 1961, col litho
Siblik, p.79 (col)
Untitled, 1960, col litho
Knigin, p.265 (col)

FAIRCLOUGH, Wilfred (British, 1907
 -)
 Siesta, etch
 Guichard, pl.23

FANTIN-LATOUR, Henri (French, 1836
 -1904)
 Bathers, 3d large plate (Baign-
 euses, 3e grande planche),
 1896, litho
 Jordan, p.24 (II/II)
 In Memory of Robert Schumann (A
 la Memoire de Robert Schumann)
 1873, litho
 Eich, pl.506
 Roses, 1879, litho
 Cleveland, pl.XXXII
 Man, pl.114
 RM-1, p.140
 RM-2, pl.38
 Sarah the Bather, 1892, litho
 Bauman, pl.51 (3d plate)
 Chase, pl.38
 RM-2, pl.39
 Symphonie Fantastique: un Bal,
 etch
 Schmeck, p.70
 Temptation of St. Anthony, 1893,
 litho
 Stein, pl.23 (II/II)
 Women at Embroidery, litho
 RM-1, p.141

FATTORI, Giovanni (Italian, 1825-
 1908)
 Noon in Tuscany, etch
 Mayor, ill.682
 Tuscan Landscape, c.1890, etch
 Sal, p.203

FAVORSKY, Vladimir Andreevich
 (Russian, 1886-1964)
 Ill. for Gogol, "Schponka and
 the Fly", 1931, wengr
 Eich, pl.127

FAWCETT, Benjamin (British, 1808-
 1893)
 Aquarium (ill.opp.p.93 of S.
 Hibberd, "Rustic Adornments
 for Homes of Taste and Recrea-
 tions for Town Folk in the
 Study and Imitation of Nature"
 after design by G.Voyez),
 1857, col wengr
 Yale, pl.XLVIII

 Jer-Falcon (pl.12 of part 3 of
 F.O.Morris, "A History of
 British Birds"), 1849-57, col
 wengr w. hand coloring
 Yale, pl.XLVIII
 Sabine's Snipe (pl.239 of part
 58 of F.O.Morris, "A History
 of British Birds"), 1849-57,
 col wengr w. hand coloring
 Yale, pl.XIV (col)
 Till the live-long day light
 fail; then to the spicy nut-
 brown ale (after design by A.
 F.Lydon), col wengr
 Yale, pl.XLV

FEDDLER, R.
 Untitled, collage print
 Eich, pl.457

FEGELER, Paul
 Women in Interior (Frauen im
 Raum), 1922, wc
 Houston, ill.47

FEIGIN, Marsha (American, 1946-)
 Tennis, 1974, etch
 Baro, p.39

FEININGER, Lyonel (American, 1871-
 1956)
 Anglers, 1919, wc
 SLAM, fig.72
 Baltic Sea Steamer, 1918, wc
 Minn, pl.38
 Buildings, 1919, wc
 Sotriffer-2, p.87
 Cathedral (cover for Bauhaus
 program), 1919, wc
 Pet-2, p.284
 RC-4, p.63
 The City, c.1920, wc
 Z2, pl.72
 Dockyard (Werft), 1918, wc
 IFCR, no.20
 Gables in Luneberg, 1924, wc
 Eich, pl.125
 Sal, p.239
 The Gate, 1912, etch and dp
 RC-4, p.47
 The Gate, 1920, wc
 Rosen, fig.59
 The Harbor, c.1918, wc
 Portland, no.141
 Houses in Neppermin, 1910, col
 litho

engr
Ad-2, p.95
Mayor, ill.598
Deux Femmes a Cheval, etch
Salaman, p.157
The Little Park (Villa d'Este at
Tivoli), c.1763, engr
Ad-2, p.103
Fenton, no.55
Satyrs Playing (Jeux de Satyres,
pl.1; A Bacchanale), 1763,
engr
Ad-2, p.97
Ivins, p.129
Salaman, p.158
Les Traitants, 1778, etch
Leipnik, pl.12

FRANCIS, Sam (American, 1923-)
Hurrah for the Red, White and
Blue, 1961, col litho
Siblik, p.71 (col)
Red Again, 1970, col ss
Baro, p.42
Tokyo Mon Amour, 1963, col litho
Sotriffer-1, p.117 (col)
Untitled, 1963, col litho
Tamarind-1, p.29 (col)
Untitled, 1969, col litho
Knigin, p.93 (col)
Untitled, 1969, col litho
RC-2, p.44
Untitled, 1969, col litho
Tamarind-2, p.37
Untitled, 1974-75, litho
Baro, p.42
Untitled, 1977, col mono
MMA, p.239 (col)
Untitled, 1978, col litho
Johnson-2, col ill.23
The Upper Yellow, 1960, col
litho
RC-1, pl.105
The White Line, 1960, col litho
RC-3, p.69 (col)
RC-4, p.169 (col)
MOMA, p.22 (col)

FRANCOIS, Jean-Charles (1717-1767)
Allegory, crayon method engr
Hayter-2, p.195
Portrait of Sir Isaac Newton
(from Saverien, "Histoire des
Philosophes Modernes"), pub.
1760-69, engr
Hind, p.289

FRANK, Mary (American, 1933-)
Amaryllis, 1977, col mono in two
parts
MMA, p.241 (col)

FRANKENTHALER, Helen (American,
1928-)
Brown Moons, 1961, col litho
MOMA, p.28 (col)
RC-1, pl.106
Nepenthe, 1972, col etch and
aqua
RC-2, p.13 (col), p.46
Savage Breeze, 1974, col wc
Baro, p.43
A Slice of the Stone Itself,
1970, col litho
Knigin, p.172 (col)
White Portal, 1967, col litho
RC-4, p.137

FRANKLIN, James (active early 18th
c.)
A Portrait of Mr.Hugh Peter
(1599-1660) (f.p. for "A Dying
Father's Last Legacy to an
Only Child"), 1717, relief cut
MGA, pl.7

FRASCONI, Antonio (American, 1919
-)
Clam Diggers, 1954, wc
Fogg, pl.76
Don Quixote and Rocinante, No.14
1949, col wc
Johnson, p.16
Johnson-2, ill.55
Franco I (from suite "Oda a
Lorca"), 1962, litho
Tamarind-2, p.55
Guns (from suite "Oda a Lorca"),
1962, litho
Tamarind-2, p.38
Monterey Fisherman, 1951, col wc
RC-1, pl.73
Night Work, 1952, col wc
Pet-2, p.298
Poster, 1967, col wc
Eich, col pl.23
San Marco, 1969, col wc
Eich, col pl.22
Self-Portrait, 1950, wc
Sachs, pl.137
Self-Portrait with Don Quixote,
1949, wc
Baro, p.43

GAUCHER
 Crowning of the Bust of Voltaire
 (after J.-M.Moreau), 1778,
 engr
 Z1, ill.304

GAUCI, W. (active 1830s)
 Patio de los Leones from the
 Hall of the Abencerrages (pl.
 20 of J.F.Lewis, "Sketches and
 Drawings of the Alhambra...";
 after design by J.F.L.), 1835,
 tinted litho
 Yale, pl.LVII

GAUGAIN, Thomas (French-English,
 1748-1809)
 Louisa (ill. for poem by J.Bowd-
 ler; after painting by G.Mor-
 land), 1789, col stipple engr
 Yale, pl.V (col)

GAUGUIN, Paul (French, 1848-1903)
 Auti Te Pape (Woman at the
 River), 1891-95, col wc
 Bowdoin, pl.60
 Haas, p.74
 Ives, p.106
 Ivins, p.184
 Long, pl.168 (col)
 Portland, no.92
 Sachs, pl.44
 Sotriffer-1, p.39
 A Change of Residence (Moving),
 1899-1903, col wc
 Chase, pl.71 (col)
 Pet-2, p.295
 Portland, no.93
 RM-2, col pl.X
 Crouching Tahitian Woman Seen
 From the Back, c.1902, col
 mono
 MMA, p.137 (col)
 Dramas of the Sea: A Descent
 into the Maelstrom, 1889,
 litho on zinc on yellow paper
 Ives, p.102
 Fisherman Drinking Beside His
 Canoe (Pecheur Buvant aupres
 de sa Pirogue), c.1896, col wc
 Pass-2, p.167 (II/II; col)
 The Gods (Te Atua), 1895-1903,
 wc in black and ochre
 Ad-1, p.31
 Long, pl.163
 Joys of Brittany, 1889, litho

 Eich, pl.515
 Ives, p.98
 Leda, 1889, litho on zinc w.
 watercolor on yellow paper
 Ives, p.98
 The Locusts and the Ants, zinco-
 graph
 Long, pl.165
 Mahana Atua, wc
 Pet-1, p.202
 Mahana no Varua Ino (The Day of
 the Evil Spirit; The Demon
 Speaks), 1894, wengr
 Ives, p.108
 Leighton, p.85
 Z5, p.93
 Manao Tupapau (Elle Pense au
 Revenant), c.1892, wengr
 Sal, p.238
 Manao Tupapau (The Spirit
 Watches), 1894, col wc
 Z2, pl.14
 Manao Tupapau (Watched by the
 Spirit of the Dead), 1894,
 litho
 Bauman, pl.55
 Chase, pl.72
 Knigin, p.21
 Pass-2, p.165
 RM-1, p.199
 RM-2, pl.69
 Sachs, pl.45
 Stein, pl.53
 Z1, ill.401
 Marquesan Landscape, 1901-02,
 traced mono
 Grunwald, p.46
 Nave Nave Fenua (Wonderful
 Earth), c.1894, col wc
 Long, pl.167 (col)
 Pass-1, p.25 (col)
 RM-1, p.223 (col)
 Sal, p.118
 Nave Nave Fenua (Delicious
 Earth; Wonderful Earth), c.
 1894, wc
 Eich, pls.107, 109
 Mayor, ill.710
 Wechsler, pl.74
 Z1, ill.450 (proof before the
 Pola Gauguin printing)
 Z2, pl.13
 Nave Nave Fenua (Delightful
 Land; Standing Woman), 1894,
 watercolor mono
 MMA, p.133 (col)

GIACOMETTI, Alberto (Swiss, 1901-
 1966)
 Bust, 1952, litho
 MOMA, p.14
 RC-4, p.153
 Femme Couchee, litho
 Z1, ill.543
 Frontispiece for M.Leiris, "Viv-
 antes Cendres, innomees", 1961
 etch
 RC-3, p.41
 Hands Holding the Void, 1934-35,
 engr
 RC-4, p.82
 The Studio (L'Atelier), 1952,
 litho
 Bauman, pl.116
 The Studio 1955 (L'Atelier 1955)
 1956, litho
 RC-3, p.39
 Two Nudes (from "Derriere le
 Miroir"), litho
 Eich, pl.550
 Untitled, 1962, litho
 Knigin, p.238

GIBBINGS, Robert
 Pandanus Grove, Tahiti (ill. for
 "Iorana: a Tahitian Journal"),
 wengr
 Leighton, p.71
 William Walcot, R.E., wc
 Leighton, p.37

GIELNIAK, Jozef (Polish, 1932-
 1972)
 Bookplate with self-portrait,
 1965, lino engr
 Eich, pl.167
 Improvisation for Grazynka,
 1963-64, lino engr
 Eich, pl.168
 Untitled, 1968, mezzo
 Eich, pl.471

GIFFORD, Sanford Robinson (Ameri-
 can, 1823-1880)
 Spring (pl.7 of J.W.Ehninger,
 "Autograph Etchings by Ameri-
 can Artists..."), pub.1859,
 glass print
 Detroit, p.192

GIGOUX, Jean-Francois (French,
 1806-1894)
 Eugene Delacroix, litho

Cleveland, pl.XIII

GIKOW, Ruth (1913-)
 Alien Corn, col seri
 Z5, p.77

GILBERT, Achille-Isidore (1828-
 1899)
 The Arts of War (after Lord
 Leighton), pub.1881, etch
 Engen, p.46

GILBERT, E.
 Girl in the Garden (after M.
 Stone), pub.1899, mezzo
 Engen, p.77

GILL, Eric (British, 1882-1940)
 Breitenbach marriage announce-
 ment, 1938, wengr
 Eich, pl.143
 Girl with Cloak, wengr
 Leighton, p.39
 Ill. for Chaucer, "Canterbury
 Tales", wengr
 Leighton, p.57
 Self-Portrait, wengr
 Leighton, p.25 (1st st), p.27
 (final st)
 The Skaters, engr
 Furst, p.357
 Venus, 1914, wengr
 Z1, ill.554

GILLBANK, Haveill (British)
 Rustic Hours: Morning (after F.
 Wheatley), 1800, col mezzo
 Yale, pl.XXX

GILLER, William (1805-1858)
 The Slave Market (Constantin-
 ople) (w.C.G.Lewis; after W.
 Allan), pub.1842, mezzo and
 etch
 Engen, p.66

GILLETT, Edward Frank (British,
 1874-1927)
 Extra Turn, etch
 Guichard, pl.25

GILLIAM, Sam (American, 1933-)
 Wave, 1972, col litho
 Baro, p.46

GILLOT, Claude (French, 1673-1722)
Ill. for A.Lamotte-Houdar,
"Fables Nouvelles", 1719, etch
Mayor, ill.562

GILLRAY, James (British, 1757-
1815)
Britannia Between Death and the
Doctors, 20 May 1804, col etch
Godfrey, pl.80
Caricature, etch w.textured
background
Hayter-2, p.109
A Cognocenti, etch
Long, pl.98
Confederated Coalition;-or-The
Giants Storming Heaven..., 1
May 1804, col etch
Godfrey, pl.81
The Cow Pock, etch
Long, pl.99
Dido Forsaken, etch
Long, pl.102
The Finishing Touch, 1791
Ad-2, p.196
The First Kiss This Ten Years!,
c.1800, col etch
Eich, col pl.35
French Liberty. British Slavery
Ad-2, p.192 (col)
Frying Sprats, pub.1791, etch
Long, pl.104
The Gout, etch
Long, pl.101
The Gradual Abolition of the
Slave Trade, c.1793
Ad-2, p.195
A March to the Bank, etch
Long, pl.103
The Morning After Marriage, etch
Long, pl.96
Un Petit Souper a la Parisienne,
or, A Family of Sansculottes
Refreshing After the Fatigues
of the Day, 1793
Ad-2, p.199
The Pic-Nic Orchestra, etch
Long, pl.100
Sansculottes Feeding Europe with
the Bread of Liberty, 1793,
col etch
Eich, pl.288
Shakespeare--Sacrificed;-or-
The Offering to Avarice, pub.
20 June 1789, col etch and
aqua

Godfrey, fig.7 (col)
Sheridan's Fishing Party, pub.
1811, etch
Sparrow, opp.p.137
Toasting Muffins, pub.1791, etch
Long, pl.105
A Voluptuary, etch
Long, pl.97
The Zenith of French Glory
Ad-2, p.197

GINNER, Charles (British, 1878-
1952)
The Thames Embankment, c.1922,
wc
Godfrey, pl.133

GIRTIN, Thomas (British, 1775-
1802)
Belle Vue and Pont de Seve taken
from the Terrace near Pont de
St.Cloud (pl.13 from "A Selec-
tion of Twenty of the Most
Picturesque Views in Paris and
its Environs"), 1802, sg etch
Sparrow, opp.p.147
The Pantheon from the Arsenal,
Paris, sg etch
Laver, pl.VII
A View of Pont Neuf, The Mint,
etc. (Vue de Pont Neuf et de
l'Hotel de la Monnaie) (pl.8
from "A Selection of...Views
in Paris and its Environs"),
1802, sg etch
Mayor, ill.643
Salaman, p.165
View of the Gate of St.Denis
Taken from the Suburbs (pl.10
from "A Selection of...Views
in Paris and its Environs"),
1802, etch w.aqua by F.C.Lewis
Sparrow, opp.p.147
View of the Thuilleries and
Bridge (pl.1 from "A Selection
of...Views in Paris and its
Environs"), 1802 (pub.1803),
sg etch
Furst, p.207
The Water-works at Marli and St.
Germain-en-Laye in the Dis-
tance (pl.15 from "A Selection
of...Views in Paris and its
Environs"), 1802, etch
Salaman, p.166

GREAVES, Derrick (1927-)
 Vase and Falling Petal, 1971,
 col litho
 Gilmour, pl.30 (col)

GREAVES, Walter (British, 1846-
 1930)
 The Last Chelsea Regatta, etch
 Guichard, pl.27

GREBINAR, Kenneth (1948-)
 Triptych, 1975, etch
 Baro, p.50

GREEN, Reginald H. (British,
 1884-1971)
 Boatyard, Rye, etch
 Guichard, pl.27

GREEN, Valentine (British, 1739-
 1813)
 General George Washington (1732-
 1799) (after C.W.Peale), 1785,
 mezzo
 MGA, pl.70
 General George Washington (1732-
 1799) (after J.Trumbull), 1781
 -83, mezzo
 MGA, pl.71 (2d st)
 Rosen, fig.150
 Georgiana, Duchess of Devonshire
 (after J.Reynolds), 1780,
 mezzo
 Godfrey, pl.52
 Lady Betty Delme and Children
 (after J.Reynolds), late 18th
 c., mezzo
 Eich, pl.468
 Lady Jane Halliday (after J.
 Reynolds), 1779, mezzo
 Colnaghi-2, pl.XXV (I/II)

GREENBAUM, Marty (1934-)
 Bklyn Local in Weege Wisconsin,
 1974, mixed media
 Baro, p.50

GREENE, Barbara (American, 1948-)
 Stan's House, 1975, glass print
 Detroit, p.140

GREENWALD, Bernard (1941-)
 Creole Jazz Band III, 1974,
 intag
 Baro, p.50

GREENWOOD, John (American, 1727-
 1792)
 Jersey Nanny, 1748, mezzo
 Z1, ill.566

GREGORY, COLLINS and REYNOLDS
 (British, mid 19th c.)
 Layer Marney Tower. Essex (f.p.
 of A.Suckling, "Memorials of
 the Antiquities and Architec-
 tural, Family History and
 Heraldry of the County of
 Essex"), 1845, col wengr
 Yale, pl.XLIV

GREVEDON, Henri (1776-1860)
 Portrait of Canova, 1826, crayon
 litho
 Brown, no.86
 Portrait of Cathelineau, 1825,
 crayon litho
 Brown, no.85

GREYBURG
 Untitled, 1969, intag w.color
 applied by stencil and roller
 Eich, col pl.43

GRIDLEY, Enoch G. (active 1803-
 1818)
 Mourning Piece for George Wash-
 ington, 1810, mixed media
 MGA, pl.80

GRIESHABER, Helmut Andreas Paul
 (German, 1909-)
 Couple, 1963, col wc
 Sotriffer-2, p.118
 Couple (Paar), 1963, wc (annual
 print for Overbeck-Gesell-
 schaft, Lubeck; also an exhi-
 bition poster)
 Siblik, p.45
 Death and the Artist (from
 "Totentanz von Basel"), pub.
 1966, col wc
 Eich, col pl.28

GRIGGS, Frederick Landseer Maur
 (British, 1876-1938)
 The Almonry, etch
 Guichard, pl.29
 Carnagh, etch
 Guichard, pl.29 (det)
 The Cross Hands, 1935, etch
 Schmeck, p.71

Memory of Clavering, etch
 Guichard, pl.28
The Minster, 1918, etch
 Laver, pl.XXXIX (1st st)
Owlpen Manor, 1930, etch
 Godfrey, pl.135
Palace Court, etch
 Guichard, pl.28
Sarras, etch
 Guichard, pl.27
St.Botolph's, Boston, etch
 Furst, p.339 (1st st)
 Guichard, pl.28
Stoke Poges, etch
 Guichard, pl.27

GRIGNION, Charles (1721-1810)
 Seated Girl (after Gravelot; pl.
 for "Male and Female Cos-
 tumes"), 1745, etch
 Godfrey, pl.35

GRIS, Juan (Spanish, 1887-1927)
 Income Tax, 1908, litho
 Ad-1, p.66
 Lacartelettre (pl.2 from Max
 Jacob, "Ne Coupez Pas Mademoi-
 selle..."), 1921, litho
 Bauman, pl.103
 RC-4, p.45

GROISEILLIEZ, Marcelin de (French,
 1837-1880)
 View of a Harbor, c.1859/62,
 glass print
 Detroit, p.92

GROMAIRE, Marcel (French, 1892-
 1971)
 In the Metro, 1927, etch
 Sotriffer-2, p.118
 Man With Spade, 1927, etch
 Pass-1, p.131
 Nude With a Vase of Flowers,
 1932, etch
 Ad-1, p.103
 The Sun in the Pines, 1947, etch
 Ad-1, p.167

GROOM, E.H. (British, active
 1920s)
 Tower of London, etch
 Guichard, pl.28

GROOMS, Red (American, 1937-)
 Gertrude, 1974, col litho w.

acrylic sheeting
 Baro, p.51
Nervous City, 1972, col litho
 Baro, p.51
The Rat, 1971, col litho
 Knigin, p.142 (col)

GROPPER, William (American, 1897-
 1977)
 Convention, 1970, col litho
 Knigin, p.127 (col)
 For the Record, 1936, litho
 Z1, ill.635
 The Judge, litho
 Craven, pl.48
 Relief, litho
 Craven, pl.49
 Sweatshop, litho, before 1938
 Craven, pl.47
 Getlein, p.257
 War, 1950, litho
 RC-1, pl.53

GROS, Antoine-Jean (French, 1771-
 1835)
 Desert Arab, 1817, litho
 Brown, no.88
 RM-1, p.39
 Mameluke Chief (Chef des Mame-
 luks demandant secours), 1817,
 litho
 Bauman, pl.16
 Cleveland, pl.IV
 Jordan, p.8
 Man, pl.63 (1st st)

GROSCH, Laura (1945-)
 Gloxinia on an Oriental Rug,
 1974, col litho
 Baro, p.52
 Iris on Bokhara, 1976, col litho
 Baro, p.52

GROSS, Anthony (British, 1905-)
 La Foule--12:30 a.m., Toulouse,
 Prairie des Filtres, 1929,
 etch
 Hayter-1, pl.53
 Pujol, 1932, etch and engr
 Eich, pl.368
 Small Italian Town, 1966, col
 etch
 Eich, pl.402
 Sortie d'Usine. No.1, 1930, etch
 Godfrey, pl.137
 St.Ouen, Fecamp, before 1940,

ant), 1870?, mono
MMA, p.36

GUERARD, Nicolas
The Villager, c.1710, engr
Ad-2, p.27

GUERIN, Charles-Francois-Prosper
(French, 1875-1939)
Bathsheba, c.1900, glass print
Detroit, p.197
Garden with Chestnut Trees (Le
Jardin aux Marronniers), c.
1900, glass print
Detroit, p.197

GUERIN, Pierre Narcisse, Baron
(French, 1774-1833)
The Idler (Le Paresseux), 1816-
17, litho
Bauman, pl.13
Man, pl.59
Le Vigilant, litho
Cleveland, pl.VII
The World at Rest (Le Repos des
Monde), 1818, crayon litho
Brown, no.92

GUILLAUMIN, Armand (French, 1841-
1927)
Barges at Bercy (Peniches a
Bercy), 1872, etch
Pass-2, p.150

GUILLOUX, Charles
The Deluge (Landscape with Pop-
lars), 1893, col litho
Stein, pl.15

GUITET, James (French, 1925-)
Terre Vive, 1962, etch w.mixed
technique
Siblik, p.111

GUSTON, Philip (American, 1913-
1980)
Untitled, 1963, litho
Tamarind-1, p.16

GUTTOSO, Renato (Italian, 1912-)
Girl in Leotards, 1969, litho
Knigin, p.182

GUYARD
But at the First Sound of the
Drum...(after Mallet), c.1794,

engr
Ad-2, p.181

GWATHMEY, Robert (American, 1903-)
Across the Field, 1944, col seri
Getlein, p.17
End of Day, 1944, col seri
Z1, ill.638
Hitchhiker, 1943, col seri
RC-1, pl.57
Matriarch, c.1963, col litho
Eich, pl.591
Singing and Mending, c.1946, col
seri
Baro, p.48 (col)

GWYNNE-JONES, Allan (British,
1892-)
Southwold Fair, 1927, etch
Guichard, pl.37

HAAGENSEN, F.H. (Norwegian, active
c.1920)
Fjord, etch
Guichard, pl.31

HAAS, Richard (American, 1936-)
The Flatiron Building, 1973,
etch and dp
Johnson-2, ill.148
Great Hall, Kip Riker Mansion,
1975, col aqua
Baro, p.52

HAASS, Terry
Ill. for Whitman, "Leaves of
Grass", 1966, col etch
Eich, pl.391
Untitled, 1970, col etch
Eich, col pl.81 (2d st)

HADEN, Francis Seymour (British,
1818-1910)
Bark Refitting, 1865, etch and
dp
Weisberg-3, p.70
Battersea Reach, 1863, etch
Guichard, pl.31
Schmeck, p.72
Breaking Up of the "Agamemnon",
1870, etch and dp
Furst, p.229
Kovler, p.99
Lumsden, p.289

Yale, LVII
The Hypaethral Temple at Philae,
called the Bed of Pharaoh (pl.
65 of vol.2 of D.Roberts,
"Egypt & Nubia"; after design
by D.R.), 1849, litho in 2
tints
Yale, pl.LVI
Private House at Antwerp (pl.IX
of "Portfolio of Sketches.
Belgium and Germany"), 1850,
2-col litho
Yale, pl.XVII (col)
North Transept—Waiting for the
Queen (attrib.to L.H.; f.p. of
vol.1 of Dickinson Brothers,
"Dickinson's Comprehensive
Pictures of the Great Exhibi-
tion of 1851"), 1854, chromo-
litho
Yale, pl.LXIV

HAIG, Axel Herman (Swedish, 1835-
1921)
On the Stour, Canterbury, etch
Guichard, pl.32

HAJDU, Etienne (Rumanian-French,
1907-)
Estampille, 1958, white relief
Hayter-1, pl.26
Heraclite: folio 9, 1965,
inkless intag
RC-4, p.141

HALASZ, Gyula
See BRASSAI

HALL, Edna Clarke
Dressing the Hair, etch
Laver, pl.LIII

HALL, Oliver (British, 1869-1957)
A Border Castle, etch
Guichard, pl.32

HALTON, Katherine (American, 1952
-)
Untitled, 1975, col seri and
offset litho w.hand drawing
Baro, p.53

HAMAGUCHI, Yozo (1909-)
Asparagus and Lemon, 1957, mezzo
RC-4, p.162
Bowl of Fruit (Coupe de Raisins)

1962, mezzo
Ad-1, p.237
Pet-2, p.66
Bunch of Grapes, col mezzo
Hayter-1, pl.25
Maize, 1963, mezzo
Siblik, p.51

HAMERA, Oldrich
Origin of Matter, II, 1969, mono
Eich, pl.639

HAMILTON, Richard (British, 1922-)
I'm Dreaming of a White Christ-
mas, 1967, col screen print
Rosen, col pl.16
Interior, 1964, seri
Godfrey, pl.144
RC-4, p.175
My Marilyn, 1966, col screen
print
RC-3, p.139 (col)
Rosen, fig.170
People, 1968, photo w.mixed med-
ia additions
Rosen, fig.171
Portrait of the Artist by Fran-
cis Bacon, 1970-71, col screen
print and collotype
RC-3, p.141 (col)
The Solomon R. Guggenheim, Aug.
1965, col seri
RC-2, p.56
RC-4, p.178

HAMMONS, David
Injustice Case, 1970, mixed
media
Eich, pl.111

HAMPE, Carl Friedrich (1772-1848)
Cain Slays Abel (Kain erschlagt
Abel), 1804, pen litho
Man, pl.27

HAMPL, Josef
Cycle, "Document IV", 1966, mono
Eich, pl.641

HANFSTAENGL, Franz
Portrait of Alois Senefelder,
1834, litho
Weber, p.21

HANGEN, Heijo (1927-)
Composition: Red-Green-Violet

(Komposition: Rot-Grun-
Violett), col ss
Clark, no.38

HANHART, M. & N. (British, 19th
c.)
Windmill (attrib. to Hanhart;
pl.IV of R.C.Dibdin, "Progres-
sive Lessons in Water-Colour
Painting"; design by T.C.D.),
1848, chromolitho
Yale, LX (IV/IV)

HANKEY, William Lee (British, 1869
-1952)
The Kiss, etch
Guichard, pl.32
La Vieille, dp
Laver, pl.XL

HANNAH, John (American, 1923-)
Deity, 1971, col intag and re-
lief
Baro, p.53

HANSEN, Arne L.
Venetian Glass-Works #1, 1970,
col litho
Knigin, p.300 (col)

HANSEN, Robert (1924-)
Ill. for G.Endore, "Satan's
Saint", 1965, litho
Tamarind-2, p.40

HARA, Kieko (1942-)
Heart in America, 1976, mixed
media
Baro, p.53

HARDEN, Marven (1939-)
The Thing Seen Suggests, This
and Other Existences, 1974,
col litho
Baro, p.54

HARDIE, Martin (British, 1875-
1952)
The Day's Work Done, Martigues,
dp
Laver, pl.XXXV
On the Seine, etch
Guichard, pl.32
The Quiet West (Martigues), etch
Guichard, pl.32

HARDING, James Duffield (British,
1798-1863)
Cascade de Thiers, Puy-de-Dome,
litho
Cleveland, pl.XV
Chateau de Foix (pl.83 from
Baron Taylor, "Voyages Pittor-
esques, Languedoc"), pub.1833,
crayon litho
Brown, no.93
Dogana & Sta Maria Maggiore,
Venice (pl.31 of "Sketches at
Home and Abroad"), 1836,
tinted litho
Yale, pl.LVI
Elm (pl.26 of "The Park and the
Forest"), 1841, tinted litho
Yale, pl.LVII
Falling in with a Laplander's
herd of rein-deer, while
crossing the Jerdis Javri...
(pl.XVII of A.de C.Brooke,
"Winter Sketches in Lapland
...": after drawing by A.B.),
1826, tinted litho
Yale, pl.LV

HARDY, Heywood (British, 1842-
1933)
Expectation, etch
Guichard, pl.33

HARRIS, Paul (American, 1925-)
One Night in Tunisia, 1969, col
litho
Tamarind-2, p.41

HART, George Overbury ("Pop")
(American, 1868-1933)
Awaiting the Boat's Return, dp
Laver, pl.LXXX
Cock Fight, Santo Domingo, 1923,
hand-col litho
Johnson-2, ill.22
The Hostess, 1924, col dp and
aqua mono
RC-1, pl.36
Man Stirring the Contents of a
Frying Pan Over a Fire, mono
Eich, pl.640
Mexican Orchestra, 1929, col
litho
RC-1, pl.37
Water Carrier, 1923, dp
Lockhart, p.200

(after J.S.Copley), 1788, etch
and engr
Godfrey, pl.44 (1st st; det),
 pl.45 (finished st)

HECHT, Joseph (1891-1951)
 Aigle Enlevant Izard, c.1919,
 engr
 Hayter-2, p.65
 Bison, c.1930, engr
 Hayter-2, p.242
 Collioure, c.1920, dp
 Hayter-2, p.38
 Deluge, 1927, burin engr
 Hayter-1, pl.12
 The Embarkation (from "Noah's
 Ark" portfolio), engr
 Eich, pl.645
 Leopards Hunting, line engr
 Ad-1, p.214
 Mont-Saint-Michel, 1946, engr
 Z1, ill.479
 Norwegian Landscape, c.1919,
 engr
 Hayter-2, p.251
 La Noyee (w.S.W.Hayter), 1946,
 engr
 Hayter-2, p.216
 Penguins, 1949, relief etch
 Ad-1, p.186
 Zebra (from "Noah's Ark" port-
 folio), etch
 Furst, p.387

HECKEL, Erich (German, 1883-1970)
 Acrobat (The Handstand), 1916,
 litho
 Eich, pl.539
 Weber, p.201
 Acrobat Standing on His Hands
 (Handstand) (from "Die Schaff-
 en" portfolio), 1916, litho
 Man, pl.178
 Bath House in the Woods, 1912,
 hand-col wc and watercolor
 Fogg, pl.41
 Fjord Landscape, 1924, dp
 Fogg, pl.43
 Z2, pl.43
 Franzi Reclining (Franzi Recumb-
 ent), 1910, col wc
 IFCR, no.30 (col)
 RC-4, p.52 (col)
 Rosen, col pl.4
 Girl by the Sea (Madchen am
 Meer), 1918, wc

Portland, no.114
 Z1, ill.499
 Z2, pl.41
 Girl Reclining, 1910, dp
 Z2, pl.26
 Half-Length Male Figure (Mann-
 Liche Halbfigur) (from Bauhaus
 Portfolio 5), 1917-22, wc
 Wingler, pl.68
 Head of a Bearded Man, 1908, wc
 Fogg, pl.40
 Insane People at Mealtime (Irre
 beim Essen), 1914, dp
 Eich, pl.363
 Z2, pl.99
 Lake in a Park, 1914, dp and
 etch
 Sotriffer-2, p.42
 Lying Woman (Liegende), after
 1923, col wc
 Houston, ill.50
 Portrait of E.H. (Bildnis E.H.)
 (title of "Der Anbruch"),
 1917, wc
 Houston, ill.2
 Portrait of Paul Klee, 1956, wc
 Eich, pl.116
 Self-Portrait, 1913, wc
 Ad-1, p.61
 Self-Portrait, 1917, wc
 Fogg, pl.42
 Self-Portrait (Portrait of a
 Man), 1919, col wc
 Portland, no.112
 Rosen, fig.69
 Sachs, pl.136
 Sal, p.120
 Z2, pl.39 (col)
 Snowstorm (Schneetreiben), 1914,
 wc
 Portland, no.113
 Z2, pl.40
 Sunrise, 1914, wc
 Portland, no.115
 Two Seated Women, 1912, col wc
 Minn, pl.32
 Two Wounded Soldiers, 1914, wc
 Sotriffer-2, p.46
 White Horses, 1912, col wc
 Sotriffer-2, p.105 (col)
 Woman Resting, 1914, litho
 Weber, p.113
 Women on the Shore (Frauen am
 Strand), 1919, wc
 IFCR, no.36
 Young Girl with Flowing Hair,

Sparrow, opp.p.49
The Orphans, 1878, dp
Hamerton, opp.p.281
Portrait of Sir Francis Seymour
Haden, etch, 1892
Sparrow, f.p.
Portrait of Sir F.Seymour Haden
in 1892, etch
Sparrow, opp.p.48

HERMES, Gertrude (British, 1901-)
Adam and Eve, 1933, wengr
Z1, ill.553
The Pilgrim's Progress: f.p.,
white-line wengr
Leighton, p.49
Spring Bouquet, 1929, wengr
Leighton, p.73

HERSENT, Louis (French, 1777-1860)
The Little Dog (Le Petit Chien)
(ill. for La Fontaine,
"Tales"), pub.1818-19, crayon
litho
Brown, no.97

HERVIER, Louis-Adolphe (French,
1818-1879)
Cul-de-Sac in Trouville, 1848,
litho
RM-1, p.60
Old Woman Washing Her Laundry
(Vieille Femme Lavant son
Linge), c.1862, litho
Weisberg-1, p.75
Old Worker Gathering Wood
(Vieux Paysan Trainant un
Fagot), 1847, litho
Weisberg-1, p.74
Woman Washing in a Tub (Femme
Lavant dans un Baquet), 1854,
etch and aqua
Weisberg-1, p.76

HEYBOER, Anton (Dutch, 1924-)
Composition of Circles, 1959,
col etch
Z1, ill.541
Composition with Three Angles
and Figures, 1957, col etch
RC-3, p.89 (col)
Red and White, c.1960, col etch
MOMA, p.31
The System with Figure, 1957,
col etch
RC-4, p.163

HEYMAN, Charles (1881-1915)
Gare St.-Lazare, etch
Leipnik, pl.78

HEYSEN, Hans (Australian, 1877-
1968)
Landscape, etch
Guichard, pl.79

HICKS, William
Elementary Design, c.1938, etch
WPA, p.13

HIGGINS, Eugene (American, 1874-
1958)
Pioneers Resting, etch
Craven, pl.55
The Tired Hack, 1909, mono
MMA, p.187

HIGGINS, Steven (American, 1946-)
Koan XIX, 1972, glass print
Detroit, p.141

HILDEBRAND, Janet (American, 1942
-)
Eagle's Nest--Gore Range, 1975,
col etch
Baro, p.56

HILL, Clinton (American, 1922-)
First Page, 1956, col wc
Johnson, p.4
Johnson-2, ill.77
21, 1975, handmade paper
Baro, p.56

HILL, David Octavius (Scottish,
1802-1870)
Landscape (from the album "Views
in Perthshire"), 1821, litho
Bauman, pl.25

HILL, John (American, active 1830s
-1840s)
New York from Governor's Island
(after W.G.Wall), mezzo
Weit, opp.p.126

HILL, Samuel (active 1789-1803)
S.W.View of the State-House in
Boston, 1791, line engr
MGA, pl.75
View of the Colleges, at Cam-
bridge, Massachusetts, 1790,
line engr

MGA, pl.74

HILL, Vernon (British, b.1887)
Evening, etch
Guichard, pl.34

HILLER, Joseph, Sr. (1748-1814)
His Excellency George Washington
Esqr. (attrib. to J.H.; after
C.W.Peale), after 1776, mezzo
MGA, pl.63
Lady Washington (1731-1802) (at-
trib. to J.H.; after C.W.
Peale), after 1776, mezzo
MGA, pl.62

HILLS, Robert (1769-1844)
Cow and Calf in a Shippen, etch
Sparrow, opp.p.139
Cow and Calf Resting in Sunlight
etch
Sparrow, opp.p.139
An Old Horse, 1801, etch
Sparrow, opp.p.138

HIRATSUKA, Unichi
Stone Buddha at Usuki, 20th c.,
wc
Eich, pl.132

HIROSHIGE (Japanese, 1797-1858)
Spring Fireworks Over Edo, col
wc
Mayor, ill.699

HIRSCH, Karl Jakob (German, 1892-
1952)
Ten Original Lithographs to the
Symphonies by Gustav Mahler
(Zehn Original Steinzeichnung-
en zu den Symphonien Gustav
Mahlers): title, 1920 (pub.
1921), litho
Houston, ill.15
Ten Original Lithographs to the
Symphonies by Gustav Mahler:
First Symphony (Erste Symphon-
ie), 1920 (pub.1921), litho
Houston, ill.16
Ten Original Lithographs to the
Symphonies by Gustav Mahler:
Fifth Symphony (Funfte Symph-
onie), 1920 (pub.1921), litho
Houston, ill.17

HIRTZEL, Sue (American, 1945-)
Little Notes II, 1974, glass
print
Baro, p.56
On the Other Side, 1977, glass
print
Detroit, p.142 (I/VI)
Paul's Window, 1979, col glass
print
Detroit, p.22 (col), p.143
(I/VI)

HITCHENS, Ivon (British, 1893-)
Still Life, 1939, litho
Weber, p.219

HOCKNEY, David (British, 1937-)
Home (from "Six Fairy Tales from
The Brothers Grimm"), 1969,
etch
RC-2, p.55
The Hypnotist, 1963, col etch
and aqua
Godfrey, pl.147
Lilies, 1971, col litho
Gilmour, pl.29 (col)
Kaisarion with All His Beauty,
1961, col etch and aqua
MOMA, p.38
Pacific Mutual Life Building
with Palm Trees, 1964, litho
RC-4, p.187
Tamarind-1, p.58
Picture of Melrose Avenue in an
Ornate Gold Frame (from "A
Hollywood Collection"), 1965,
col litho
RC-3, p.143 (col)
The Print Collector (Portrait of
Felix Man) (from "Europaische
Graphik VII"), 1969-70, litho
Gilmour, fig.16
Godfrey, fig.16
Man, pl.275
The Rake's Progess: plate, 1961,
etch and aqua
Eich, pl.401
Still Life, 1969, etch and aqua
RC-3, p.145

HODGKINS, Frances (British, 1869-
1947)
Arrangement of Jugs (Still Life)
1938, col litho
Bauman, pl.120

G.E.Hicks), pub.1868, mixed
media
Engen, p.76
A Siesta (after C.E.Perugini),
line engr
Engen, p.71

HOLL, William, the Younger (Brit-
ish, 1807-1871)
An English Merry-making in the
Olden Time (after W.P.Frith),
pub.1852, line and stipple
engr
Engen, p.19 (includes det.)
Prison's Solace: "When love with
unconfined wings" (after R.
Carrick), pub.1863, stipple
engr
Engen, p.94

HOLLAND, Tom (American, 1936-)
Ryder, 1972, col litho
Baro, p.57

HOLLANDER, Irwin (American, 1927-)
Bread, 1976, litho
Baro, p.58

HOLMES, Kenneth (British, 1902-)
Ponte Aventino, Rome, dp
Guichard, pl.34
Laver, pl.LVI

HOLROYD, Charles (1861-1917)
The Bather, etch
Wedmore, opp.p.180
Giorgione at Asolo, etch
Guichard, pl.34
Nymphs of the Sea, etch
Sparrow, opp.p.207
The Yew Tree on Glaramara, 1903,
etch
Laver, pl.XXVII
Sparrow, opp.p.207

HOMAR, Lorenzo
Ill. for R.E.Alegria, "Los Rene-
gados", 1962, wengr
Eich, pl.135

HOMER, Winslow (American, 1836-
1910) See also Lagarde
Art Students and Copyists in the
Louvre Gallery, Paris (anon.
after W.H.; for "Harper's
Weekly"), pub.Jan.11, 1868,

wengr
Eich, pl.104
August in the Country--The Sea-
shore (ill. for "Harper's
Weekly"), pub.Aug.27, 1859,
wengr
WISC, no.25
Camp Life, Part I: The Guard
House, pub.1864, litho
Boston, p.72
Camp Life, Part I: Tossing in
the Blanket, pub.1864, litho
Boston, p.72
Campaign Sketches: Card Game,
1862, litho
Weit, opp.p.190
Campaign Sketches: Letter for
Home, 1862, litho
Eich, pl.571
Z1, ill.593
"Dad's Coming" (Waiting) (anon.
after W.H.; for "Harper's
Weekly"), 1873, wengr
Long, pl.158
Portland, no.84
Z1, ill.596
Dancing at the Mabille, Paris,
hand-col engr
Long, pl.155
Eight Bells, 1887, etch
Rosen, fig.7
Fly Fishing, Saranac Lake, 1889,
etch and aqua
WISC, no.27
Gloucester Harbor (anon. after
W.H.), engr
Long, pl.159
Gloucester Harbor (anon. after
W.H.), 1873, wengr
Long, pl.161
Portland, no.86
Ill. for "Eventful History of
Three Little Mice", 1858,
wengr
Mayor, ill.452
The Life Line, 1884 (pub.1887),
etch
Z1, ill.594
Lumbering in Winter (anon. after
W.H.; ill. for "Every Satur-
day"), 1871, wengr
Mayor, ill.693
The Morning Bell (anon. after W.
H.), 1873, wengr
Portland, no.85
On the Beach (anon. after W.H.),

1872, wengr
 Long, pl.157
 Portland, no.87
On the Bluff at Long Branch,
 engr
 Long, pl.160
Our Jolly Cook, litho
 Cleveland, pl.XXVII
A Parisian Ball, hand-col engr
 Long, pl.154
Perils of the Sea, 1888, etch
 Bowdoin, pl.49
 Eich, pl.371
Raid on a Swallow Colony, 1874,
 wengr
 Sachs, p.239
A Sharp-shooter on Picket Duty
 (anon. after W.H.; ill. for
 "Harper's Weekly"), 1862,
 wengr
 Long, pl.152
 Mayor, ill.639
Thanksgiving in Camp, engr
 Long, pl.153
Winter--A Skating Scene, 1868,
 engr
 Bowdoin, pl.48
 Long, pl.156

HOOK, James Clarke (British, 1819-
1907)
 Colin, thou ken'st the southern
 shepherd boy, etch
 Guichard, pl.35
 The Fisherman's "Good-Night",
 1857, etch
 Sparrow, opp.p.176
 The Land of Cuyp, 1872, etch
 Sparrow, opp.p.176
 Sea Urchins, 1872, etch
 Sparrow, opp.p.176

HOPKINS, Donald (American, 1945-)
 Somewhere Near the Border, 1975,
 etch and "chine colle" w.hand
 coloring
 Baro, p.58

HOPPER, Edward (American, 1882-
1967)
 American Landscape, 1921, etch
 Pet-1, p.235
 Pet-2, p.78
 Z3, p.173
 Aux Fortifications, 1923, etch
 Z3, p.161

The Cat Boat, 1922, etch
 Craven, pl.58
 Z3, p.159
East Side Interior, 1922, etch
 Bowdoin, pl.13
 Craven, pl.57
 Johnson-2, ill.30
 Z3, p.158
Evening Wind, 1921, etch
 RC-1, pl.21
 Sachs, pl.186
 Z1, ill.609
 Z3, p.156
House at Tarrytown, 1923, dp
 Z3, p.162
House Tops, 1921, etch
 Z3, p.167
The Lighthouse (Maine Coast),
 1923, etch
 Z3, p.171
The Lonely House, 1922, etch
 Mayor, ill.747
 RC-1, pl.23
 Z3, p.168
Man's Head, c.1902, mono
 MMA, p.43
Night in the Park, etch
 Laver, pl.LXXIV
Night Shadows, 1921, etch
 Grunwald, p.58
 RC-1, pl.22
 RC-4, p.123
 WISC, f.p.
 Z1, ill.610
 Z3, p.165
The Railroad, 1922, etch
 Eich, pl.378
 Z3, p.170
Railroad Crossing, 1923, dp
 Z3, p.164

HOPPER, W.H.
 Adam and Eve (ill. for W.Morris,
 "Dream of John Ball"; after E.
 Burne-Jones and W.Morris),
 pub.1892, wc
 Z1, ill.415
 Ill. for "The works of Geoffrey
 Chaucer" (after E.Burne-Jones)
 pub.1896, wc
 Portland, no.88

HOREN, Michael
 Ills. for M.Henrichs, "The Pter-
 odactyl and the Lamb", 1962,
 wengr

HUNDERTWASSER, Friedrich (Fritz
 Stowasser) (Austrian, 1928-)
 Good Morning City, Bleeding Town
 1970-71, col seri
 RC-2, p.11 (col), p.37
 RC-3, p.91 (col)
 Rosen, fig.181
 Goodbye to Africa, 1967, col
 litho
 RC-4, p.176 (col)
 Untitled, 1963, col litho
 Knigin, p.206 (col)

HUNT, Diane (American, 20th c.)
 Counting as an Occupation, 1976,
 litho
 Rosen, fig.110 (final st,
 proof)

HUNT, Richard (American, 1935-)
 Composition, 1969, litho
 Baro, p.58
 Crucifix Figure, 1957, litho
 RC-1, pl.99
 Untitled, 1965, col litho
 Tamarind-2, p.42
 Untitled (from the portfolio
 "Details"), litho
 Tamarind-1, p.26
 Untitled, No.2, 1970, litho
 Knigin, p.109
 Untitled, No.17, c.1965, litho
 Johnson-2, ill.91

HUNT, William Holman (British,
 1827-1910)
 A Day in the Country, pub.1865,
 etch
 Guichard, pl.35
 Sparrow, opp.p.183
 The Sphinx, or The Desolation of
 Egypt (pl. for "Etchings for
 the Art Union of London"),
 1857, etch
 Godfrey, pl.103

HUNT, William Morris (American,
 1824-1879)
 Flower Girl, litho
 Weit, opp.p.196
 Woman at Well, c.1856, litho w.
 tint stone
 Z1, ill.597

HUNTER, Bernece
 Moon Wake, 1966, col intag

 Eich, col pl.92
 Wild Sea Birds, 1967, col intag
 Eich, pl.399

HUNTER, Colin (1841-1904)
 Fishing in Scotland, etch
 Sparrow, opp.p.192

HUNTER, John
 Surf's Up, 1969, col litho
 Tamarind-2, p.43

HUNZIGER, Max
 Untitled, c.1940, col relief
 Eich, col pl.26

HURD, Nathaniel (1730-1777)
 Francis Dana bookplate, c.1770s,
 line engr
 MGA, pl.47b

HUYBERTS, Cornelius (1669-1712)
 The Foetus (ill. for F.Ruyschius
 "Thesaurus anatomicus"), pub.
 1702, engr
 L-S, pl.132
 Frontispiece for F.Ruyschius,
 "Thesaurus anatomicus", pub.
 1702, engr
 L-S, pl.130
 The Jar (ill. for F.Ruyschius,
 "Thesaurus anatomicus"), pub.
 1702, engr
 L-S, pl.131

IBELS, Henri-Gabriel (French,
 1867-1936)
 At the Circus (Circus Ring),
 1893, col litho
 Stein, pl.4
 Le Devoir (for "Le Theatre
 Libre"), 1892-93, litho
 Weisberg-1, p.78
 The Street Pavers, 1894, etch
 Stein, pl.74
 The Street Vendor, n.d., litho
 Weisberg-1, p.80
 The Weavers (Les Tisserands)
 (for "Le Theatre Libre"),
 1892-93, litho
 Weisberg-1, p.79

IKEDA, Masuo (Japanese, 1934-)
 Dream of Summer #2, 1966, col

ITTEN, Johannes (Swiss, 1888-1967)
Dictum (Spruch) (from Bauhaus
Portfolio 1), 1921, col litho
Wingler, pl.8 (col)
House of the White Man ("Haus
des Weissen Mannes") (from
Bauhaus Portfolio 1), 1921,
litho
Wingler, pl.9

IVES, James Merritt
See CURRIER and IVES

JACKSON, Herb (American, 1945-)
Bloom, 1975, col intag
Baro, pl.59
22 x 30: Luna, Eclipse, Down
Wind, Sand Dust, 1975, litho
in 4 parts
Baro, pl.60

JACKSON, John Baptist (British,
1701-c.1780)
The Building and the Vegetable
(pl.3, opp.p.15, of "An essay
on the invention of engraving
and printing in chiaro
oscuro"), 1754, chiaroscuro wc
Yale, pl.II (col)
Crucifixion: right panel, 1741,
chiaroscuro wc
Portland, no.75
Heroic Landscape with Fisherman,
Cows, and Horsemen (after M.
Ricci), 1744, chiaroscuro wc
Colnaghi-1, pl.LVII
Heroic Landscape with Sheep,
Statues and Gentlemen, 1744,
col wc
Godfrey, fig.2 (col)
Holy Family and Four Saints (pl.
3 from "Titiani Vecellii,
Pauli Caliarii, Jacobi Robusti
et Jacobi de Ponte, opera
selectiora"), 1745, chiaro-
scuro wc
Yale, pl.I (col), pl.XXVI
The Meal (after a Venetian engr)
Ad-2, p.138
The Murder of the Innocents,
1745, chiaroscuro wc
Eich, pl.91

JACOB, L.
Departure of the Italian Actors
(after A.Watteau), engr
Ad-2, p.13

JACOB, Nicolas Henri (active early
19th c.)
Portrait of Alois Senefelder,
pub.1819, litho
Weber, p.52
To the Glory of Alois Senefelder
(A Guardian Angel in a French
Lithographer's Shop; Genius of
Lithography Inspires the Arts
and Crafts), 1819, litho
Weber, p.58
Z5, p.69

JACOBE, John (1733-1797)
Miss Meyer as Hebe (after J.Rey-
nolds), 1780, mezzo
Colnaghi-2, pl.1 (I/II)

JACQUE, Charles-Emile (French,
1813-1894)
L'Abreuvoir de Moutons, etch
Salaman, p.198
Weisberg-3, p.76
La Gardeuse de Moutons, etch
Salaman, p.199
Head of a Man, 1848, etch
Weisberg-3, p.72
Hens (Poules), c.1867, etch
Weisberg-3, p.74
The Hurdy-Gurdy Player (Jouer de
Vielle), etch
Weisberg-3, p.72
Landscape, Evening (Paysage
Soir), 1890, etch
Hamerton, opp.p.170
Schmeck, p.77
Landscape, Storm (Paysage, l'
Orage), 1848, dp
Weisberg-3, p.73
The Large Cottage at Kercassier
(Le Grand Chaumiere Kercass-
ier), 1875, etch
Weisberg-3, p.75
The Large Sheepfold (La Grande
Bergerie), 1859, etch, dp, and
aqua
Kovler, p.109
Leipnik, pl.15
Ma Petite Fille, 1850, etch
Lumsden, p.296
The Merchant of Fried Fish (La

Marchande de Friture), 1843,
etch
Weisberg-3, p.72
Le Moulin, dp and mezzo
Lumsden, p.282
Le Pecheur, litho
Cleveland, pl.XXX
Rag-picker (Chiffonnier), 1843,
etch
Weisberg-3, p.72
Recureuse, etch
Furst, p.225
Lumsden, p.295 (right half)
Road at the Entrance of a Wood
(Chemin a l'Entree d'un Bois),
c.1859/62, glass print
Detroit, p.97
A Rustic Stair, etch
Hamerton, opp.p.169
The Swine-herd, etch
Hind, p.314
Troupeau de Porcs Sortant d'un
Bois, 1849, etch
Salaman, p.197
La Vachere, etch
Wedmore, opp.p.78
Watering Place with Sheep (L'
Abreuvoir aux Moutons), 1888,
etch
Weisberg-3, p.77
Work Horses Near a Shed (Chevaux
de Labour, pres d'un Hangar),
c.1859/62, glass print
Detroit, p.96

JACQUEMART, Jules (French, 1837-
1880)
Coupe de Jaspe Orientale, etch
Wedmore, opp.p.56
Frontispiece for the Societe des
Aquafortistes, 1862-63, etch
Weisberg-3, p.15
Oriental Arms, etch
Hamerton, opp.p.165
Porphry Vase, etch
Furst, p.269
Remembrances of the Trip (Sou-
venirs de Voyage), c.1861-62,
etch
Furst, p.271
Weisberg-3, p.78
Wilhelm van Hethuysen (after F.
Hals), etch
Hamerton, opp.p.303

JACQUEMIN, Andre
Landscape with Fisherman, etch
RM-2, pl.123

JACQUETTE, Yvonne (American, 1934
-)
Traffic Light Close Up, 1934,
col mono
Baro, p.60

JACQUOT
Voeux, 1969, litho
Knigin, p.214

JAMES, Francis
See LAING, Frank

JAMES, Walter John (British, 1869-
1932)
The Ilex, etch
Guichard, pl.35

JANES, Norman Thomas (British,
b.1892)
Ratcliffe Wharves, 1930s?, etch
Guichard, pl.36

JANINET, Jean-Francois (1752-1814)
Colonnade and Gardens of the
Medici Palace (after H.Robert)
engr
Ad-2, p.175
Mme Dugazon in the Role of Nina
(after J.B.Hoin), 1787, col
mixed engr
Z1, ill.322
Swiss Mountain View (after C.
Wolff), col aqua
Sotriffer-1, p.67 (col)

JANSEN, Angela (American, 1929-)
Cactus and Cabbage, 1974, etch
Baro, p.60

JANSEN, Franz M. (German, 1885-
1958)
8 O'Clock, 1920, wc
Z2, pl.107

JANSSEN, Horst (German, 1929-)
Melancholic Self-Portrait
(Selbst Elegisch), 1965, etch
RC-3, p.103
RC-4, p.159

JAQUES, Bertha E. (American, 1863-
1941)
The Tangle, Chioggia, etch
Laver, pl.LXXIII
Villefranche, 1914, etch
WISC, no.17

JARRY, Alfred (French, 1873-1907)
Ubu roi, c.1896-98, wc
Ad-1, p.33

JAWLENSKY, Alexei von (Russian,
1867-1941)
Head (Kopf) (from Bauhaus Port-
folio 4), c.1922, litho
Wingler, pl.54
Seated Nude (from the "Female
Nude" series), 1912, litho
Sotriffer-2, p.30

JAZET, Jean Pierre Marie (1788-
1871)
Leonora; or, The Dead Travel
Quickly (after H.Vernet), engr
L-S, pl.190

JEFFERYS, Thomas (active 1753-
1775)
A Prospective View of the Battle
Fought near Lake George, on
the 8th of Sept.1755 (after S.
Blodget), 1756, line engr
MGA, pl.23

JENKINS, Paul (American, 1923-)
Red Parrot, 1964, col litho
Siblik, p.73 (col)
Untitled, 1967, col litho
Eich, pl.594

JENNIS, J.G. (British, active
1910-1925)
Dr. Crippen Playing Chess, etch
Guichard, pl.36

JENSEN, Alfred (American, 1903-)
Growth of a 4 x 5 Rectangle
(from the portfolio "A Pythag-
orean Notebook"), 1965, col
litho
Tamarind-1, p.30
Maya Structure! (from the port-
folio "A Pythagorean Note-
book"), 1965, col litho
Tamarind-2, p.45

JOHANNOT, Tony (French, 1803-1852)
See also S. Williams
Plates from A.de Musset, "Voyage
ou il vous plaira", pub.1843
L-S, pls.177-79

JOHN, Augustus Edwin (British,
1878-1961)
The Bathers, 1921, litho
Bauman, pl.78
Benjamin Evans, 1897 or 1907,
etch
Colnaghi-1, pl.LXXI
Charles McEvoy, etch
Lumsden, p.344
Gwendolen, 1902, etch and dp
Godfrey, pl.125 (5th st)
Jacob Epstein, Sculptor, etch
Guichard, pl.36
Portrait of W.B.Yeats, etch
Schmeck, p.76
Self-Portrait, etch
Furst, p.351
Self-Portrait with Hat, 1919,
etch
Ad-1, p.91
Tete Farouche: Portrait of the
Artist, c.1906, etch
Lumsden, p.343
Schmeck, p.76
Virginia, etch
Guichard, pl.36
Woman with Necklace, etch
Guichard, pl.37

JOHN, Jiri (Czechoslovakian, 1923-
1972)
Autumn, 1967, dp
Eich, pl.412
Tree-trunk, 1962, dp
Siblik, p.119

JOHNS, Jasper (American, 1930-)
Ale Cans (Beer Cans), 1964, col
litho
MOMA, p.34 (col)
RC-3, p.119 (col)
RC-4, p.180 (col)
Coat Hanger, 1960, litho
Mayor, ill.752
The Critic Sees, 1967, emboss-
ment
Eich, pl.398
Decoy, 1971, litho
Johnson-2, ill.109
Decoy I, 1971, litho

Fleet of Buses"), 1966, col
litho
Tamarind-1, p.56 (col)
Tamarind-2, p.47

JONES, David (British, 1895-1974)
Animals at Rest, etch
Guichard, pl.37
Going into Church (ill. for "The
Rime of the Ancient Mariner"),
1929, engr
Godfrey, pl.138
Ill. for "The Chester Play of
the Deluge", white-line wengr
Leighton, p.69

JONES, John (c.1745-1797)
Beatrice Listening to Hero and
Ursula (after H.Fuseli), 1791,
mezzo
Colnaghi-2, pl.XXI
Lady Caroline Price (after J.
Reynolds), 1788, mezzo
Colnaghi-2, pl.XXIX (III/IV)
Hind, p.278

JONES, John Paul (American, 1924-)
Annunciation, 1959, sg etch
Johnson-2, ill.75
Landscape Woman, 1961, etch
Eich, pl.389
Night Lady, 1963, litho
Tamarind-2, p.48
Suspension, aqua and engr
Pet-2, p.131
White Table, 1957, etch, sg etch
and aqua
Troche, p.63
Woman in the Wind, 1962, litho
Tamarind-1, p.47
Yellow, 1950, col etch and sg
etch
RC-1, pl.82

JONES, Joseph John (Joe)
(American, 1909-)
Missouri Wheat Farmers, litho
Craven, pl.59

JONES, Owen (British, 1809-1874)
See also F.Bedford; A.Warren
Borders from vases (pl.XVI of
"Examples of Chinese Ornament
Selected from Objects in the
South Kensington Museum and
Other Collections"), 1867,

chromolitho
Yale, pl.LXIV
Capitals of Columns, Court of
Lions (pl.XL of vol.2 of
"Plans, Elevations, Sections,
and Details of the Alhambra"),
1836-45, chromolitho
Yale, pl.LXI
Funeral Passing Over the Sacred
Lake of the Dead and its Arri-
val at the Tomb on the Other
Side, Thebes (pl.84 of supple-
ment to J.G.Wilkinson, "A
Second Series of the Manners
and Customs of the Ancient
Egyptians"), 1841, chromolitho
Yale, pl.LXIII
Illuminated text of Ecclesiastes
(p.32 of "The Preacher"),
1849, chromolitho
Yale, pl.LXII
The Peacock (pl.11 of M.A.Bacon,
"Winged Thoughts"), 1851, '
chromolitho
Yale, pl.LXII

JONES, Raymond Ray-
See RAY-JONES, Raymond

JONES, Sydney Robert Fleming
(British, 1881-1966)
Notre Dame, etch
Guichard, pl.38

JONGKIND, Johan Barthold (Dutch,
1819-1891)
Canal pres Rotterdam, 1875, etch
Leipnik, pl.51
Demolitions, 1875, etch
Leipnik, pl.52
Harbor Mouth at Honfleur (Sortie
du Port d'Honfleur), 1864,
etch
Pass-2, p.27 (I/IV)
Weisberg-3, p.23
Z1, ill.407
Leaving the Port of Honfleur,
1863, etch
RM-1, p.101
Moored Fishing-Boat, 1882, etch
RM-2, pl.22
The Old Port of Rotterdam (Le
Vieux Port de Rotterdam),
1863, etch
Weisberg-3, p.79
Sunset at Antwerp (Soleil Couch-

siegt), 1904, etch
 GM, p.34
Jugler in April, 1928, etch
 Pet-1, p.241
Kleinwelt, 1914, etch
 Hayter-1, pl.32
A Man in Love, 1923, col litho
 Eich, pl.541
Old Man Reckoning (Rechender
 Gris), 1929, etch
 Fogg, pl.68
 Sachs, pl.123
 Z1, ill.505
 Z2, pl.37
 Z5, p.95
The Pergola, 1910, dp
 Eich, pl.360
Portrait of My Father (Bildnis
 meines Vaters), 1906, glass
 print
 Detroit, fig.10 (det)
Prickle the Clown, 1931, etch
 Hayter-2, p.237
The Saint of the Inner Light
 (Die Heilige vom innern Licht)
 (from Bauhaus Portfolio 1),
 1921, col litho
 IFCR, no.62 (col)
 Mayor, ill.746
 Wingler, pl.10 (col)
 Z2, pl.70 (col)
The Tightrope Walker (Seil-
 tanzer), 1923, col litho
 Ad-1, p.133
 Fogg, pl.67
 IFCR, no.65 (col)
 RC-4, p.64 (col)
 Sal, p.123
 Weber, p.205 (col)
 Z1, ill.506
Virgin in the Tree, 1903, etch
 Haas, p.110
 RC-4, p.15
 Sachs, pl.120
Why Does He Run?, 1932, etch
 Sachs, pl.125
Witch with the Comb (Die Hexe
 mit dem Kamm), 1922, litho
 Bauman, pl.91
 Grunwald, p.56
 IFCR, no.64
 Man, pl.197
 Z2, pl.69

KLEIBER, Hans (b.1887)
 Pintails, etch

Schmeck, p.77

KLEIN, Cesar (German, 1876-1954)
 Woman, wc
 Sotriffer-2, p.79

KLEIN, Johann Adam (German, 1792-
 1875)
 Students from Erlangen out Rid-
 ing (Ausritt von Erlanger
 Studenten), 1811, chalk litho
 Man, pl.46

KLEINSCHMIDT, Paul (German, 1883-
 1949)
 Odalisque, 1923, dp
 Z2, pl.109
 Samson's Wedding (Samsons Hoch-
 zeit), n.d.
 Houston, ill.34

KLIMT, Gustav (Austrian, 1862-
 1918)
 Portrait of a Woman, 1896, litho
 RM-1, p.127

KLINE, Franz (American, 1910-1962)
 Poem (from "21 Etchings and
 Poems"), pub.1960, etch and
 aqua
 Eich, pl.421
 RC-1, pl.101

KLINGER, Max (German, 1857-1920)
 Bookplate for Elsa Asekijeff,
 1890-1910, etch
 Mayor, ill.82
 Early Spring, etch and aqua
 RM-1, p.217
 Evocation (from "Eine Brahms-
 phantasie"), mixed method
 Furst, p.291
 The Glove: plate, 1881, etch
 Eich, pl.316
 The Glove: pl.9, Abduction, 1880
 -81, etch and aqua
 Rosen, fig.227
 A Love: plate, 1887, etch and
 aqua
 Eich, pl.317
 The Plague (pl.V from "Death II"
 portfolio), 1903, etch
 RC-4, p.14
 Rosen, fig.146

Schaffenden", vol.11), 1920,
litho
Bowdoin, pl.70
Marie, The Acrobat, 1948, col
litho
Eich, col pl.60
RC-3, p.23 (col)
Still Life With Blue Vase, 1951,
col litho
Fogg, pl.143
Untitled, 1953, col litho
Knigin, p.264 (col)
The Vase, 1926, col litho
Fogg, pl.142
The Vase (Abstraction Still
Life), 1927, col litho
RC-4, p.103
Woman With Flower, 1951, col
litho
Weber, p.213 (col)

LEGRAND, Augustin (1765-1815)
Reception du Decret du 18 Flor-
eal (after P.-L.Debucourt),
late 18th c., engr
Ad-2, p.187
Eich, pl.297

LEGROS, Alphonse (French, 1837-
1911)
After the Day's Work, etch
Sparrow, opp.p.64
An Aged Spaniard, c.1872, etch
Weisberg-3, p.87
Alfred Stevens, c.1870, dp
Godfrey, pl.117
The Angler (Pecheur a la Ligne),
etch
Leipnik, pl.30
Bathers (Baigneuses), dp
Furst, p.275
Le Bonhomme Misere, etch
Hamerton, opp.p.198
Le Canal, dp
Salaman, p.236
Cardinal Manning, Archbishop of
Westminster, 1876-77, etch
Minn, pl.16 (II/III)
Chailli, Storm (Chailli, Effet
d'Orage), etch and dp
Weisberg-3, p.89
Les Chantres Espagnols, etch
Salaman, p.230
La Communion dans l'Eglise de
St.Medard, 1861, etch
Jordan, p.28

Le Coup de Vent, etch
Laver, pl.XXV
The Death of the Vagabond (La
Mort du Vagabond), n.d., etch,
aqua and dp
Kovler, p.123 (III/III)
Salaman, p.229
Sparrow, opp.p.65 (2d st)
Weisberg-1, p.82
The Death of the Woodcutter (La
Mort et le Bucheron), etch
Leipnik, pl.33
Sparrow, opp.p.65 (2d st)
La Ferme de l'Abbaye, etch
Schmeck, p.82 (I/IX)
Les Grands Arbres, mixed method
Furst, p.279
Lisiere du Bois, dp
Salaman, p.239
Le Long de la Rive, dp
Lumsden, p.287
The Merchant of Chickweed (Le
Merchand de Mouron), n.d.,
etch
Weisberg-1, p.83
Le Mur du Presbytere, etch
Salaman, p.237
Schmeck, p.80
Wedmore, opp.p.64
Paysanne Assise pres d'une Haie,
dp
Salaman, p.234
The Plough, aqua
Chase, pl.37
RM-2, pl.37
Portrait of a Man, etch
RM-1, p.102
Portrait of Auguste Rodin, etch
Hind, p.310
Portrait of Dalou, etch
Lumsden, p.285
Portrait of G.F.Watts, etch
Guichard, pl.41
Salaman, p.233
Portrait of H.Fantin-Latour,
etch
Schmeck, p.80
Portrait of the Artist, 1880,
etch
Schmeck, p.80 (II/IV)
Le Pre en Soleille, dp
Salaman, p.240
Pres d'Amiens. Les Tourbieres,
dp
Salaman, p.241
The Prodigal Son (L'Enfant

Prodigue) No.3, etch
 Hind, p.317
 Schmeck, p.81 (V/V)
La Promenade d'un Convalescent,
 dp
 Salaman, p.231
Repros au Bord de la Riviere,
 etch
 Salaman, p.235
Return from the Wood (Le Retour
 du Bois), n.d., etch
 Weisberg-1, p.84
Scene du Coup d'Etat--2 Dec.1851
 etch
 Furst, p.277
Shepherd Resting, etch
 Leipnik, pl.32
Sir E.Poynter, etch
 Leipnik, pl.31
The Storm (Un Orage), dp
 Guichard, pl.41
 Sparrow, opp.p.64 (2d st)
The Trees at the Bank of the
 Water (Les Arbres au Bord de
 l'Eau), etch
 Weisberg-3, p.88
The Triumph of Death (Le Triom-
 phe de la Mort), etch
 Sparrow, opp.p.57 (4 examples)
The Triumph of Death (Le Triom-
 phe de la Mort: La Mort a
 Prepare une Demeure a des
 Abandonnees), etch
 Schmeck, p.81
The Wayfarer, etch
 Guichard, pl.41
The Woodcutters (Les Bucherons),
 etch
 Weisberg-3, p.86

LEHEUTRE, Gustave (French, 1861-
1932)
 Canal a Troyes, etch
 Leipnik, pl.81
 Notre Dame de Chartres, 1913,
 etch
 Schmeck, p.83 (final st)

LEHMBRUCK, Wilhelm (German, 1881-
1919)
 Apparition, 1914, dp
 RC-4, p.35
 Four Woman, 1913, etch (signed
 proof)
 Z1, ill.516
 Z2, pl.91

The Lonely Woman (Das einsame
 Weib), 1913, etch
 Z2, pl.90
Macbeth, 1918, etch
 Z2, pl.96
Melancholy Figures, 1912, dp
 Sotriffer-2, p.45
Prodigal Son, 1913, dp
 Fogg, pl.55
 Sachs, pl.144
Seated Girl With Head Bent, 1912
 dp
 Fogg, pl.54

LEHMDEN, Anton (Austrian, 1929-)
 Arco di Giano, 1959-60, etch
 Z3, p.11
 The Church, 1959-60, etch
 Z3, p.5
 Colosseum, 1959-60, etch
 Z3, p.2
 Fountain, 1959-60, etch
 Z3, p.10
 Palatin, 1959-60, etch
 Z3, p.8
 Pantheon, 1959-60, etch
 Z3, p.6
 Pyramid of Caius Cestius, 1959-
 60, etch
 Z3, p.9
 Ruin, 1959-60, etch
 Z3, p.7

LEHRER, Leonard (American, 1935-)
 Classical Landscape (after Pous-
 sin), 1967, power burin engr
 Eich, pl.432 (I/V), pl.433
 (III/V), pl.434 (V/V)

LEIBER, Gerson (American, 1921-)
 The Beach, 1965, etch
 Johnson-2, ill.120
 The Crowd, 1967, etch and aqua
 Eich, pl.388
 Under the El, 1957, intag
 Getlein, p.259

LEIBL, Wilhelm (German, 1844-1900)
 Peasants, 1874, etch
 Eich, pl.315
 Portrait of the Painter Hortig,
 etch
 RM-1, p.128

LEIGHTON, Clare (British, b.1899)
 Cavtat, wengr

LEOPOLD, Franz Joseph (German,
 1783-1832)
 King Frederick William III of
 Prussia (Friedrich Wilhelm
 III, Konig von Preussen),
 1807, chalk litho
 Man, pl.31

LEPAPE, Georges (b.1887)
 The White Hind, 1916
 Ad-1, p.122

LEPERE, Auguste-Louis (French,
 1849-1918)
 A l'Exposition Universelle:
 Frontispiece, Tour Eiffel,
 1889, wengr
 Kovler, p.87
 Amiens: l'Inventoire, etch
 Pennell, p.199
 Wedmore, opp.p.84
 The Cathedral at Amiens, 1907,
 etch
 SLAM, fig.55
 Convalescente, Mme.Lepere, 1892,
 col wc
 Ives, p.19 (col)
 L'Eglise de Saint-Prix, etch
 Leipnik, pl.71
 The Game of Backgammon, 1891,
 wengr
 Ad-1, p.30
 The Horse-Pond Behind Notre Dame
 wc
 RM-2, pl.70
 The Houses of Parliament at Nine
 O'Clock in the Evening (ill.
 for "Black and White"), 1890,
 wengr
 SLAM, fig.48
 Landscape with Figures, etch
 Schmeck, p.85
 Laundresses or, How Quickly
 Youth Fades (The Washerwomen),
 1893, col sg etch and aqua
 Stein, pl.24 (III/III)
 Weisberg-1, p.89 (III/III)
 Le Long de la Seine: f.p., 1889-
 90, wengr
 Kovler, p.87
 Marche aux Pommes, etch
 Leipnik, pl.69
 Paris Under Snow, View from the
 Top of Saint-Gervais, 1890,
 wengr
 Kovler, p.129

RM-1, p.168
 Plunderers and Wrecks (Pilleurs
 et Epaves), n.d., etch
 Weisberg-1, p.86 (1st st)
 Poetry and Music Assisting the
 Arts (f.p. for a Gala program
 at the Opera), 3-col wengr
 SLAM, fig.49 (trial proof)
 Porte St.Denis, wengr
 Kovler, p.126
 Quartier Juif a Amsterdam, etch
 Leipnik, pl.70
 Rouen Cathedral, wc
 RM-2, pl.71
 The Stevedore (Le Debardeur),
 1886, wc
 Weisberg-1, p.88
 Unloaders of Plaster, Canal St.
 Martin (Les Dechargeurs de
 Platre), 1890, wengr
 Weisberg-1, p.87

LEPIC, Louis Napoleon, comte de
 (1839-1889)
 L'Intrigant, etch
 Leipnik, pl.47
 Untitled (Terrier), c.1876, mono
 MMA, p.23
 View of the Banks of the Escaut
 (Vue des Bords de l'Escaut)
 (L'Orage; Apres l'Orage; La
 Pluie; Claire de Lune; Les
 Saules; La Lune dans les Saul-
 es), 1860s, etch
 MMA, pp.20-21 (6 impressions)
 View...(Vue): Fire (L'Incendie)
 du Moulin, c.1870-76, etch
 MMA, p.94
 View...(Vue): Willows and Pop-
 lars (Saules et Peupliers),
 c.1870-76, etch
 MMA, p.95
 View...(Vue): Snow (La Neige),
 c.1870-76, etch
 MMA, p.95

LEPICIE, Bernard (1699-1755)
 The Busy Mother (after J.-B.
 Chardin), 1744, engr
 Ad-2, p.131
 La Gouvernante (after J.-B.
 Chardin), 1739, engr
 Z1, ill.306

LE PRINCE, Jean-Baptiste (French,
 1734-1781)

La Menagere, aqua
 Hind, p.300
Le Paysan, 1768, etch
 Schmeck, p.85
Russian Concert, c.1770
 Ad-2, p.142
La Vue, 1774, etch and aqua
 Z1, ill.327
 Z5, p.67

LE SIDANER, Henri Eugene (French,
 1862-1939)
 La Ronde, 1899, litho
 Jordan, p.29

LESLIE, Alfred (American, 1927-)
 Alfred Leslie, 1974, litho
 Baro, p.71

LESPINASSE, Herbert (b.1884)
 The Harbor, wc
 RM-2, pl.121
 The Mysterious Voyage III, 1938,
 etch
 Ad-1, p.164

LESSORE, Therese (British, 1884-
 1945)
 Receiving Office, etch
 Guichard, pl.42

LEUTZE, Emanuel Gottlieb (German-
 American, 1816-1868)
 The Puritan (pl.2 of J.W.Ehning-
 er, "Autograph Etchings by
 American Artists..."), pub.
 1859, glass print
 Detroit, p.191

LEVEE, John (American, 1924-)
 L-69#6, 1969, col litho
 Tamarind-2, p.53

LEVINE, Jack (American, 1915-)
 Death's Head Hussar, c.1969, dp
 Eich, pl.411
 The General, 1963, etch and aqua
 Z1, ill.647

LEVINE, Les (Canadian, 1935-)
 Les Levine LXVI: S29, 1966,
 photo offset
 RC-4, p.203

LEVINE, Martin (American, 1945-)
 The Barn, 1974, intag

Baro, p.71
The Pardee House (West View,
 Oakland, Ca), 1976, etch
 Baro, p.72

LEVY, Paul M. (American, 1944-)
 Commonwealth of Massachusetts
 Building Code, 1975, seri
 Baro, p.72

LEWIS, Charles George (1808-1880)
 The Slave Market (Constantino-
 ple) (w. W.Giller; after W.
 Allan), pub.1842, mezzo and
 etch
 Engen, p.66

LEWIS, Frederick Christian
 (British, 1779-1856)
 Landing of Aeneas (w. G.R.Lewis;
 pl.35 from part II of John
 Chamberlaine, "Original de-
 signs of the most celebrated
 masters of the Bolognese,
 Roman, Florentine, and Vene-
 tian schools"; after drawing
 by Claude Lorrain), 1812,
 aqua and col etch
 Yale, pl.XXIX

LEWIS, George Robert (British,
 1782-1871)
 Landing of Aeneas (w.F.C.Lewis;
 pl.35 from part II of John
 Chamberlaine, "Original de-
 signs of the most celebrated
 masters..."; after drawing by
 Claude Lorrain), 1812, aqua
 and col etch
 Yale, pl.XXIX

LEWIS, John Frederick (British,
 1805-1876) See also W.Gauci
 Buck Shooting, pub.1836, etch
 Sparrow, opp.p.138
 Sierra Nevada and Part of the
 Alhambra, 1835, tinted litho
 Godfrey, pl.91

LEWIS, Martin (American, 1881-
 1962)
 Derricks at Night, 1927, dp
 RC-1, pl.38
 Spring Night, Greenwich Village,
 1930, dp
 Rosen, fig.8

Stoops in Snow, 1930, dp, sand-
paper ground
Johnson-2, ill.39
Late Traveler, 1948, dp, sand-
paper ground
Rosen, fig.9
Little Penthouse, 1931, etch and
dp
RC-1, pl.40

LEWITT, Sol (American, 1928-)
The Location of a Square (No.II
from "The Location of Six Geo-
metric Figures"), 1975, etch
Ontario, p.20
The Location of a Straight Line,
a Not-Straight Line, and a
Broken Line (from "the Loca-
tion of Lines"), 1975, etch
Ontario, p.21
Sixteen Lithographs in Black and
White, 1971, col litho
Knigin, p.114 (col)
Untitled, 1971, etch
RC-2, p.63
Untitled, 1971, etch
RC-3, p.157
Untitled (from series of six-
teen), 1971, etch
Johnson-2, ill.96
Untitled (from "Squares With a
Different Line Direction in
Each Half Square"), 1971, etch
Ontario, p.19

LHERMITTE, Leon Augustin (French,
1844-1925)
A Harvest (Une Moisson), c.1883,
etch
Weisberg-1, p.25
Potato Gathering (La Recolte des
Pommes de Terre), c.1878, etch
Weisberg-1, p.92
The Reapers (Les Foins), c.1872,
etch
Weisberg-1, p.91

LHOTE, Andre (French, 1885-1962)
Wind on the Quarter, 1925, wc
Ad-1, p.99

LIAO, Shiou-Ping
Festival of Moon, 1936, etch
Eich, pl.405

LIBERMAN, Alexander (American,
1912-)
Untitled, 1962, col litho
RC-1, pl.91
Untitled, 1963, col litho
MOMA, p.33
Untitled (pl.4 from "For Meyer
Schapiro" portfolio), 1973,
col litho
GM, p.65

LICHTENSTEIN, Roy (American, 1923
-)
Bull series: II, 1973, col litho
and linocut
Rosen, col pl.20
Bull series: III, 1973, col
litho and ss
Rosen, col pl.21
Bull series: IV, 1973, col litho
and ss
Rosen, col pl.22
Bull series: VI, 1973, col litho
and ss
Rosen, col pl.23
Cathedral 2, 1969, col litho
Eich, col pl.84
Crak!, 1964, col offset litho
Z5, p.133
Entablature II, 1976, col litho,
screen print and collage w.
embossing
Baro, p.72
Entablature VIII, 1976, col
screen print and collage w.
embossing
Baro, p.73
Fish and Sky (from the portfolio
"Ten from Leo Castelli"), 1967
col ss on photo w.laminated
textured plastic
Eich, pl.633
Homage to Max Ernst, 1975, col
ss
Baro, p.73
Peace Through Chemistry I, 1970,
litho
Knigin, p.80
Peace Through Chemistry IV, 1970
litho
Johnson-2, ill.106
RC-3, p.133
Still Life with Crystal Bowl,
1976, col litho and ss
Baro, p.73
Sweet Dreams, Baby! (or Pow!)

col litho
GM, p.43
Victory Over the Sun...: pl.3,
Sentinel, 1923, litho
Rosen, fig.223
Victory Over the Sun...: pl.5,
Globetrotter in Time, 1923,
col litho
Rosen, col pl.24
Victory Over the Sun...: pl.9,
Gravedigger (Totengraber),
1923, col litho
GM, p.44
Victory Over the Sun...: pl.10,
Modern Man (Neuer), 1923, col
litho
GM, p.44
Z1, ill.525

LITTEN, Sidney Mackenzie (British,
1887-1949)
A Scottish Inn, etch
Guichard, pl.42

LIVENS, Horace Mann (1862-1936)
Self-Portrait, etch
Guichard, pl.42

LOBDELL, Frank
Untitled, 1966, col litho
Tamarind-2, p.54

LOCKE, Charles (1899-)
The Terrace, litho
Craven, pl.64
Water Front, litho
Craven, pl.63

LOCKWOOD, George
Portrait of a Lady, 1971, litho
Knigin, p.102
The Real Cricket, c.1966, col
intag
Eich, pl.392

LONG, Edwin (1829-1891)
Diana or Christ? Let her cast
the incense--But one grain--
and she is free (anon. after
E.L.), pub.1889, photogravure
Engen, pp.62-62

LONG, Sydney (Australian, 1878-
1955)
Kookaburras, etch
Guichard, pl.80

LONGACRE, James Barton (American,
19th c.)
Andrew Jackson (after Sully),
stipple engr
Weit, opp.p.76

LONGHI, Alessandro (Italian, 1733-
1813)
The Ridotto (after Pietro
Longhi), c.1760, etch
Sopher, p.36

LONGO, Vincent (American, 1923-)
ABCD, 1971, col etch and aqua
Baro, p.74
First Cut, Second Cut, Third Cut
1974-75, wc
Baro, p.74
Temenos, 1978, etch and aqua
Johnson-2, ill.129
Untitled, 1976, col aqua
Johnson-2, col ill.25
Untitled, 1976, col aqua
Baro, p.75 (col)

LONGUEIL, J.de
La Courtisane Amoureuse (from La
Fontaine, "Contes et Nouv-
elles"; after C.Eisen), 1761,
engr
Z1, ill.285 (proof before
letters)
Vignette (after C.Eisen), engr
Ad-2, p.48
Vignette (after C.Eisen), engr
Ad-2, p.49

LORD, Elyse (British, d.1971)
Kingfisher Dancers, dp
Guichard, pl.42

LORJOU, Bernard (1908-)
Apollinaire's Goat (from Apolli-
naire, "The Bestiary"), wc
Pass-1, p.141 (col)
The Cat (from Apollinaire, "The
Bestiary"), wc
Pass-1, p.12

LOTIRON, Robert (b.1886)
The Chestnut Trees, c.1950,
litho
Ad-1, p.205

LOUVION, Jean-Baptiste (1740-1804)
The Ninth Thermidor, or The

Sirr, "China and the Chinese
...."; after design by H.C.S.),
1849, litho
Yale, pl.LIX

McMILLAN, Janet
Abstraction, 1969, mixed media
col intag
Eich, col pl.40

McNAB, Iain (British, 1890-1967)
Nude, 1920s, etch
Guichard, pl.44
Self-Portrait, 1920s, etch
Guichard, pl.44

MAGUIRE, Henry Calton (British,
1790-1854)
Patterns of Diapering Discovered
on the Images in the Choir at
Cologne Cathedral (pl.29 of A.
W.N.Pugin "Glossary of Eccle-
siastical Ornament and Costume
...."; after drawing by A.W.N.
P.) 1846, chromolitho
Yale, pl.LIX

MAILLOL, Aristide (French, 1861-
1944)
Bather, litho
RM-2, pl.101
Europa and the Bull (ill. for
"Odes of Horace"), 1939, wc
Wechsler, fig.6
Juno, litho
Z1, ill.487
Nude, c.1923, litho
Ad-1, p.126
Nude 2, litho
Haas, p.36
Nude from Behind, c.1920, litho
Weber, p.128
Ovid, "The Art of Love": man and
woman, 1935, wc
Sotriffer-1, p.51
Ovid, "The Art of Love": Stand-
ing Nude, 1935, litho
Haas, p.85
Wechsler, pl.77
Vergil, "Eclogues": title page
(Pipe Player), c.1913, wc
Sachs, pl.84
Vergil, "Eclogues": ill., pub.
1926, wc
Portland, no.150
Vergil, "Eclogues": ill.on p.16,

pub.1927, wc
RC-4, p.98
Vergil, "Eclogues": Shepherd
Corydon, c.1913, wc
Sachs, pl.83
Woman from the Back, Draped,
1924, litho in sanguine
Pass-1, p.27 (col; 1st st)
Woman in Wind, litho
Sachs, p.242

MALBESTE, Georges (1754-1843)
La Sortie de l'Opera (after J.M.
Moreau; from "Le Monument du
Costume"), 1783, engr
Z1, ill.299

MALEUVRE, Pierre
Night Departs and Dawn Appears
(after J.M.Nattier), engr
Ad-2, p.24

MALEVICH, Kasimir (Russian, 1878-
1935)
Front and back covers for N.
Punin, "First Cycle of Lec-
tures", 1920, litho
Rosen, fig.235
The Prayer (ill.for "Explodity")
1913, litho
Rosen, fig.244
Simultaneous Death of a Man in
an Airplane and at the Railway
(ill.for A.Kruchenyckh,
"Vzorval" (Explodity)), 1913,
litho
RC-4, p.51

MALLARD, Paul (French, b.1809)
Bridge Across Mountain Stream,
glass print
Detroit, p.198

MANESSIER, Alfred (French, 1911-)
Composition, 1944, etch
Ad-1, p.184
Composition, 1963, col litho
Siblik, p.83 (col)
Live Flame, 1957, col litho
Pass-1, p.143 (col; artist's
proof)

MANET, Edouard (French, 1832-1883)
The Absinthe Drinker (Le Buveur
d'Absinthe), 1861-62, etch
Leymarie, pl.M14 (III/III)

Genesis II (The Story of Crea-
tion II; Shopfungsgeschichte
II), 1914, col wc
Bowdoin, pl.66
Z2, pl.65 (col)
Horse and Hedgehog (Pferd und
Igel), 1913, wc
GM, p.47
Horse Drinking (Trinkendes
Pferd), 1913, wc
IFCR, no.71
Horses Resting, 1912, col wc
Sotriffer-2, p.57 (col)
Lizards (Eideschen), 1912, wc
GM, p.46
Riding School, 1913, wc
RC-4, p.34
Z2, pl.68
Sleeping Shepherdess (Schlafende
Hirtin), 1912, wc
GM, p.46
Portland, no.131
Tigers, 1912, wc
Fogg, pl.69
IFCR, no.70
Z2, pl.64

MARCHANT, Leonard
Snail and Bowl, mezzo
Colnaghi-2, pl.XLIII
Vivary, 1969, mezzo
Eich, pl.474

MARCHI, Giuseppe Filippo Liberati
(c.1735-1808)
Miss Cholmondeley (after J.
Reynolds), 1768, mezzo
Colnaghi-2, pl.XXVII (II/III)
Oliver Goldsmith (after J.
Reynolds), 1770, mezzo
Colnaghi-2, pl.XVII (II/III)

MARCKS, Gerhard (German, b.1889)
Angel of Cologne, 1946, wc
Z2, pl.95
Black Steer (Schwarzer Stier),
1922, wc
Houston, ill.31
Cats (Die Katzen) (from Bauhaus
Portfolio 1), 1921, wc
Wingler, pl.12
Z1, ill.503
Z2, pl.92
Drummers, 1921, wc
Z2, pl.94
Flight, 1946-47, wc

Portland, no.133
The Owl (Die Eule) (from Bauhaus
Portfolio 1), 1921, wc
Wingler, pl.13
Peasant With Cow (Kuhbauer),
1924, wc
Z2, pl.61
Polish Mother (Polenmutter), 1922
wc
Z2, pl.93

MARCOUSSIS, Louis (Ludwig Markus)
(French, 1883-1941)
Head of Woman (Weiblicher Kopf)
(from Bauhaus Portfolio 2),
1912-24, etch
Rosen, fig.184
Wingler, pl.21
Plate from "Planches de Salut",
1931, etch and engr
Hayter-2, p.247
Pet-2, p.147
Portrait of Guillaume Apolli-
naire, 1912-20, etch and dp
Ad-1, p.74 (det)
Fogg, pl.27
Melamed, p.36
RC-4, p.44
Still Life: Zither and Shellfish
(Nature Morte: Cithare et
Coquillage), 1922, etch and
aqua
Melamed, p.37
RC-4, p.44

MARDEN, Brice (American, 1938-)
Painting Study II, 1974, ss w.
wax and graphite applications
Baro, p.77
Untitled (a) (from "Five
Plates"), 1973, etch and aqua
Ontario, p.34
Untitled (g) (from "Adriatics"),
1973, etch
Ontario, p.32

MARGO, Boris (American, 1902-)
Great Wall, 1964, cellocut
Eich, pl.444
Jewels in Levitation, 1949, col
cellocut
Baro, p.78 (col)
Pathway (from portfolio of 12
cellocuts), 1960-71
Johnson-2, ill.98
Reflections from Space, 1952,

col cellocut
Johnson, p.36
The Sea, 1949, col cellocut
RC-1, pl.78
The Wall, 1964, cellocut, em-
bossment on paper
Pet-2, p.240

MARIESCHI, Michele (Italian, 1696-
1743)
The Bridge and Market of Rialto
(from a set in "Magnificent-
iores selectioresque urbis
venetiarum prospectus"),
c.1741, etch
Colnaghi-1, pl.LI
Campo San Rocco (from "Magnifi-
centiores..."), pub.1741, etch
Sopher, p.17
Piazza S.Marco With Campanile
and View of S.Giorgio Maggiore
1741, etch
Schmeck, p.90

MARILLIER, Clement-Pierre (French,
1740-1808)
Ill. for C.-J.Dorat "Fables Nou-
velles" (Cupids) (anon. after
C.-P.M.), 1773, etch
Mayor, ill.565

MARIN, John (American, 1870-1953)
Brooklyn Bridge, 1913, etch
Z2, pl.122
Brooklyn Bridge, 1913, etch and
dp
Haas, p.105
RC-1, pl.3
Brooklyn Bridge No.6, 1913, etch
and dp
Fogg, pl.73
Johnson-2, ill.6
Chartres Cathedral, 1910, etch
WISC, no.18
Downtown, the El (1st version),
1921, etch
Eich, pl.380
Downtown, the El, 1921, etch
Z5, p.109
Downtown New York, 1921, etch
Craven, pl.66
From Ponte S.Panaleo, Venice,
1907, etch
Weisberg-2, no.17
Ponte Ghetto, Venice, etch
Z4, fol.p.8

Sailboat, 1932, etch
Z1, ill.618
Z4, fol.p.8
St.Gervais, Rue Grenier sur l'
Eau, Paris, 1909, etch
Weisberg-2, no.46
Woolworth Building: No.2, 1913,
etch and dp
RC-1, pl.2
Woolworth Building: The Dance,
1913, etch
Fogg, pl.74
RC-1, pl.1
RC-4, p.47
Sachs, pl.192
Sotriffer-2, p.86
Z1, ill.625
Z4, fol.p.8

MARINI, Marino (Italian, 1901-
1980)
Acrobats and Horses, 1952, col
litho
Sachs, pl.163
Green Man--Pink Horse, 1969,
col litho
Knigin, p.256 (col)
Horse, 1952, litho
Hayter-1, pl.63
Horse, c.1960, col etch
Ad-1, p.176
Horse and Rider, 1952, col litho
Z1, ill.539
Horseman (L'Idea del Cavaliere)
(from "Europaische Graphik,
VI"), 1968, litho
Man, pl.247
Horses (Chevaux), 1951, col
litho
Bauman, pl.113
Juggler and Horses, green back-
ground, yellow border, 1953,
col litho
Fogg, pl.150
Rider Falling, 1954, col litho
Weber, p.223 (col)
Rider on a Black Ground (Rider
on a Starry Black Background;
Cavalier sur Fond Noire
Etoile), 1961, col litho
Siblik, p.35
Sotriffer-1, ill.75

MARISOL (Marisol Escobar) (French-
American, 1930-)
Five Hands and One Finger, 1971,

litho
 Knigin, p.173
Phnom Penh I, 1970, etch
 Johnson-2, ill.95

MARKOVITZ, Sherry (American, 1947
 -)
 Ovulation II, 1975, gum biochro-
 mate w.watercolor added
 Baro, p.79

MARKUS, Ludwig
 See MARCOUSSIS, Louis

MARLET, Jean Henri (1770-1847)
 Promenade aux Tuileries, Qu'est-
 ce qu'on regarde?, mezzo
 Cleveland, pl.XI
 The Sad Farewell, c.1820, litho
 Weber, p.55

MARPLES, George (British, 1869-
 1939)
 The Lure, etch
 Guichard, pl.45

MARQUET, Albert (French, 1875-
 1947)
 Boulogne Harbor, c.1930, litho
 Pass-1, p.67
 RM-2, pl.100

MARRIOTT, Frederick (British, 1860
 -1941)
 Rue Gubernates, Nice, etch
 Guichard, pl.45

MARSH, Reginald (American, 1898-
 1954)
 Bowery, 1928, litho
 Eich, pl.580
 Breadline--No One Has Starved,
 1932, etch
 Craven, pl.69
 RC-1, pl.46
 The Courtship, 1932, litho
 Rosen, fig.6
 Erie R.R.Locos Watering, 1934,
 etch
 Bowdoin, pl.68 (VII/VII)
 Felicia, etch
 Craven, pl.70
 The Jungle, 1931, etch
 Craven, pl.67
 Getlein, p.255
 Merry-Go-Round, etch

Craven, pl.72
Merry-Go-Round, 1938, etch
 WISC, no.55
The Star Burlesque, 1933, etch
 Craven, pl.68
 Lockhart, p.208
The Steeplechase, 1932, etch
 RC-1, pl.44
Steeplechase Swings, pub.1935,
 etch
 Johnson-2, ill.32
Tattoo, Shave and Haircut, 1932,
 etch
 Craven, pl.71
 Z1, ill.627

MARSTON, Freda (British, 1895-
 1949)
 Arundel, Sussex, c.1933-36, etch
 Guichard, pl.45

MARTIAL, Adolphe (A.Potemont)
 (French, 1828-1883)
 Le Canal St.Martin, c.1864, etch
 Weisberg-3, p.94
 Le Louvre, etch
 Leipnik, pl.41
 Siege de la Societe des Aquafor-
 tistes, c.1864, etch
 Weisberg-3, p.11
 Street Angle in the Rue St.Roch,
 etch
 Hamerton, opp.p.186

MARTIN, Agnes (American, 1912-)
 On a Clear Day: pl.18, 1973, ss
 RC-4, p.199
 On a Clear Day: Untitled, 1973,
 ss
 Ontario, p.38

MARTIN, Camille (1861-1898)
 Decorative cover for "L'Estampe
 originale", 1894, col litho
 Stein, pl.41

MARTIN, Frank (1921-)
 Mathilde de la Mole (ill. for
 Stendhal, "Le Rouge et le
 Noir"), 1965, wengr
 Ad-1, p.207

MARTIN, John (British, 1789-1854)
 Belshazzar's Feast (2d plate),
 1832, mezzo
 Colnaghi-2, pl.XX

Soleils Bas: pl.2, 1924, dp
 RC-4, p.74
Sysiphus, etch and aqua
 Eich, pl.345
 Pass-1, p.137

MATARE, Ewald (German, 1887-1965)
 Cows Grazing at Night (Nacht-
 liche Wiese), c.1932, col wc
 Z2, pl.81

MATHEWS, Richard George (b.1870)
 Charles Dickens, etch
 Schmeck, p.92
 Rudyard Kipling, etch
 Schmeck, p.92

MATHIESON, John George (Scottish,
 active 1920s)
 Stirling Castle from Touch, etch
 Guichard, pl.46

MATISSE, Henri (French, 1869-1954)
 Apollinaire Rouveyre, Matisse,
 c.1930, aqua
 Eich, pl.346
 Apples, c.1914-17, mono
 MMA, p.211
 Arabesque, litho
 Eich, pl.546
 Long, pl.194
 Le Boa Blanc, litho
 Eich, pl.545
 Crouching Nude with Black Hair,
 litho
 Long, pl.190
 Girl with a Vase of Flowers,
 1923, litho
 Fogg, pl.87
 Long, pl.192
 Head (Tete de Face), 1948, aqua
 RC-3, p.21
 Head of a Woman, c.1938, linocut
 Rosen, fig.75
 Head of a Woman, Turned to the
 Left, c.1914-17, mono
 MMA, p.208
 Head with the Eyes Closed (Bust
 of a Woman with Eyes Closed),
 1906, litho
 Fogg, pl.15
 Pet-1, p.250
 Ill. for "Anthology of the
 Amours of Ronsard", pub.1941,
 col litho
 Long, pl.199

Ill. for H.de Montherlant, "Pas-
 iphae", pub.1937-44, linocut
 Sotriffer-1, p.51
Ill. for J.Joyce, "Ulysses": The
 Blinding of Polyphemus, etch
 Long, pl.196
Ill. for "Poesies de Stephane
 Mallarme": Portrait of Baude-
 laire, 1930-32, etch
 Long, pl.198
 Mayor, ill.729
 Pet-2, p.101
 Sachs, pl.66
Ill. for "Poesies de Stephane
 Mallarme": pl.24, Swan, 1930-
 32, etch
 Fogg, pl.91
 RC-4, p.89
 Sachs, pl.67
Interior: Artist Drawing Three
 Apples and Sculpture, c.1914-
 17, mono
 MMA, p.210
 SLAM, fig.66
Jazz: Desting, 1947, col seri
 Pet-1, p.253, opp.p.50 (col)
Jazz: Horse, Rider and Clown,
 1947, pochoir sheet
 RC-4, p.100 (col)
Jazz: The Knife Thrower, pub.
 1947, col stencil
 Z1, ill.471
Jazz: Lagoons, 1944-47, col
 stencil
 Mayor, ill.730
Jazz: The Nightmare of the White
 Elephant, 1947, col stencil
 RC-2, p.9 (col), p.24
Jazz: pl.7, The Burial of Pier-
 rot (L'Enterrement de Pierrot)
 1947, col stencil
 RC-3, p.19 (col)
Jazz: pl.8, Icarus, 1947,
 pochoir
 Rosen, fig.172
Jazz: pl.14, Le Cowboy, 1947,
 col stencil
 Fogg, pl.92
Jazz: pl.15, Le Lanceur de Cout-
 eaux, 1947, col stencil
 Fogg, pl.93
Joan Massia, 1914, etch
 Fogg, pl.85
Nu Assis au Bras Releve (Ara-
 besque V), 1926, litho
 Grunwald, p.41

MECKSEPER, Friedrich (German, 1936
 -)
 John--Tobacconist and Snuff, col
 etch
 Clark, no.67
 Still Life with Spring (from
 "Reconnaissance du Cuivre"),
 1975, col etch
 Rosen, col pl.8

MEE, Nancy (American, 1951-)
 A Modesto Truck Driver, 1975,
 col diazo and Xerox transfer
 w.hand coloring
 Baro, p.98 (col)

MEEKER, Dean Jackson (1920-)
 Crowd, 1958, seri
 Hayter-1, pl.42
 Genghis Khan, 1962, collagraph,
 screen print
 Johnson-2, ill.121
 Surgeon, 1957, intag
 Getlein, p.263

MEIDNER, Ludwig (German, 1884-
 1966)
 Figure with Raised Hands (Ge-
 stalt mit erhobenen Handen),
 1918, litho
 Houston, ill.19
 Party at W.Z. (Boheme bei W.Z.)
 (after a drawing; ill. for "Die
 Anbruch", Jan.1919), 1919?
 Houston, ill.24
 Portrait of a Man, dp
 Getlein, p.27
 Prophet, c.1918, litho
 Sotriffer-2, p.77
 Z2, pl.97
 Self-Portrait with Brush, 1920,
 dp
 SLAM, fig.71

MEISSONIER, Ernest (French, 1815-
 1891) See also P.Rajon
 Fishermen, etch
 RM-1, p.29
 Paul et Virginie et la Chaumiere
 Indienne (ill. from "Chaumiere
 Indienne"), pub.1838, wengr
 Kovler, p.143

MEISSONIER, Juste-Aurele (French,
 1693-1750)
 Apartment for Count Bielenski,

 probably at Nancy, 1723-35,
 etch
 Mayor, ill.540

MELLON, James
 Untitled, 1966, col etch
 Eich, col pl.86

MENDEZ, Leopoldo (1893-)
 Deportation to Death, 1942, wc
 Fogg, pl.83
 Haab, pl.51
 Dream of the Poor, 1943, wengr
 Z1, ill.561
 Ill. for Heine, "Gods in Exile",
 1962, wengr
 Eich, pl.138
 On the Merry-Go-Round, 1947,
 linocut
 Haab, pl.52
 The Torches, 1948, linocut
 Haab, pl.50
 Vision, 1945, wengr
 Eich, pl.106

MENPES, Mortimer L. (British, 1855
 -1938)
 Captive Persian (cat), etch
 Guichard, pl.47
 Evening, etch
 Guichard, pl.46
 Heavy Laden, etch
 Guichard, pl.47
 Mother and Child, etch
 Guichard, pl.45
 Portrait of Henry Irving, etch
 Guichard, pl.46
 A Portrait of Whistler, etch
 Guichard, pl.46

MENSE, Carl (German, 1886-1965)
 The Stigmatization of St.Francis
 (from Bauhaus Portfolio 5), c.
 1922, litho
 Wingler, pl.72

MENZEL, Adolf Friedrich von
 (German, 1815-1905)
 See also A.Vogel
 The Antiquary (Self-Portrait),
 1851, litho
 Minn, pl.8
 The Bear, 1889, tinted litho
 Weber, p.94
 Brush and Scraper, 1851, litho
 Eich, pl.522

Salaman, p.206 (V/IX)
La Rue des Mauvais Garcons, etch
 Salaman, p.207 (2d st)
Rue des Toiles, Bourges, 1853,
 etch
 Hind, p.320
 SLAM, fig.35
St.Etienne du Mont, Paris, 1852
 or 1862, etch
 Mayor, ill.700 (signed proof)
 Salaman, p.209 (I/VIII)
 Schmeck, p.93 (IV/VIII)
Le Stryge, 1853, etch
 Haas, p.57
 Hamerton, opp.p.152
 Leipnik, pl.25
 Lockhart, p.146
 Sachs, p.240
 Sal, p.225 (IV/VIII)
 Salaman, p.200
 Weisberg-2, no.30
 Weisberg-3, p.97
 Z1, ill.429 (V/VIII)
Le Tombeau de Moliere au Pere-
 Lachaise, Paris, 1854, etch
 Schmeck, p.93 (II/II)
Tourelle, Rue de l'Ecole de
 Medecine, c.1861, etch
 Weisberg-3, p.99

METTENLEITER, J.M.
Laundry Book, 1813, litho
 Weber, p.76

METZINGER, Jean (French, 1883-
1956)
Untitled, dp
 Melamed, p.41

MEUNIER, Constantin-Emile
(Belgian, 1831-1905)
Miner, 1895, litho
 Stein, pl.86

MEYER, Henry
Lady Hamilton as Nature (after
 G.Romney), c.1782, mezzo
 Z1, ill.335

MICHALEK, Ludwig (1859-1942)
Exercise in intaglio on a plate,
 stipple engr, roulette, etch,
 sg etch, mezzo, aqua and ss
 Sotriffer-1, p.14
Test plate of intaglio techni-
 ques, late 19th c.

Eich, pl.406

MIELATZ, Charles Frederick William
The Poe Cottage, Fordham, New
 York, 1905?, etch
 Weit, opp.p.48

MIGNOT, Louis Remy (American, 1831
-1870)
The Tropics (pl.11 of J.W.Ehnin-
 ger, "Autograph Etchings by
 American Artists"), pub.1859,
 glass print
 Detroit, p.90

MIKUS, Eleanore
Tablet Litho 2, 1968, col litho
 Tamarind-2, p.57

MILLAIS, John Everett (British,
1829-1896) See also
T.O.Barlow; W.H.Simmons
The Foolish Virgins (ill. for
 "The Parables of Our Lord and
 Saviour Jesus Christ, engraved
 by the Dalziel Brothers"),
 1864, wengr
 Godfrey, pl.100
Ill. for A. Trollope, "The Small
 House at Allington" (for "The
 Cornhill Magazine"), 1863,
 wengr
 Mayor, ill.690
The Reluctant Sitter, etch
 Guichard, pl.47
Untitled, 1861, etch
 Laver, pl.XX
The Young Mother, pub.1857, etch
 Guichard, pl.47
 Sparrow, opp.p.186

MILLER, John Douglas (c.1872-
c.1903)
Invocation (after Lord Leighton)
 pub.1893, mezzo
 Engen, p.53

MILLER, Kenneth Hayes (1876-1952)
Women Shopping, etch
 Craven, pl.75

MILLET, Jean-Francois (French,
1814-1875)
Digger Resting (L'Homme Appuye
 sur sa Beche), n.d., etch
 Weisberg-1, p.95

Pet-2, p.100
Composition with Crossed Beams
(Composition avec des Poutres
Croisees), c.1948, litho
Bauman, pl.118
Decoration to book "A Toute
Epreuve", pub.1958, col wc
Z1, ill.491
Equinox, 1968, col etch and aqua
RC-3, p.55 (col)
RC-4, p.72
Rosen, col pl.9
Filette Sautant a la Corde,
Femmes, Oiseaux, 1947, etch
Hayter-2, p.83
Fond Vert, 1950-51, col litho
Hayter-1, pl.60
The Foresters (Les Forestiers),
1958, col etch
Fogg, pl.159
The Foresters--Gray (Les Forest-
iers--Gris), 1958, col etch
and aqua
GM, p.47
Person in a Garden (Personnage
dans le Jardin), 1951, col
litho
Troche, p.65
Personnage aux Oiseaux, 1948,
col litho
Z1, ill.490
Z5, p.127
Les Philosophes II, 1958, col
etch
Fogg, pl.158
Pierrot the Fool (Pierrot-le-
Fou), 1964, col litho
Siblik, p.23 (col)
Plate 1 for G.Hugnet, "Enfances"
1933, etch
RC-4, p.77
Poem of Ruthven Todd with Decor-
ations, 1947, intag print and
relief print
Hayter-2, pp.86-87
Preparatifs d'Oiseau #1, 1964,
litho
Knigin, p.248
Sad Traveler (The Melancholy
Traveler), 1955, col litho
Ad-1, p.212 (col)
Pass-1, p.133 (col)
Series I (the Family): No.4,
1952, col etch and engr
RC-3, p.53 (col)
RC-4, p.78

Series III, 1953, col aqua
Sotriffer-1, p.71 (col)
Stars and Smoke, 1968, col etch
and aqua
RC-2, p.39
The Sun Eater, 1955, col litho
MOMA, p.19
Untitled, 1977, col mono w.
additions by hand
MMA, p.243
Woman with Mirror, 1957, col
litho
Weber, p.222

MOENCH, Erich
The Moon, 1969, photo litho
Eich, pl.610
Small Magic Zodiac, 1967, litho
Eich, pl.602
Test lithographic proofs, var-
ious textures
Eich, pls.603-09

MOHOLY-NAGY, Laszlo (Hungarian,
1895-1946)
Abstraction, wc
Eich, pl.123
Konstruktionen: pl.1, 1923,
litho
RC-4, p.66

MOLZAHN, Johannes (German, 1892-
1965)
Composition (from Bauhaus Port-
folio 3), 1921, wc
Wingler, pl.38

MONET-DUCLOS
Execution of Queen Marie Antoin-
ette, late 18th c., engr
Eich, pl.296

MONKIEWITSCH, Lienhard von (1941-)
Stutze, col ss
Clark, no.69

MONROY, Guillermo (1925-)
Trees, 1949, litho
Haab, pl.73

MOODY, John Charles (British, 1884
-1962)
The Moor, etch
Guichard, pl.48

Ad-1, p.147

MOREAU, Pierre Louis
 Sistenon, etch
 Leipnik, pl.91
 View of Gardanne, etch
 RM-2, pl.89

MOREAU l'Aine (Louis-Gabriel Mor-
 eau) (French, 1740-1806)
 The Cottage
 Ad-2, p.109
 The Footbridge
 Ad-2, p.109
 Paysage Montagneux au Pont a
 Deux Arches, etch
 Fenton, no.88

MOREAU le Jeune (Jean-Michel Mor-
 eau) (French, 1741-1814)
 See also C.Baquoy; N.Delaunay;
 Gaucher; I.S.Helman; N.LeMire;
 G.Malbeste
 Foire de Gonesse (from de la
 Borde, "Choix de Chansons"),
 pub.1772, engr
 Z1, ill.290
 Le Paix du Menage (after J.-B.
 Greuze; finished w.engr by P.
 C.Ingouf), 1765-66, etch
 Mayor, ill.600

MORGAN, Norma
 Dark Vision, 1961, engr
 Eich, pls.430 (I/III), 431
 (III/III)
 Granite Tor, 1954, engr
 Hayter-1, pl.14
 Tired Traveler, 1950, aqua and
 engr
 Johnson-2, ill.68

MORGAN, William Evan Charles
 (British, 1903-)
 Perseus, engr
 Furst, p.401
 Young Love Birds
 Guichard, pl.48

MORGHEN, Raphael (Italian, 1758-
 1833)
 The Madonna of the Grand Duke
 (after Raphael), 1823-26, engr
 Mayor, ill.580

MORGNER, Wilhelm (German, 1891-
 1917)
 Field and Woman, 1912, wc
 Sotriffer-2, p.69

MORIN, Edmond (1824-1882)
 The Sources of the Budget (ill.
 for "Le Monde illustre"),
 2 May 1863
 L-S, pl.200

MORISOT, Berthe (French, 1841-
 1895)
 The Drawing Lesson (Le Lecon de
 Dessin), c.1890, dp
 Chase, pl.67
 Eich, pl.333
 Pass-2, p.134
 RM-1, p.167
 RM-2, pl.65
 Geese (Les Oies), etch
 Leipnik, pl.50
 Young Girl with Cat, 1889, dp
 Wechsler, fig.17

MORLEY, Eugene (American, 1909-)
 Execution, 1940, col seri
 Z1, ill.640
 Structure, 1939, col litho
 WPA, p.15

MORLEY, H.Collison- (British, d.
 1915)
 Boiling Up the Billy, etch
 Guichard, pl.48

MORLEY, Harry (British, 1881-1943)
 The Infant Mars, engr
 Guichard, pl.48
 Tarantella, engr
 Furst, p.355

MORRIS, Carl (1911-)
 Span, 1962, col litho
 Tamarind-2, p.58

MORTENSEN, Gordon (American, 1938
 -)
 Summer Pond, 1976, col wc
 Baro, p.81

MORTENSEN, Richard (Danish, 1910-)
 Caen, 1960, col seri
 Siblik, p.149 (col)
 Composition, 1953, col litho
 Knigin, p.301 (col)

Portrait of Kandinsky, 1906, col
wc
GM, p.53

MURPHY, John J.A. (1888-1967)
Morning Gossip, wengr
Leighton, p.63
Wild Horses, 1921, wengr
Z1, ill.622

MURRAY, Charles Oliver (1842-1923)
My Lady's Garden (after J.Y.
Hunter), c.1900 (pub.1904),
etch in brown
Engen, pp.88-89

MUSIALOWICZ
Reminiscence XII, 1970, mono
Eich, pl.638

MUSIC, Zoran (1909-)
Landscape (Paysage), 1959, col
aqua
Siblik, p.101 (col)

MYERS, Frances (American, 1936-)
Monte Alban I, 1976, col aqua
Baro, p.82

MYERS, Jerome (American, 1867-
1940)
Cronies, etch
WISC, no.37

MYERS, Malcolm (American, 1917-)
Fox in Costume, 1967, mixed
media
Johnson-2, ill.122

NADELMAN, Elie (American, 1882-
1946)
High Kicker (from the portfolio
"The Drypoints of Elie Nadel-
man"), 1920, dp
RC-1, pl.4
Vers la Beaute plastique (female
head), c.1921-23, dp
Johnson-2, ill.79

NAMA, George A.
Computer Landscape No.6, 1970,
col intag
Eich, col pl.49 (w.progressive
proofs 1,2 and 4)

Reeds, 1975, col collagraph,
intag and seri
Baro, p.83

NANAO, Kenjilo (1929-)
Further Variations on a Sucker,
1973, col litho
Baro, p.83

NANTEUIL-LEBOEUF, Celestin-
Francois (1813-1873)
The Drummer's Bride, 1835, litho
RM-1, p.58
Sur le Balcon, litho
Cleveland, pl.XXII

NARBONA, Pia
Suenos, 1965, litho
Knigin, p.295

NAROTZKY, Norman
El Juego, la Rosa, y el Tiempo,
1969, col litho
Knigin, p.294 (col)

NASH, James
The Letter Writer, Constantino-
ple (after D.Wilkie), 1840,
litho
Weber, p.162

NASH, John Northcote (British,
1893-1977)
Cover for "Shell Mex House",
pub.1933, litho
Gilmour, pl.13
Foxgloves (ill. for "Poisonous
Plants"), wengr
Leighton, p.55
Ill. for Adrien Bell, "Men and
the Fields", 1939, col letter-
press and litho
Gilmour, pl.7 (col)
Woodland Study, Suffolk, c.1924,
wc
Godfrey, pl.132

NASH, Paul (British, 1889-1946)
Black Poplar Pond, 1922, wc
Godfrey, pl.131
Book cover design, wengr
Leighton, p.67
Mine Crater, Hill 60, 1917,
litho
Bauman, pl.119
Rain, Lake Zillebeke, 1918,

litho
Weber, p.191

NASON, Thomas Willoughby
(American, 1889-1971)
Back Country, wengr
Z4, fol.p.132
Penobscot Bay, copper engr
Z4, fol.p.132
Pennsylvania Landscape, wengr
Z4, fol.p.132
Village Street, wengr
Craven, pl.76

NAST, Thomas (American, 1840-1902)
That's what's the matter (anti-
Tweed cartoon for "Harper's
Weekly")
Weit, opp.p.274

NAUDIN, Bernard (French, 1876-
1946)
The Crucifixion, etch
RM-2, pl.93
The Guitar-Player and the Cara-
van, etch
RM-2, pl.94

NAUMAN, Bruce (American, 1941-)
M.Ampere, 1973, col litho
Baro, p.84
Untitled, 1971, col litho
Baro, p.83

NAWARA, James (American, 1945-)
Deadwood, 1975, col litho
Baro, p.84
Horseshoe Mound, 1972, glass
print
Detroit, p.151 (artist's
proof)

NAY, Ernst Wilhelm (German, 1902-
1968)
Composition, 1966, col litho
Siblik, p.77 (col)
Untitled, c.1957, col etch, dp
and aqua
MOMA, p.27 (col)

NEAL, Avon (American, 1922-)
Adam and Eve (ink rubbing based
on a stone in a Scottish
churchyard)
Eich, pl.177
Ink rubbing from a Bush Negro

carved wood panel, Surinam
(19th c.)
Eich, pl.170
Ink rubbing from a gravestone in
the old cemetery, Wakefield,
Mass. (18th c.)
Eich, pl.178
Ink rubbing from a house-shaped
stone tomb of the Bogomile
sect, central Yugoslavia (c.
14th-15th c.)
Eich, pl.175
Ink rubbing from an Irish grave-
stone (18th c.)
Eich, pl.176
Ink rubbing from pre-Inca carv-
ing on facade of "Gate of the
Sun", Tiahuanaco, Bolivia
Eich, pl.174 (det)
Priest with Offering (based on a
Mayan temple carving, Palen-
que, Chipas, Mexico)
Eich, pl.172

NEAL, Reginald (British-American,
1909-)
Red Circle Moire No.2, 1965, col
litho
Eich, col pl.69

NEE and MASQUELIER
Breakfast at Ferney (after D.V.
Denon), engr
Ad-2, p.117

NELSON, Robert A. (American, 1925
-)
Bombs of Barsoom, 1971, litho-
gravure and collage
Baro, p.85
Cat and Mice, 1975, col litho
Baro, p.85
Torpedo Tabby, 1974, col litho-
gravure and collage
Baro, p.85

NESBITT, Lowell (American, 1933-)
Lily, 1975, dp
Baro, p.86 (I/VI)
Sandstone Tulip, 1976, col litho
Baro, p.86

NESCH, Rolf (Norwegian, 1893-1975)
Barmbeck Bridge, 1932, etched
and soldered zinc plate
Z3, p.46

Barmbeck Bridge (from "Hamburger
 Brucken" series), 1932, metal
 print
 Z3, p.47
Bishop, 1948-49, material print
 Sotriffer-1, p.86
Cafe Vaterland, Berlin, 1926,
 etch and aqua w.bitten holes
 on copper plate
 Z3, p.43
Composition, 1955, relief print
 Hayter-1, pl.54
Dance, 1955?, col metal print
 Z3, p.54
The Dance, 1956, col mixed media
 RC-3, p.59 (col)
The Dane, 1948, col litho
 Z3, p.50
Dark Lady, 1953, metal print
 Z1, ill.544
 Z3, p.53
Elevated Bridge (from "Hamburger
 Brucken" series), 1932, col
 metal print
 Z3, p.48
Fishing Boats in a Storm (from
 "Lofoton" series), 1936, col
 metal print
 Z3, p.49
Garde Offizier, col metal-
 collage print
 Eich, pl.443
The Herring Catch, 1938, metal
 print
 RC-4, pp.156-57
Mask, 1953-54, col metal print
 Z3, p.52
Oriental King, 1954, metal print
 Rosen, fig.204
Pharoh's Baker, 1956, col metal
 print
 Z3, opp.p.54 (col)
Ragnhildrud, 1952, panel from a
 col metal print polyptych
 Z3, p.51
Self-Portrait, 1931, dp
 Z3, p.40
Skaugum (from "Schnee" series),
 1933-34, metal print
 Z1, ill.545
 Z3, p.48
Tuba and Trombones (from "Muck
 und sein Orchester" series),
 1931, etch and aqua
 Z3, p.45
Wind, metal print

Pet-2, p.235
Yellow Flower, 1953, col metal
 print
 Z3, opp.p.55 (col)
 Z5, p.121

NEVELSON, Louise (American, 1900-)
 The Ancient Garden, 1954, etch
 Baro, p.86 (1st st)
 Tropical Leaves series: plate,
 1970-73, lead intag
 Johnson-2, ill.83
 Untitled, 1963, col litho
 RC-1, pl.97
 Untitled, 1963, litho
 RC-4, p.139
 Tamarind-1, p.15
 Untitled, 1967, litho
 Knigin, p.158
 Tamarind-2, p.61

NEVINSON, Christopher Richard
 Wynne (British, 1889-1946)
 Banking at 4,000 Feet, 1917,
 litho
 Weber, p.190
 Boesinghe Farm, 1916, dp
 Godfrey, pl.127
 Chalk Pits, Amberley, etch
 Guichard, pl.49
 Edith Sitwell, 1927, etch
 Guichard, pl.49
 From a Paris Plane, c.1928,
 litho
 Godfrey, pl.128
 From a Paris Window, etch
 Guichard, pl.49
 In Suburbia, etch
 Lumsden, p.359
 On Brooklyn Bridge, etch
 Laver, pl.L
 The Road to Arras, litho
 Boston, p.69
 Success, etch
 Guichard, pl.50
 Swooping Down, 1917, litho
 Z1, ill.552
 That Cursed Wood, 1918, dp
 Lumsden, p.357
 Troops Marching, etch
 Guichard, pl.49
 Westminster from the Savage Club
 dp
 Furst, p.379
 Wind, mezzo
 Guichard, pl.49

NEWMAN, Barnett (American, 1905-
1970)
 Canto III, 1963, litho
 Knigin, p.176
 Canto VI (from "18 Cantos"),
 1963-64, litho
 RC-3, p.71
 Untitled, 1961, litho
 RC-1, pl.108
 RC-4, p.136
 Untitled, 1969, etch and aqua
 RC-2, p.47

NEWTON, Eric Ernest (British,
1893-1965)
 The Plough, engr
 Guichard, pl.50

NICE, Don (American, 1932-)
 Double Sneaker, 1975, litho
 Baro, p.87
 Tootsie Pops, 1974, col litho
 Baro, p.87

NICHOLSON, Ben (British, b.1894)
 Halse Town, Cornwall, 1948, dp
 Godfrey, pl.142
 Still Life, 1948, dp
 Ad-1, p.177

NICHOLSON, Francis (British, 1753
-1844)
 Knaresborough, Yorkshire (from
 "Lithographic Impressions from
 Nature"), 1821, litho
 Godfrey, pl.92

NICHOLSON, Sir William (British,
1872-1949)
 The Barmaid (ill. for "London
 Types" album) 1898, col litho
 transfer from woodblock
 Godfrey, pl.121
 Under the Arch of the Bridge,
 1894, col litho
 Stein, pl.75

NICOLSON, John (British, 1891-
1951)
 Alsatian, 1920s?, etch
 Guichard, pl.50
 On a Basque Farm, 1926, etch
 Guichard, pl.50

NIEDLICH, Johann Gottfried (1766-
1837)

Queen Louisa of Prussia (Louise,
 Konigin von Preussen), 1807/8,
 chalk litho
 Man, pl.30 (trial proof)

NIEPCE, Joseph Nicephore (French,
1765-1833)
 Portrait of Cardinal d'Amboise
 (after Isaac Briot), 1827
 (printed 1864), photo-etch or
 heliogravure
 Z1, ill.459

NINI, Giovanni Battista (Italian,
1688-1762)
 Landscape with a River, 1740,
 etch
 Sopher, p.56

NISBET, Robert Hogg (b.1879)
 Marine Miniature, etch
 Schmeck, p.96
 Through the Willows, No.2, dp
 Schmeck, p.96

NIVISKSIAK (20th c.)
 Man Hunting at a Seal Hole in
 Ice, stencil print
 Eich, pl.626

NIXON, Job (British, 1891-1938)
 The Castle, Dieppe, etch
 Guichard, pl.50
 Italian Hill Town, dp
 Laver, pl.XLIV
 The Tables, Dieppe Casino, 1925,
 etch
 Guichard, pl.51

NOEL, Jules-Achille (French, 1815-
1881)
 Moonlit Landscape, 1855, glass
 print
 Detroit, p.100

NOFER, Werner (1937-)
 Drilling, col ss
 Clark, no.73

NOLDE, Emil (German, 1867-1956)
 The Actress, 1913, litho
 Rosen, fig.94
 Dancer, 1913, col litho
 Ad-1, p.97 (col)
 Dancer, 1922, etch and aqua
 Z2, pl.55

ORLEANS, Antoine-Philippe d', Duc
 de Montpensier (French, 1775-
 1807)
 Adelaide d'Orleans, 1806, litho
 Boston, p.76
 Mayor, ill.613
 Portrait of the Artist and His
 Brother, 1805, litho
 Eich, pl.480
 Z3, p.119

ORLOWSKI, Alexandr (Polish, 1777-
 1832)
 On the Persian Border (Caucas-
 ians), 1819, litho
 Bauman, pl.23
 Russian Courier Being Driven in
 a Three-Horse Cart (Un cour-
 rier russe en telegue a trois
 chevaux), 1819, chalk litho
 Man, pl.80 (proof before
 letters)
 Russian Swell Driving in a Droz-
 hki, litho
 Boston, p.71
 Sledge Ride in Russia, 1820,
 litho
 Bauman, pl.22

ORLOWSKI, Hans (German, b.1894)
 Washing of Feet (Fussbad), 1921,
 wc
 Houston, ill.53

OROVIDA (Orovida Camille Pissarro)
 (British, 1893-1968)
 Curves, etch
 Laver, pl.LV
 The Scarf Game, etch
 Guichard, pl.54
 Strategy, etch
 Furst, p.389
 Guichard, pl.54

OROZCO, Jose Clemente (Mexican,
 1883-1949)
 La Bandera, 1928, litho
 Fogg, pl.80
 Demonstration (The Masses), 1935
 litho
 Knigin, p.33
 Figures in a Landscape, c.1926,
 litho
 Fogg, pl.79
 Mouths, 1935, litho
 Z5, p.87

Rear Guard, 1929, litho
 Eich, pl.554
 Sachs, p.195
Requiem, 1928, litho
 Haas, p.121
 Z1, ill.559

ORR, John William (American, 19th
 c.)
 The Great Eastern, 1853-58,
 wengr
 Mayor, ill.107

ORTMAN, George Earl (American,
 1926-)
 Dance of Life, 1966, col litho
 Tamarind-2, p.63
 Flight (from the portfolio
 "Oaxaca"), 1966, litho
 Tamarind-1, p.36
 Red Print, 1966, col litho
 Tamarind-2, p.64

OSBORNE, Malcolm (British, 1880-
 1963)
 Mrs. Heberden, 1923, etch
 Guichard, pl.51
 Portrait of My Mother, c.1916,
 dp
 Ad-1, p.94
 Portrait of Sir Frank Short,
 etch
 Guichard, pl.51
 The Problem, etch
 Laver, pl.XXXIV
 Trekkers of the Plain, Salonika,
 1921, etch
 Guichard, pl.51

OSK, Roselle (b.1884)
 Old Man with Muffler, dp
 Schmeck, p.97

OSPEL, Anton
 Galeria Reale, Stage Set (after
 G.G.da Bibiena), 1740, engr
 Z1, ill.333

OTIS, Bass (American, 1784-1861)
 Landscape, 1819, litho
 Eich, pl.567
 Weit,opp.p.180
 Untitled, 1820, litho
 Bauman, pl.28a
 Weit, opp.p.180

muses orne de XL tableaux ou
sonts representes les eveme-
ments..."), pub.1733, engr
L-S, pl.113

PICASSO, Pablo (Spanish, 1881-
1973)
The Acrobats, 1905, dp on copper
Ad-1, p.53
The Acrobats: Le Bain, 1905, dp
Sal, p.136
Andre Breton, 1923, dp
Sachs, p.96
Artist and Model (La Pose Habil-
lee), 1954, litho
Fogg, pl.138
Au Cirque, 1905, dp
Fogg, pl.12
Bacchanal, 1957, litho
Weber, p.221
Balzac, "Le Chef d'Oeuvre Incon-
nu": Painter and Model Knit-
ting (pl.4), 1927, etch
Fogg, pl.109
Mayor, ill.740
RC-4, p.109
Z5, p.142
Balzac, "Le Chef d'Oeuvre Incon-
nu": Painter at Work, 1931,
etch
Z5, p.17
Balzac, "Le Chef d'Oeuvre Incon-
nu": The Sculptor Modelling,
on the right two of his works,
1927, etch
Sal, p.70
Banderillas, 1959, col linocut
Pass-1, p.101 (col)
Buffon, "L'Histoire Naturelle":
Ass, 1936, aqua
Pet-2, p.121
Buffon, "L'Histoire Naturelle":
The Frogs, 1942, sugar aqua
Ad-1, p.230
Buffon, "L'Histoire Naturelle":
The Lizard, 1942, sugar aqua
Ad-1, p.233
Hayter-2, p.95
Buffon, "L'Histoire Naturelle":
Ostrich, 1936-37 (pub.1942),
lift-ground aqua
Fogg, pl.122
SLAM, fig.76
Wechsler, fig.22
Buffon, "L'Histoire Naturelle":
The Wasp, 1941-42, sugar aqua

Sal, p.28
Bull, 1945, litho
Rosen, figs.214-18 (II,IV,
VIII,IX,XI/XI)
Wechsler, fig.35 (I,V,VIII,XI/
XI)
Bull, Horse and Woman, 1934,
etch
Pet-1, p.261
Bust of a Woman with a Hat,
1962, col linocut
Rosen, col pl.5
Bust White on Black, 1949, litho
w.lift-ground process
Sotriffer-1, p.131
Buste de Femme, 1905/06, wc
Eich, pl.151
The Cock, aqua in black and gray
Long, pl.221
Combat, 1937, burin and dp
Hayter-2, p.63
Pet-2, p.15
The Convent (Le Couvent), 1910,
etch
Melamed, p.22
The Dance (La Danse), 1905, dp
Colnaghi-1, pl.LXXII
Dance of Salome, 1905, dp
Ad-1, p.52
Sal, p.137
Wechsler, fig.16
Z1, ill.532
Dancer with Tambourine (Danseuse
au Tambourin; Woman with a
Tambourine; Femme au Tambour-
in), 1938, etch and aqua
Fogg, pl.123
Hayter-2, p.74
RC-4, p.112
SLAM, fig.77
Z1, ill.533
The Dancers, 1954, litho
Eich, pl.548
Dancing Centaur, 1948, litho
Z1, ill.534
David and Bathsheba (after L.
Cranach), 30 March 1947, 1948
SLAM, fig.78 (IV/X)
Sotriffer-1, p.128 (VI/X)
Death in the Sun, 1933, dp
Mayor, ill.741
The Departure, 1951, col litho
Sotriffer-1, p.115 (col; 10th
st)
Les Deux Saltimbanques, 1905, dp
Eich, pl.409

The Stone Bridge at Rouen, 1887,
 etch
 Leymarie, pl.P65 (II/II)
A Street in Montmartre, 1865,
 etch
 Leymarie, pl.P4
Street in Paris: Rue Saint-
 Lazare, 1897, litho
 Leymarie, pl.P188
Street in Rouen: Rue Damiette,
 1884, etch
 Leymarie, pl.P52 (II/II)
Street in Rouen: Rue de l'Epic-
 erie, 1886, etch
 Leymarie, pl.P63 (II/II)
Street in Rouen: Rue des Arpents
 1887, etch
 Leymarie, pl.P67 (III/III)
Street in Rouen: Rue du Gros-
 Horloge, 1883, etch
 Leymarie, pl.P43 (III/III)
Street in Rouen: Rue Eugene-
 Dutuit, Feb.1896, litho
 Leymarie, pl.P164
Street in Rouen: Rue Gericault,
 Feb.1896, litho
 Leymarie, pl.P162
Street in Rouen: Rue Gericault a
 Rouen, Feb.1896, etch
 Leymarie, pl.P119 (VII/VII)
Street in Rouen: Rue Malpalue,
 1885, etch
 Leymarie, pl.P53 (III/III)
Street in Rouen: Rue Moliere,
 Feb.1896, litho
 Leymarie, pl.P163 (II/II)
Street in Rouen: Rue Saint-
 Romain (1st plate), Feb.1896,
 litho
 Leymarie, pl.P165
Street in Rouen: Rue Saint-
 Romain (2d pl.), 1896, litho
 Leymarie, pl.P166 (II/II)
Street in Rouen: Rue Saint-
 Romain (3d pl.), 1896, litho
 Leymarie, pl.P167
Street in Rouen: Rue Saint-
 Romain (4th pl.), 1896, litho
 Leymarie, pl.P168
Three Women Bathing, 1894, etch
 Leymarie, pl.P108 (II/II)
Tramps (Les Chemineaux), c.1894,
 litho
 Leymarie, pl.P151
Tree and Ploughed Feld, c.1879,
 etch

Leymarie, pl.P25
Two Women Bathing, 1894, etch
 Leymarie, pl.P107 (IX/IX)
The Vagabonds (Les Trimardeurs),
 1896, litho
 Leymarie, pl.P175 (V/V)
Vegetable Market at Pontoise,
 1891, etch
 Leymarie, pl.P96 (II/II)
View of Pontoise, 1885, etch
 Leymarie, pl.P59 (VII/VII)
View of Rouen: Cours la Reine,
 1884, etch
 Leipnik, pl.54
 Leymarie, pl.P50 (III/III)
View of Rouen: L'Ile Lacroix,
 aqua
 Leymarie, pl.P131
Woman and Child in the Fields,
 1874, litho
 Leymarie, pl.P139
Woman at a Gate, 1889, etch
 Leymarie, pl.P83 (XI/XI)
Woman Bathing: Evening, 1895,
 litho
 Leymarie, pl.P160
Woman Bathing: Near a Wood,
 1894, litho
 Leymarie, pl.P146 (I/VI)
Woman Bathing: Putting on Her
 Stockings, 1895, etch
 Leymarie, pl.P115 (II/II)
Woman Bathing, Seen from Behind,
 1895, etch
 Leymarie, pl.P116 (V/V)
Woman Bathing: with Geese, 1895,
 etch
 Leymarie, pl.P117 (X/XVII)
Woman Carrying a Basket (Femme
 Portant une Manne), c.1889,
 col mono
 MMA, p.33
Woman Emptying a Wheel-Barrow
 (Femme Vidant une Brouette),
 1880, etch and aqua
 Chase, pl.31
 Leymarie, pl.P31 (XII/XII)
 Minn, pl.17
 Pass-2, p.87 (XI/XII)
 RM-2, pl.31
Woman Haymaker (Faneuse), c.1874
 litho
 Leymarie, pl.P140
Woman Haymaker at Eragny, 1897,
 etch
 Leymarie, pl.P125 (III/III)

Work in the Fields: Women Mind-
ing the Cows, pub.1904, wengr
Leymarie, pl.P200
Work in the Fields: Women Weed-
ing (Les Sarcleuses), pub.1904
col wengr
Leymarie, pl.P202 (col)
Work in the Fields: Women Weed-
ing the Grass, pub.1904, col
wengr
Leymarie, pl.203 (col)

PISSARRO, Orovida Camille
See OROVIDA

PITTERI, Giovanni Marco (Italian,
1703-1786)
St.John the Evangelist (after G.
B.Piazzetta), etch
Mayor, ill.579

PLACE, Francis (English, 1647-
1728)
The Bass Island (after F.Barlow)
etch
Sparrow, opp.p.101
Fighting Cocks, and Other Birds
(after F.Barlow), etch
Sparrow, opp.p.105
Outside a Cottager's Farm (after
F.Barlow), etch
Sparrow, opp.p.101

PLATT, Charles Adams (American,
1861-1933)
Mud Boats on the Thames, etch
Weit, opp.p.14

PLATTEL, Henri Daniel
Copper-engraving in dispute with
lithography, litho
Sotriffer-1, p.13

PLOTKIN, Linda (American, 1938-)
Morning Light, 1976, intag
Baro, p.91

POGACNIK, Marjan (1920-)
Gardener's House, 1963, intag w.
embossment
Eich, pl.400
Untitled, 1962, zinc-plate etch
Sotriffer-1, p.86

POLESKIE, Stephen Francis (Ameri-
can, 1938-)

Big Patchogue Bent, 1969, col ss
Eich, col pl.76 (w.proofs 1 &
2)

POLIAKOFF, Serge (Russian-French,
1906-1969)
Abstract Composition (Composi-
tion Abstraite), 1966, col
litho
Siblik, p.75 (col)

POLLOCK, Jackson (American, 1912-
1956)
Harvesting Scene, 1937, litho
Eich, pl.589
Untitled, 1936, litho and air-
brush
RC-1, pl.51
Untitled 4, 1945, engr and dp
Eich, pl.379
RC-1, pl.64
RC-4, p.129
Untitled 5, 1944-45, engr
Johnson-2, ill.49
Untitled, 1951, ss
Mayor, ill.751

POMODORO, Gio (Italian, 1930-)
Black Seal, 1967, col litho
Tamarind-1, p.28
Male and Female Seal I, 1967,
col litho
Tamarind-2, p.69

POMPADOUR, Jeanne Antoinette
Poisson, Madame de (French, 1721
-1764)
Child (after F.Boucher), 1751,
etch
Ad-2, p.113
Eich, pl.275

PONCE
Headpiece to Dorat, "Les
Baisers" (after C.Eisen), 1770
engr
Z1, ill.289

PONCE de LEON, Michael (American,
1922-)
Entrapment, collage intag
Pet-2, p.237
Self-Portrait, 1966, cast-paper
print
Eich, col pl.89
Succubus, 1966, cast-paper col

on zinc
 Haab, pl.6
Decima: Trade, etch on zinc
 Haab, pl.7
Dialogue Between Good Calaveras,
 metal cut
 Haab, pl.35
Dialogue of the Calaveras, metal
 cut
 Haab, pl.33
Don Chepito Marihuano, metal cut
 Haab, pl.4
"Even here I shall not forget
 you", metal cut
 Haab, pl.34
The Execution, metal cut
 Haab, pl.17
The Execution of Captain Calapiz
 relief print
 Eich, pl.137
Execution of Captain Cloromiro
 Cota, wc
 Portland, no.153
Federalistic Calavera, metal cut
 Haab, pl.21
Gallery of the Calaveras, metal
 cut
 Haab, pl.22
Gallery of the Calaveras, metal
 cut
 Haab, pl.24
Gallery of the Calaveras, metal
 cut
 Haab, pl.29
Ill. to a Legend, metal cut
 Haab, pl.11
In "The White Bridge", etch on
 zinc
 Haab, pl.3
The Jarabe Dance in the Beyond,
 metal cut
 Haab, pl.19
The Military Band, etch on zinc
 Haab, pl.12
Political Speech, metal cut
 Haab, pl.8
Revolutionary, etch on zinc
 Haab, pl.2
The Seven Vices, wc
 Portland, no.152
The Soldier and the Maid, metal
 cut
 Haab, pl.36
Spiritual Calavera, metal cut
 Haab, pl.23
Sweeping the Streets, metal cut

Haab, pl.37
Witty and Amusing Calavera of
 Dona Tomasa and Simon, the
 Water-Carrier, metal cut
 Haab, pl.30
Zapata (1877-1919), etch on zinc
 Haab, pl.1

POSTMA, Hannes (Dutch, 1933-)
 To Signal with a Mirror, 1970,
 col litho
 Knigin, p.278 (col)

POTEMONT, A
 See MARTIAL, Adolphe

POTT, Constance Mary (British,
 b.1862)
 The Strand, 1905, etch
 Guichard, pl.54

POYNTER, Edward John (British,
 1836-1919)
 Feeding the Sacred Ibis in the
 Halls of Karnac (anon.after E.
 J.P.; ill. in "Art Journal"),
 c.1871, line engr
 Engen, p.54

POZZATTI, Rudy (American, 1925-)
 Etruscan Lady, 1963, litho
 Baro, p.91
 Ruins 1, 1966, col etch
 Eich, col pl.87
 Venetian Sun, wc
 Pet-2, p.286

PRAMPOLINI, Enrico (Italian, 1896-
 1956)
 Figure in Movement (Figure
 Motif) (from Bauhaus Portfolio
 4), 1922 litho
 Weber, p.204
 Wingler, pl.57

PRASSINOS, Mario (French, 1916-)
 Tree (L'Arbre), 1962, col aqua
 and etch
 Siblik, p.115 (col)

PRENDERGAST, Maurice Brazil
 (American, 1859-1924)
 Bastille Day (Le Quatorze Juill-
 et), 1892, col mono
 MMA, p.161 (col)
 The Breezy Common, c.1895-97,

col mono
MMA, p.45
Children at Play, c.1901, col
mono
Johnson-2, col ill.2
Fiesta, Venice, c.1898-99, col
mono
MMA, p.163
Nouveau Cirque, c.1895, col mono
MMA, p.165 (col)
Orange Market, c.1898-99, col
mono
MMA, p.167
Sachs, p.205
Six Sketches of Ladies, c.1891-
94, mono
MMA, p.157
Street Scene, c.1891-94, col
mono
MMA, p.158
Street Scene, Boston (later
pull), c.1891-94, col mono
MMA, p.159

PRIBYL, Ludomir (Czechoslovakian,
1937-)
Gravure Concrete, 1963, col
mixed media
Siblik, p.129 (col)

PRICE, Gordon (American, 1944-)
The Table, 1975, seri
Baro, p.92

PRICE, Kenneth (American, 1935-)
Figurine Cup VI, 1970, col litho
Baro, p.92
Japanese Tree Frog Cup, 1968,
col litho
Tamarind-1, p.53 (col)
Tamarind-2, p.70

PRIEST, Alfred (British, 1874-
1929)
Libellula Depressa (Dragonfly),
1897, etch
Guichard, pl.54

PRINCE, Richard (Canadian, 1949-)
Post Studio Artist, 1976, mixed
media
Baro, p.92
Property Owner, 1976, mixed
media
Baro, p.93

PROUT, Samuel (British, 1783-1852)
See also G.Baxter
Botisfleming, sg etch
Laver, pl.XIII
Ill. from Senefelder, "Course of
Lithography", 1818, transfer
litho
Bauman, pl.23a
Tamerton in 1816, sg etch
Sparrow, opp.p.130
Windmill Near Crowland Abbey,
sg etch
Sparrow, opp.p.130

PROUVE, Victor Emile (1858-1943)
Birds of Prey, 1893, col etch
Stein, pl.27
Opium, 1894, col litho
Stein, pl.65

PRUD'HON, Pierre-Paul (French,
1758-1823)
Phrosine et Melidore (ill. for
G.Bernard, "Oeuvres"), pub.
1797, engr and etch
Ad-2, p.224
Mayor, ill.601
Schmeck, p.105
Z1, ill.291
A Reading (Une Lecture), 1822,
crayon litho
Bauman, pl.21
Brown, no.121
Man, pl.73

PRUNAIRE, Alphonse A. (active 1867
-1900)
Olympia (after E.Manet), 1865,
wengr
Leymarie, pl.M87
The Print Collector (after H.
Daumier), col wengr
Portland, no.80
The Railway (Le Chemin de Fer)
(after E.Manet), 1874, wengr
Leymarie, pl.M88

PUGIN, Augustus Charles (British,
1762-1832)
Christie's Auction Room (w.T.
Rowlandson; from "The Micro-
cosm of London"), pub.1811,
col aqua
Z1, ill.365
Copying Old Masters at the
British Institution (w.T.Row-

landson; from "The Microcosm
of London"), 1808-10, aqua
Mayor, ill.604
Pass-Room at Bridewell (w.T.Row-
landson), 1808, etch w.aqua by
Hill
Sparrow, opp.p.132

PUIGMARTI, Jose
Caballo de la Selva, 1971, col
litho
Knigin, p.312 (col)

PURRMANN, Hans (German, 1880-1966)
Self-Portrait, 1964, litho
Weber, p.230

PUVIS de CHAVANNES, Pierre
(French, 1824-1898)
Normandy, 1893, litho
RM-1, p.200
Stein, pl.36
The Poor Fisherman, litho
RM-2, pl.61
Study of a Woman (Abundance),
1895, litho
Stein, pl.88
La Toilette, transfer litho
Ivins, p.174

PUXKANDL, Karl (German?, early
20th c.)
Title page for "Der Weg", no.10,
pub.1919, wc
Houston, ill.4

PYE, John
Ill. for Samuel Roger, "Italy, a
Poem" (after J.M.W.Turner),
pub.1830, engr
Ivins, p.150

PYLE, Howard (American, 1853-1911)
Viewing the Battle of Bunker
Hill (ill. for "Harper's Maga-
zine"), pub.1901
Weit, opp.p.230

PYNE, Henry (British, 1769-1843)
Angling Studies, etch
Sparrow, opp.p.133

PYTLAK, Leonard
Uptown, 1939, col litho
WPA, p.17

QUAGLIO, Lorenzo II (1793-1869)
Courtyard in Munich, c.1815,
etch
RM-1, p.22
Mosaics in San Vitale--Ravenna
(pl.10 of H.G.Knight, "The
Ecclesiastical Architecture of
Italy from the Time of Con-
stantine to the Fifteenth Cen-
tury"), 1843, chromolitho
Yale, pl.LXI
Peasants' Brawl (after A.Brouw-
er), c.1819, tinted litho
Weber, p.155
Portrait of Aloys Senefelder
(f.p. for J.G.Zeller, "Samm-
lung von Original Handzeich-
nungen"), 1818, chalk litho
Man, pl.48
Portrait of Aloys Senefelder,
1828, litho in 2 tones
Bauman, pl.11a
Sotriffer-1, p.16 (det)
Z1, ill.373

RAALTE, Henry B. van (Australian,
1881-1929)
Low Light (gum trees)
Guichard, pl.80

RABEL, Kathleen J. (American, 1943
-)
Dobro, 1976, relief w.hand color-
ing
Baro, p.93
Trinity, 1975, col intag
Baro, p.93

RACHOU, Henri (b.1856)
Decorative panel, 1893, col
litho
Stein, pl.16

RACZ, Andre (1916-)
Medusa, 1945, engr and sg etch
Hayter-2, p.267
Perseus Beheading Medusa VIII,
1945, col engr, aqua and sg
etch
RC-1, pl.72
Reign of Claws: pl.VIII, 1945,
engr
Pet-2, p.41

Leipnik, pl.46
Prayer (La Priere), c.1862-63,
etch
Weisberg-3, p.103

RICCI, Marco (Italian, 1676-1729)
See also J.B.Jackson
Classical Ruins with Doric Tem-
ple, Fountain, and Gothic
Church, 1723, etch
Sopher, p.10

RICE, Bernard
Beggars, wengr
Leighton, p.81

RICHARDS, Ceri Geraldus (British,
1903-1971)
La Cathedrale Engloutie, 1959,
col litho
Siblik, p.95
The force that through the green
fuse drives the flower (from
"Twelve Lithographs for Six
Poems by Dylan Thomas"), 1965,
col litho
Gilmour, pl.25 (col)
The Hammerklavier Theme: La
Cathedrale Engloutie I, 1958,
col litho
Hayter-1, pl.38 (col)

RICHARDS, Frederick Charles
(British, 1887-1932)
Oxford, etch
Guichard, pl.55

RICHARDSON, Thomas Miles (British,
1813-1890)
Church & Town of St.Georgio,
Lago di Como (pl.4 of "Sketch-
es in Italy, Switzerland,
France & c"), 1837, tinted
litho
Yale, pl.LVI

RICHIER, Germaine (French, 1904-
1959)
In Honor of the Hand: the Head-
line, 1949, etch
Ad-1, p.202

RICHMOND, George (British, 1809-
1896)
Christ the Good Shepherd, 1827-
29, engr

Godfrey, pl.79

RICHTER, Gerhard (German, 1932-)
Atelier, offset
Clark, no.87
Canary Landscapes: pl.4, 1971,
photo engr and aqua
RC-4, p.200

RICHTER, Hans Theo (German, 1902-
1969)
Boy Reading, 1954, litho
Weber, p.139
Girl in Front of a Mirror, 1956,
litho
Weber, p.131

RICHTER, Ludwig (German, 1803-
1884)
The Night Before Christmas (ill.
for "Neuer Strauss fur's
Haus"), 1864, wengr
Mayor, ill.451

RICKETTS, Charles (British, 1866-
1931)
Daphnis and Chloe: ill., 1893,
wc
Godfrey, pl.119 (trial proof)
Deluge, 1894, wengr
Stein, pl.66

RIDGWAY, William (c.1860-1880)
The Ninth Hour (w.Herbert
Bourne; after G.Dore), 1880,
line engr
Engen, p.64

RIGAL, Jean-Joachim-Jacques (1926
-)
The Luxembourg Gardens, c.1955,
etch
Ad-1, p.213

RIGGS, Robert (American, 1896-
1970)
Elephant Act, c.1937, litho
Johnson-2, ill.40
Psychopathic Ward, 1945, litho
Eich, pl.575
RC-1, pl.47

RIMMER, William (1825-1874)
Odalisque, litho
Eich, pl.570

Mother and Child (after C.R.Les-
lie), pub.1853, line engr
Engen, p.12 (det), p.13

ROBINSON, Sally Winston (American,
1924-)
Within the Bridge, 1977, glass
print
Detroit, p.159

ROCHE, Pierre (1855-1922)
Algae, 1893, col gypsograph
Stein, pl.35
The Salamander, 1895, col litho
Stein, pl.91

ROCKBURNE, Dorothea (Canadian)
Untitled (from "Locus"), 1975,
relief etch and aqua
Ontario, p.47

RODIN, Auguste (French, 1840-1917)
Cupids Guiding the World, c.1881
etch (on back of a plate by
Legros)
Chase, pl.36
Eich, pl.330
Leipnik, pl.58
RM-1, p.159
RM-2, pl.36
Nude (anon. after A.R.; for O.
Mirbeau, "Le Jardin des Supp-
lices"), 1902, litho
Mayor, ill.717
Portrait of Henry Becque, 1893,
dp
Schmeck, p.110 (III/V)
Stein, pl.19 (III/V)
Portrait of Monsieur Bugne,
c.1885, dp
RM-1, p.160
Portrait of Victor Hugo, c.1885,
dp
Furst, p.281
Leipnik, pl.59
Mayor, ill.716
RM-1, p.148
Springtime (Le Printemps), pub.
1883, etch
Chase, pl.35
RM-2, pl.35
Rosen, fig.231
Victor Hugo, 1884, dp
Chase, pl.34
RM-2, pl.34
Z1, ill.457

RODRIGUEZ, Jose Julio (1912-)
Man's Head, 1954, wc
Haab, pl.78

ROGALSKI, Walter
Homage to a Technique, 1968,
engr
Eich, pl.383
Scorpion and Crab, 1951, engr
and embossment
Pet-2, p.33

ROGER
The Bath (after P.-P.Prud'hon),
engr
Ad-2, p.223

ROHLFS, Christian (German, 1849-
1938)
Dancing Couple (Tanzendes Paar)
(from Bauhaus Portfolio 5),
c.1913-22, linocut
Houston, ill.70
Wingler, pl.74
Prisoner, 1918, wc
Z2, pl.82
The Prodigal Son (Der Verlorene
Sohn) (ill. for "Der Anbruch",
Jan.1919; after original wc)
Houston, ill.25
Return of the Prodigal Son
(Ruckkehr des verlorenen Sohn-
es), 1916, wc
IFCR, no.99
A Spectre, c.1911, wc
Sotriffer-2, p.71
Street in Soest (Strasse in
Soest), c.1919, linocut
Houston, ill.22
The Three Kings, c.1910, wc
Fogg, pl.53
Two Dancers (from Bauhaus Port-
folio 5), 1913 (pub.1921), wc
RC-4, p.28

ROLLINSON, William (1762-1842)
Alexander Hamilton (after A.
Robertson), 1804, stipple engr
MGA, pl.93 (2d st)

ROMANO, Clare (American, 1922-)
Cape View II, 1970, col colla-
graph
Eich, col pl.52 (w.progressive
proofs 1 & 2)
River Canyon, 1976, collagraph

brown
Stein, pl.70

SAFF, Donald (American, 1937-)
 Triptych, 1974, intag
 Baro, p.102

SAINSBURY, Hester
 The Lamp, white-line wengr
 Leighton, p.41

SAINT-AUBIN, Augustin de (French,
 1736-1807) See also C.N.Cochin;
 A.G.Duclos; A.F.Sergent
 At least be discreet!
 Ad-2, p.110
 Madame de Pompadour (after C.
 Cochin), 1764, engr
 Ad-2, p.102
 Pierre-Jean Mariette, the First
 Great Connoisseur of Prints
 and Drawings (after C.N.Cochin
 II), 1765, etch
 Mayor, ill.291
 You may count on me!
 Ad-2, p.111

SAINT-AUBIN, Charles Germain de
 (French, 1721-1786)
 Butterfly Fantasies (Papillon-
 neries Humaines): Ballet
 champetre, 1750, etch
 L-S, pl.143
 Butterfly Fantasies: The Butter-
 fly at Her Toilet Table (La
 Toilette), etch
 Mayor, ill.593
 Butterfly Fantasies: Pyrotechny
 (Fireworks), 1750, etch
 Ad-2, p.92
 L-S, pl.144
 Butterfly Fantasies: Theatre
 Italien, etch
 Eich, pl.277
 Butterfly Fantasies: The Tight-
 rope Walker, etch
 Ad-2, p.93
 LS in a monogram for embroidery
 (anon. after C.G.de S.A.),
 1770, etch
 Mayor, ill.592

SAINT-AUBIN, Gabriel de (French,
 1724-1780)

Academie Particuliere, c.1773-76
 Ad-2, p.101
 Z1, ill.309
A Conference of Lawyers
 Ad-2, p.107
The Journalists' Coffeehouse,
 1752, etch
 Mayor, ill.594
Les Nouvellistes, 1752, etch
 Ad-2, p.108
 Z1, ill.310
The Procession of the Fatted Ox
 Ad-2, p.105
Le Salon du Louvre, 1753, etch
 Ad-2, p.104
 Z1, ill.308
Spectacle des Tuileries: Les
 Chaises, 1760, etch
 Fenton, no.119b (II/II)
 Z1, ill.307
Spectacle des Tuileries: Le Ton-
 neau d'Arrosage, 1760, etch
 Fenton, no.119a (II/II)
Theatre Italien, etch
 Z1, ill.311
The Two Lovers
 Ad-2, p.106

SAINT MEMIN, Julian Fevret de
 (French, 1770-1852)
 Portrait of Jefferson, engr w.
 physionotrace
 Z1, ill.321
 Portrait of Levington
 Ad-2, p.220

SAINT-NON, Jean Claude Richard,
 abbe de (French, 1727-1791)
 The Stubborn Donkey (after
 Fragonard), engr
 Ad-2, p.98

SAITO, Kiyoshi (1907-)
 Winter in Aizu, 1958, col wc,
 sosaku hanga
 Z1, ill.737

SAL, Jack (American, 1954-)
 Untitled, 1977, glass print
 Detroit, p.161
 Untitled, 1977, glass print
 Detroit, p.161
 Untitled, 1978, col glass print
 Detroit, p.25 (col), p.163
 Untitled, 1978-79, glass print
 Detroit, p.162

Stein, pl.28

SCHWARTZ, Aubray
Flowers, 1960, litho
Tamarind-2, p.76

SCHWARTZ, Carl E. (American, 1935-)
Heirloom 4, 1975, litho
Johnson-2, ill.143

SCHWITTERS, Kurt (German, 1887-
1948)
Abstraction (from "Merz Mappe
III"), pub.1923, litho
Eich, pl.540
Z1, ill.521
Composition with Profile (from
Bauhaus Portfolio 3), 1921,
litho
Wingler, pl.39
Cover for anthology of K.S.
poems, pub.1919, litho
Rosen, fig.192
Ill. for "Die Kathedrale", 1920,
litho
Rosen, fig. 193

SCOTT, James (1809-1889)
Duke of Wellington Visiting the
Effigy and Personal Relics of
Napoleon (after G.Hayter),
pub.1854, mezzo
Engen, p.37

SCOTT, William (British, 1913-)
Still Life with Pears, 1956,
litho
Weber, p.232

SEAWELL, Thomas (American, 1936-)
The First Street, 1975, seri
Baro, p.105

SECUNDA, Arthur (American, 1927-)
The Road to Arles, 1976, col
screen print
Johnson-2, col ill.21

SEEWALD, Richard (German, b.1889)
Sodom and Gomorrha, col wc
Sotriffer-2, p.82

SEGUI, Antonio (Argentinian, 1934
-)
L'Adieu aux Armes, 1963, col
litho

Knigin, p.206 (col)

SEGUIN, Armand (1869-1903)
Landscape, 1894, etch and aqua
in brown
Stein, pl.67

SEKINO, Junichiro
Collagraph No.3, 1965, col
collagraph
Eich, pl.455

SELF, Colin (British, 1941-)
Prelude to 1,000 Temporary Ob-
jects of Our Time, 1971, etch
Rosen, fig.206

SELIGMANN, Kurt (Swiss, 1900-1962)
Actaeon, 1947, etch
RC-1, pl.62
The Marriage (from "The Myth of
Oedipus" portfolio), 1944,
etch
Johnson-2, ill.52
Meditation, 1950, etch and aqua
Eich, pl.367

SENEFELDER, Alois (German, 1771-
1834)
Facsimile of a margin-drawing
for the Emperor Maximilian's
Prayer-Book (after A.Durer),
pub.1819, litho
Weber, p.29
Gallows Press (from the manual
of 1818), litho
Weber, p.22
Landscape with Gate and Round
Tower, 1799, litho
Weber, p.24

SERGENT, Antoine Francois (called
Sergent-Marceau) (French, 1751-
1847)
The Happy Mother (after A. St.-
Aubin)
Ad-2, p.178
Les Peuples Parcourant les Rues,
col aqua
Z1, ill.325

SERUSIER, Louis Paul Henri (French
1863-1927)
Landscape, 1893, col litho
Stein, pl.20
Weisberg-1, p.109

SERYCH, Jaroslav (Czechoslovakian, 1928-)
Composition, 1964, mixed media
 Siblik, p.93

SEUPHOR, Michel (Ferdinand Louis Berckelaers) (Belgian, 1901-)
Nocturne, 1958, seri
 Siblik, p.151

SEVERINI, Gino (Italian, 1883-1966)
Harlequin's Family (from "Bauhaus Portfolio 4"), 1922-23, litho
 Weber, p.209
 Wingler, pl.58

SEVERN, Walter (British, 1830-1904)
December (pl.12 of "The Golden Calendar with a Perpetual Almanac"), 1864, chromolitho, etch and letterpress
 Yale, pl.LXX
The Plea of the Midsummer Fairies, etch
 Guichard, pl.58

SHAHN, Ben (American, 1898-1969)
All That is Beautiful, 1965, ss
 Eich, pl.619
Alphabet of Creation, 1958, screen print
 Johnson-2, ill.71
Immigrant Family, 1941, col seri
 RC-1, pl.56
Laisse-faire, c.1950, ss
 Mayor, ill.748
Mask, 1962, col ss
 Wechsler, fig.31
Phoenix, 1952, hand-col seri
 RC-1, pl.55
Sacco and Vanzetti, 1958, col seri
 MOMA, p.18
Silent Music, 1950, seri
 Fogg, pl.78
 Sotriffer-1, p.103
 Z1, ill.653
T.V. Antennae, 1953, seri
 Z5, p.107
Triple Dip, 1952, seri w. hand coloring
 RC-4, p.120 (col)
Wheatfield, 1958, ss

Ad-1, p.235
Years of Dust, c.1936, col litho
 Eich, pl.581

SHANNON, Charles Haslewood (British, 1863-1937)
Lucien Pissarro, 1895, litho
 Cleveland, pl.XXXVIII
The Romantic Landscape, 1893, litho
 Godfrey, pl.101
The White Watch, litho
 Boston, p.68
The Woman with Cats (Biondina), 1894, litho
 Stein, pl.68
The Wood Engraver, 1896, litho
 Godfrey, fig.15

SHAPIRO, Shmuel
Brother and Sister (no.2 from "Tor des Todes"), 1966-67, litho
 Gilmour, pl.21

SHARP, William (British, 1749-1824)
King Lear, Act III, Scene 4 (after B.West; for Boydell, Shakespeare Gallery), 1789, engr
 Godfrey, fig.9 (det), pl.43
Saul and the Witch of Endor (after B.West), line engr
 Engen, p.65

SHARP, William (active 1840-1885)
Dr.F.W.P.Greenwood, 1840, col litho
 Boston, p.73
Thomas Howard, Earl of Arundel (after Van Dyck), etch and engr
 Hind, pp.206-07 (det)

SHARPE, Charles William (1818-1899)
Tuileries, 20 June 1792 (after A. Elmore), pub.1883, line engr
 Engen, p.42

SHARPLES, James (British, 1825-1893)
The Forge, 1859, engr
 Godfrey, pl.99

col litho
Bauman, pl.62 (col)
Knigin, p.23
Pass-1, p.29 (col)
Pass-2, p.185 (col)
Z3, p.92
Saint-Tropez (The Port of Saint-
Tropez), 1894, col litho
Stein, pl.69
Soir, Flessingue, 1897-98, col
litho
Z3, p.90

SILVA, Maria Helena Vieira da
See VIEIRA DA SILVA, Maria Hel-
ena

SIMMONS, William Henry (British,
1811-1882)
Claudio and Isabella (after W.H.
Hunt), pub.1864, line and
stipple engr
Engen, pp.78-79 (det)
The Departure (Second Class)
(after A.Solomon), c.1854,
mixed mezzo
Engen, p.12
Dominion (after E.Landseer),
pub.1878, mezzo
Engen, p.64
The Last of the Clan (after T.
Faed), pub.1868, mixed mezzo
Engen, p.35
The Light of the World (after W.
H.Hunt), pub.1860, line and
stipple engr
Engen, p.5 (det), p.60
The Proscribed Royalist (after
J.E.Millais), 1858, engr
Godfrey, fig.10 (det)
Rosalind and Celia--a scene from
Shakespeare's "As You Like It"
(after J.E.Millais), c.1868
(pub.1870), mezzo
Engen, pp.92-93

SIMON, John (1675-c.1755)
Etow Oh Koam, King of the River
Nation (after J.Verelst), 1710
mezzo
MGA, pl.9 (1st st)
The Indian Chief Ho Nee Yeath
Taw No Row, King of the Gener-
ethgarich (after J.Verelst),
1710, mezzo
Eich, pl.465

MGA, pl.8 (1st st)

SIMONET
Soiree des Tuileries (after a
painting by P.-A. Baudouin),
1774, engr
Z1, ill.296

SIMPSON, Joseph (British, 1879-
1939)
Frank Brangwyn, etch
Guichard, pl.61
James Pryde, etch
Guichard, pl.61
The Priest, etch
Furst, p.369

SIMPSON, William (British, 1823-
1899)
The Transept from the Grand En-
trance (pl.5 of J.McNevin,
"Souvenir of the Great Exhibi-
tion"), 1851, chromolitho w.
hand coloring
Yale, pl.LXV

SINGIER, Gustave (Belgian-French,
1909-)
Migration Solaire, 1961, col
litho
Siblik, p.81

SIQUIEROS, David Alfaro (Mexican,
1896-1974)
Head, 1930, litho
Haab, pl.90
Head of a Woman, 1931, litho
Z1, ill.478
Moises Saenz, 1931, litho
Fogg, pl.82
RC-4, p.121
Peace, 1947, litho
Eich, pl.555
Zapata, 1930, litho
Haab, pl.91
Sotriffer-2, p.119

SISLEY, Alfred (French, 1839-1899)
Geese on the River Bank (Bords
de Riviere, les Oies), 1897,
col litho
Leymarie, pl.S6 (col)
Pass-2, p.115 (col)
RM-1, p.100 (col)
RM-2, col pl.XII
On the Banks of the Loing: The

Summer Joy, 1971, col aqua
Baro, p.116
Trio from Suite Transition, 1970
aqua
Johnson-2, ill.127
Untitled, 1961, col mono on
Japan tissue
MMA, p.227

TODD, Arthur Ralph Middleton
(British, 1891-1966)
An Old Melody, before 1933, dp
Guichard, pl.69

TOMKINS, Charles Algernon (1812-
c.1897)
Ordered on Foreign Service
(after R.Collinson), pub.1865,
mezzo
Engen, p.32

TOMKINS, Peltro William (English,
1759-1840)
Mrs. Siddons (after Downman),
1797, stipple engr
Z1, ill.344
Vignette of Countryman Fishing:
Summer (pl.6, opp.p.53 of J.
Thomson, "The Seasons"; after
W.Hamilton), 1797, col stipple
engr
Yale, pl.VI (col)

TOOVEY, Richard Gibbs Henry (Brit-
ish, 1861-1927)
The Washerwoman, 1880s, etch
Guichard, pl.69

TOPFFER, Rudolphe (1799 1046)
Landscape with Folly, litho
RM-1, p.78

TOPP, Arnold (1887-1960?)
Abstract Composition (from Bau-
haus Portfolio 3), 1921, wc
Wingler, pl.41

TORLAKSON, James (American, 1951-)
51st and Coronado, 1973, etch
and aqua
Baro, p.116
19th Avenue Booth, 1:00 AM,
1975, etch and aqua
Baro, p.117

TOULIS, Vasilios
Blind Lunar Head, photo intag
Eich, pl.426
Moon Bra, 1970, embossment w.
rolled-on color
Eich, pl.424
Necrophiliac, 1964, tape collage
and aqua
Eich, pl.441

TOULOUSE-LAUTREC, Henri de
(French, 1864-1901)
A la Gaite-Rochechouart: Nicolle
en Pierreuse, 1893, litho
Wechsler, pl.79
A la Souris, c.1895, litho
RM-1, p.189
Aristide Bruant dans son Cabar-
et (poster), 1893, col litho
Ives, p.81
L'Artisan Moderne, 1894, col
litho
Jordan, p.14 (I/III)
At the Cafe-Concert (Aux Ambass-
adeurs), 1894, col litho
Stein, pl.59
Wechsler, pl.78 (col)
At the Circus: the Clown (Au
Cirque: le Clown), 1899, col
mono
MMA, p.139
At the Moulin Rouge: La Goulue
and Her Sister, La Mome From-
age, col litho
Bauman, pl.58 (col)
Ives, p.91 (col)
Long, pl.187
Pet-1, opp.p.18 (col), p.206
Au Hanneton, litho
Chase, pl.59
RM-2, pl.58
Au Rideau, 1895, col litho
Stein, pl.81
The Box with the Gilded Mask,
1893, col litho
Chase, pl.62 (col)
RM-2, col pl.VIII
Weber, p.173 (col)
Brandes in Her Dressing-Room,
litho
Chase, pl.61
RM-2, pl.60
Cecy Loftus, 1895, litho
RM-1, p.191
The Chestnut Merchant (Le March-
and de Marrons), 1901, litho

Nude (from the "Elles" series),
 1896, col litho
 Sachs, pl.25
La Petite Loge, col litho
 Lockhart, p.160
Polaire, 1898, litho
 Wechsler, pl.81
Preparing Bathtub, col litho
 Long, pl.180 (col)
Rejane and Galipaux in "Madame
 sans Gene", 1894, col litho
 Sal, p.232
Seated Clowness (La Clowness
 Assise; Mlle.Cha-U-Ka-O) (from
 the "Elles" series), 1896, col
 litho
 Colnaghi-1, pl.LXX
 Ives, p.95 (col)
 Pass-2, p.187 (col)
 Rosen, fig.232
 Sachs, pl.55
 Sotriffer-1, p.101 (col)
Sleep, 1896, litho
 RM-1, p.188
The Swan, 1899, litho
 Sachs, p.38
Valse des Lapins, 1895, litho
 Sachs, p.39
Woman in a Corset, col litho
 Long, pl.186
Woman in Bed, col litho
 Long, pl.181 (col)
Woman Washing (Femme Qui se
 Lave) (from the "Elles" ser-
 ies), 1895-96, col litho
 Pass-2, p.189
 Pet-1, p.14
Woman with a Looking-Glass
 (Femme a la Glace) (from the
 "Elles" series), 1895-96, col
 litho
 Pass-2, p.191 (col)
Yvette Guilbert, transfer litho
 Long, pl.188
Yvette Guilbert, 1893, litho
 Pet-1, p.208
 Z1, ill.452
Yvette Guilbert, 1894, litho
 Sachs, pl.54
Yvette Guilbert, 1898, litho
 Mayor, ill.708
Yvette Guilbert (Sur la Scene),
 1894-98, litho
 Eich, pl.512
Yvette Guilbert Singing in the
 Divan Japonais, Jane Avril in

the Audience (Divan Japonais
 poster), 1892, col litho
 Mayor, ill.709
 Rosen, fig.93
Yvette Guilbert Singing "Linger,
 Longer, Loo" (from a series of
 eight), 1898, col litho
 Ives, p.92

TOWNLEY, Hugh (American, 1923-)
 Untitled, 1969, col litho
 Tamarind-2, p.84

TOWNSEND, Frederick Henry (Brit-
 ish, 1868-1920)
 Caught!, etch
 Guichard, pl.69
 A Gyroscopic Judge's Box for the
 Detection of Foul Riding, 1913
 etch
 Guichard, pl.69

TOWNSEND, Henry James (British,
 1810-1866?)
 The Shepherd, 1850 (pub.1857),
 etch
 Guichard, pl.70
 Sparrow, opp.p.186
 Where the Bee Sucks
 Guichard, pl.70

TOWNSEND, Lee (b.1895)
 Jockey Clothes, litho
 Craven, pl.87

TREMOIS, Pierre-Yves (1921-)
 The Art of Love, pub.1962, line
 engr
 Pass-1, p.13
 The Faun, 1947, line engr
 Ad-1, p.222

TRENCHARD, James (1747-c.1797?)
 An East View of Gray's Ferry,
 on the River Schuylkill (after
 C.W.Peale), 1787, line engr
 MGA, pl.76
 View of the Triumphal Arch and
 the Manner of Receiving Gener-
 al Washington at Trenton, on
 His Route to New York, 1789,
 line engr
 MGA, pl.77

TREVELYAN, Julian
 During the Night...1932, aqua

Hayter-1, pl.52

TRIER, Hann (German, 1915-)
Composition, 1961, aqua and
blind embossing
Siblik, p.121

TROKES, Heinz (German, 1913-)
Composition, 1960, litho
Siblik, p.107
Wappen und Blaue Figur, col ss
Clark, no.101

TROUVE, Nicolas-Eugene (French,
1808-1888)
Cottage Among Trees (La Chaum-
iere dans les Arbres), c.1859/
62
Detroit, p.200

TROVA, Ernest (American, 1927-)
Four Figures on an Orange Square
(from the "Falling Man"
series), 1965, col ss
Eich, pl.624
Manscapes, 1969, screen print
Johnson-2, ill.93

TROWBRIDGE, David (American, 1945
-)
Untitled, 1972, col ss on Mylar
Baro, p.117

TUNNICLIFFE, Charles Frederick
(British, 1901-)
The Bull, etch
Guichard, pl.70
Carting Hay, etch
Guichard, pl.70
The Thief, etch
Furst, p.399

TURNBULL, William (British, 1922-)
Untitled, 1961, litho
Tamarind-1, p.41

TURNER, Janet (American, 1914-)
Dead Snow Goose II, 1974, intag
and ss
Baro, p.117

TURNER, Joseph Mallord William
(British, 1775-1851) See also
F.Short; J.Varrall
The Castle Above the Meadows,
mezzo

Ivins, p.142
Liber Studiorum: pl.44, Calm,
1812, sg etch and aqua
Colnaghi-2, pl.XXXVII (VI/
VIII)
Lumsden, p.257
Salaman, p.167 (without aqua),
p.169
Liber Studiorum: pl.66, Aesacus
and Hesperie, etch
Salaman, p.170
Liber Studiorum: pl.83, The
Stork and the Aqueduct, 1806-
19, etch
Eich, pl.285
Salaman, p.171
Liber Studiorum: The Stork and
the Aqueduct, 1806-19, etch
and mezzo
Eich, pl.286
Liber Studiorum: Ben Arthur,
Scotland, 1807-19, dp and aqua
RM-1, p.19
Sparrow, opp.p.144
Liber Studiorum: Junction of the
Severn and the Wye, etch
Hind, p.245
Liber Studiorum: Little Devil's
Bridge near Altdorf, 1809
(pub.1815), etch (mezzo by C.
Turner)
Z1, ill.410
Liber Studiorum: Near Blair
Athol (Vista to left), etch
Hamerton, opp.p.213
Liber Studiorum: Procris and
Cephalus, etch
Sparrow, opp.p.146
Liber Studiorum: Spenser's
"Fairie Queen", 1811, etch
Mayor, ill.644
Liber Studiorum: Swiss Bridge
(Via Mala), etch
Sparrow, opp.p.144
Liber Studiorum: Temple of Jupi-
ter (Vista to left), etch
Hamerton, opp.p.219
Liber Studiorum: The Woman with
the Tambourine, etch and aqua
Furst, p.209
The Little Devil's Bridge, etch
Laver, pl.VI
Sparrow, opp.p.146
Little Liber: The Evening Gun,
c.1825, mezzo
Godfrey, pl.88

RC-4, p.43
Portrait of an Actor (Felix
Barre), 1913, dp
Fogg, pl.28
Portrait of Felix Barre, 1913,
engr
Melamed, p.29
Le Potin, 1905, etch, aqua and
dp
Grunwald, p.50
Prometheus, 1942, col mono
MMA, p.213
Renee, Three-Quarters View
(Renee de Trois-quarts), 1911,
dp
Bowdoin, pl.62
Pass-1, p.71
RC-4, p.43
Sal, p.252
Self-Portrait, 1935, dp
Pet-2, p.53
Soldier Polishing Metal (L'Asti-
quage), 1907, etch and aqua
Weisberg-1, p.132
Still Life (after G.Braque), c.
1926, col aqua
Sotriffer-1, p.73 (col)
Still Life (w.G.Braque), c.1926,
col aqua
Hayter-1, pl.36 (col)
Woman with a Collie Dog (Femme
au Chien Colley), 1905, dp
Rosen, fig.121
Yvonne D., Full-face (Yvonne D.
de Face), 1913, dp
Colnaghi-1, pl.LXXIII
Melamed, p.30
Yvonne D. from the Side, 1913,
dp
Pass-1, p.73 (2d st)

VISENTINI, Antonio (Italian, 1688-
1782)
Palazzo Grimani, Venice (after
Canaletto), 1742-51, etch
Mayor, ill.46

VIVARES, Francois (French, 1709-
1780)
A View in Craven, Yorkshire,
1753, etch and engr
Godfrey, pl.41

VIZETELLY, Henry (British, 1820-
1894)
Title page for B.Foster,

"Christmas with the Poets"
(after design by B.F.), 1852,
col wengr
Yale, pl.XLVII

VIZETELLY BROTHERS (British, 19th
c.)
Esquimaux Travellers Harnessing
a Sledge (pl.2 of Mrs. P.
Sinnett, "Hunters and Fishers:
or Sketches of Primitive Races
in the Lands Beyond the Sea",
1846, tinted wengr w.hand col-
oring
Yale, pl.XLVII
The Sufis (p.1 of L.S.Costello,
"The Rose Garden of Persia";
after designs by L.S.C.), 1845
col wengr and letterpress
Yale, pl.XLVI

VLAMINCK, Maurice de (French, 1876
-1958)
The Bridge in Chatou, c.1914, wc
Sotriffer-2, p.37
The Bridge of Chatou, c.1927,
litho
Bauman, pl.97
Girl's Head, c.1905, wc
Sotriffer-2, p.13
Head of a Girl, c.1906, wc
RC-4, p.20
Head of a Young Girl, 1915, col
wc
Fogg, pl.21
Landscape, c.1925, col litho
Wechsler, pl.97 (col)
Martigues Harbor, c.1907, wc
Pass-1, p.77
The Oise at Sergy, 1923, aqua
Pass-1, p.79 (2d st)
RM-2, pl.119
Rue a Hesonville, c.1925, litho
Wechsler, fig.29
Sailboats #19, wc
Portland, no.148
Three Women in a Brothel, c.1905
wc
Sotriffer-2, p.99

VOGEL, Albert
Frederick the Great (ill. from
Scherr, "Schiller und seine
Zeit"; after A.Menzel), pub.
1859, wengr
Ivins, p.178

WACH, Alois (1892-1940)
The Son and the Girl, 1920, wc
Portland, no.143

WACHSMUTH, Jeremias (German, 1711-
1771)
Winter (from a set of the Four
Seasons), etch
Mayor, ill.567

WACQUEZ, Adolphe Andre (French,
1814-1865)
Bodelu Farm (Ferme de Bodelu),
1860, glass print
Detroit, p.106
The Bodmer at Bas-Breau (Le Bod-
mer au Bas-Breau, or La Futaie
au Bas-Breau), 1860, glass
print
Detroit, p.105
Trees at the Edge of a Pond
(Arbres au Bord d'une Mare),
1860, glass print
Detroit, p.105

WADSWORTH, Edward (British, 1889-
1949)
Liverpool Shipping, 1918, wc
Godfrey, pl.129
Riponelli: a Village in Lemnos,
1917, col wc
Godfrey, pl.130

WAGENBAUER, Max Joseph (German,
1774-1829)
Chlorine with her Brother and
Parents (w.F.Piloty; after J.
C.von Mannlich), pub.1812,
litho
Weber, p.152
Goats and Sheep (Ziegen und
Schafe), 1807, chalk litho
Man, pl.44a

WAGNER, T.P.
Dream, 1894, litho
Stein, pl.50

WAHLSTEDT, Walter (1898-1970)
Fiorenza, 1921, litho w.paint
and watercolor
Rosen, fig.209

WALCOT, William (British, 1874-
1943)
Egyptian Temple, etch

Guichard, pl.71
The Hospital of St.Mark's,
Venice, etch
Guichard, pl.71
St.Peter's, Rome, etch
Laver, pl.XLI
Venice in the Eighteenth Century
aqua
Furst, p.337

WALD, Sylvia (1914-)
Dark Wings, 1953-54, screen
print
Johnson-2, ill.78
Spirit's Constellation, 1952,
col seri
RC-1, pl.58
Tundra, 1950, col seri
Z1, ill.639
Tundra, 1952, seri and mono
Johnson, p.37

WALKER, Charles Alvah (American,
1848-1920)
Trees, 1881, mono
MMA, p.155

WALKER, Frederick (British, 1840-
1875)
Man, Seated Beside a Dresser,
Reading a Letter (ill. after
p.8 of J.Cundall, "Electro-
photography or Etching on
Glass"), pub.1864
Detroit, fig.2

WALKER, Todd (American, 1917-)
Untitled, 1975, col seri
Baro, p.121
Untitled, 1975, col seri
Baro, p.123

WALKER, William (Scottish, 1878-
1961)
Le Cafe Nice, bet.1913 and 1926,
etch
Guichard, pl.71

WALKOWITZ, Abraham (American, 1880
-1965)
Three Nude Men Asleep, 1909,
mono in brown
MMA, p.185

WALLACE, Robin (British, 1897-)
Summer, c.1925, dp

Guichard, pl.71

WALMSLEY, William (American, 1923
 -)
 Ding Dong Daddy #4 Oars, 1966,
 col litho
 Baro, p.122 (col)
 Ding Dong Daddy Whew, 1973,
 litho
 Baro, p.123

WARD, James (British, 1769-1859)
 "Adonis": the favourite charger
 of George III (from the series
 "Celebrated Horses"), pub.1824
 litho
 Bauman, pl.24
 Man, pl.78 (trial proof)
 Phantom (The Celebrated Race-
 horse), 1823, litho
 Weber, p.161
 A Tiger Disturbed whilst Devour-
 ing its Prey, 1799, mezzo
 Godfrey, pl.55

WARD, Leslie Moffat (British, b.
 1888)
 A Mile to Worth Maltravers, etch
 Guichard, pl.71

WARD, William (1766-1826)
 Daughters of Sir Thomas Frank-
 land (after J.Hoppner), 1797,
 mezzo
 Wechsler, fig.24
 The Earl of Chesterfield's State
 Carriage (after H.B.Chalon),
 1800, mezzo
 Colnaghi-2, pl.XXIII
 Elizabeth, Countess of Mexbor-
 ough (after J.Hoppner), 1784,
 mezzo
 Colnaghi-2, f.p.
 Louisa, 1786, mezzo
 Hind, p.298
 Variety (after G.Morland), 1788,
 stipple engr
 Godfrey, pl.53
 A Visit to the Child at Nurse
 (after G.Morland), 1788, col
 mezzo
 Yale, pl.XXIX

WARHOL, Andy (American, 1928-)
 Banana, 1966, col ss
 Eich, pl.622

Electric Chairs: pl.1, 1971,
 seri
 GM, p.60
Flowers, 1970, col ss
 RC-3, p.137 (col)
Jackie (from "Eleven Pop Art-
 ists" portfolio), 1966, screen
 print
 Rosen, fig.37
Marilyn (from "Ten Marilyns"),
 1967, col ss
 Baro, p.123
Marilyn (from "Ten Marilyns"),
 1967, col seri
 RC-2, p.59
Marilyn (from "Ten Marilyns"),
 1967, ss
 RC-3, p.135
Marilyn (from "Ten Marilyns"),
 1967, col seri
 RC-4, p.179
Mick Jagger, 1975, screen print
 Johnson-2, ill.105
Mick Jagger: print #8, 1975, col
 ss and wc
 Baro, p.119 (col)
Untitled (pl.12 from "For Meyer
 Schapiro"), 1974, col seri
 GM, p.69

WARING, John Burley (British, 1823
 -1875)
 A Chimney Piece by Messrs. Maw &
 Co. Broseley (anon.after J.B.
 W.; pl.224 of vol.3 of "Mas-
 terpieces of Industrial Art &
 Sculpture at the International
 Exhibition, 1862"), 1863,
 chromolitho
 Yale, pl.XXIV (col)

WARLOW, Herbert Gordon (British,
 1885-1942)
 Cathedral Square, etch
 Guichard, pl.72
 Rouen Cathedral, etch
 Guichard, pl.72

WARNBERGER, Simon (1769-1847)
 The Ridge near Lake Kochel (Das
 Joch bey dem Kochelsee), 1809,
 pen litho
 Man, pl.45

WARNER, E. (Australian, 20th c.)
 A Full Load, etch

Guichard, pl.81

WAROQUIER, Henry de (French, 1881-
1970)
Head of a Man, 1939, col wc
Ad-1, p.169
Man's Face Turned Upwards, 1934,
dp
Ad-1, p.168

WARREN, Albert (British, 19th c.)
Egyptian scene (untitled, after
design by O.Jones and H.War-
ren; pl.8 of T.Moore, "Para-
dise and the Peri"), 1860,
chromolitho
Yale, pl.LXII
Scenes from the Winter's Tale:
pl.1, Hermione entreating Pol-
ixenes to stay (after design
by O.Jones and H.Warren), 1866
chromolitho
Yale, pl.XX (col)

WARSAGER, Hyman (1909-)
Manhattan Night, 1939, col aqua
Z1, ill.628

WASHBURN, Cadwallader (American,
1873-1965)
Creek Ferns (Norlands series,
no.2), 1906, dp
Johnson-2, ill.4
Head of an Old Man, dp
Furst, p.333
Japanese Priest, dp
Weit, opp.p.44
Shimmering Light, dp
Laver, pl.LXXXI

WASHINGTON, William (British,
1885-1956)
House of Commons Chamber, line
engr
Guichard, pl.72

WATERSON, David (Scottish, 1870-
1954)
The Ruined Abbey
Guichard, pl.72

WATKINS, Franklin C. (1894-1973)
Softly-Softly, 1951, wengr
Z1, ill.624

WATSON, C.J.
Cafes at Abbeville, etch
Wedmore, opp.p.174

WATSON, James (1740-1790)
L'Allegro (Mrs. Hale) (after J.
Reynolds), mezzo
Colnaghi-2, pl.X
Jemima, Countess Cornwallis
(after J.Reynolds), 1771,
mezzo
Colnaghi-2, pl.XI
Richard Lord Viscount Howe (1726-
1799) (after T.Gainsborough),
1778, mezzo
MGA, pl.58 (2d st)

WATSON, Thomas
Lady Bamfylde (after J.Reynolds)
mezzo
Z1, ill.334 (proof before let-
ters)

WATT, J.H.
The Highland Drovers (after E.
Landseer), pub.1938, mixed
media
Engen, p.8 (etched st; det),
p.9 (engraved st; det)

WATT, William Henry (1804-1845)
Una and the Lion (after W.Hilt-
on), pub.1842, line engr
Engen, p.45

WATTEAU, Antoine (French, 1684-
1721) See also P.A.Aveline; F.
Boucher; L.Cars; L.Jacob; Suru-
que; N.H.Tardieu
Costume Study, engr
Ad-2, p.14
Figure de Mode, 1709-10, etch
Mayor, ill.585
Figures de Mode, Paris: plate,
1725, etch
Salaman, p.155
Figures de Mode, Paris: plate,
etch
Leipnik, pl.9
Figures de Mode, Paris: Seated
Woman, 1725, etch
Ad-2, p.15
Salaman, p.155
Gersaint's Shop Sign, Painted
1721 (anon.after A.W.), 1732,
etch

1723, mezzo
Godfrey, pl.32
Portrait of Abel Roper, mezzo
Hind, p.269

WHITING, Frederick (British, 1874-1962)
Hare-coursing--The Return, dp
Guichard, pl.77

WHITNEY, J.H.E.
Jo (after J.A.M.Whistler; ill. for "Scribner's Magazine"), pub.1879, wengr after etch
Pennell, p.7

WHYDALE, Ernest Herbert (British, 1886-1952)
Passing Showers, before 1931, etch
Guichard, pl.78

WICHT, John von (German, 1888-1970)
Black and White, 1960, stencil
Baro, p.121
Icarus, stencil
Pet-2, p.216
The Juggler, 1963, stencil
Johnson-2, ill.60

WICKEY, Harry (b.1892)
Central Park, etch
Craven, pl.89
Hogs Near a Corncrib, 1936, litho
Craven, pl.91
Hudson Highlands Under Snow, etch
Craven, pl.90
Railroad Cut No.3, etch
Z4, fol.p.72
Sailors' Snug Harbor, dp
Z4, fol.p.72
Sultry August Afternoon, litho
Z4, fol.p.72

WIELAND, Joyce (Canadian, 1931-)
O Canada, litho
Knigin, p.121

WILES, Irving Ramsey
See also H.Wolf
Study of Two Men, One Smoking, c.1890-1900, mono
MMA, p.42

WILEY, William T. (American, 1937-)
Ecnud, 1973, litho w.wood veneer
Baro, p.127
Little Hide: Slake, 1973, litho and acrylic on chamois
WISC, no.79
Scarecrow, 1974, col etch and aqua
Baro, p.128

WILKIE, David (Scottish, 1795-1841) See also James Nash
The Lost Receipt, dp
Salaman, p.183
Reading the Will, 1819, etch
Sparrow, opp.p.169 (1st-4th sts)

WILKINSON, John Gardner (British, 1797-1875)
Design showing how green may be used to light up other colours (pl.1 of "On Colour and on the Necessity for a General Diffusion of Taste Among all Classes"), 1858, chromolitho
Yale, pl.LXIX

WILKINSON, Norman (British, 1878-1971)
The Stream Pool, River Orchy, Argyll
Guichard, pl.78

WILLAUME, L.
Kerity, etch
Leipnik, pl.92

WILLCOCKS, Janice
With North Over the Barn, 1969, etch w.stenciled color
Eich, col pl.41

WILLE, Johann Georg (German, 1715-1808)
Portrait of the Marquis de Marigny (after L.Toque), 1761, engr
Z1, ill.271

WILLETTE, Adolphe-Leon (1857-1926)
The Cricket and the Ant, litho
RM-2, pl.72
Fortune, 1893, litho
Stein, pl.30

Hanging Clown, 1894, litho
 Stein, pl.60
Revenge, 1895, litho
 Stein, pl.93

WILLIAMS, Alfred Mayhew (British,
 1826-1893)
 Covent Garden, etch
 Guichard, pl.78

WILLIAMS, Samuel (British, 1788-
 1853)
 The Admiral Guarinos (tailpiece
 for J.G.Lockhart, "Ancient
 Spanish ballads"; after draw-
 ing by W.Simson), 1841, tinted
 wengr
 Yale, pl.XLVII
 Paul et Virginie: ill. (after T.
 Johannot), pub.1838, wengr
 Ivins, p.162

WILSON, Stanley Reginald (British,
 1890-1973)
 Long-Tailed Duck, bet.1923 and 33
 etch
 Guichard, pl.78

WINKLER, John (American, 1894-
 1979)
 Chou Seller, 1919, etch
 Johnson-2, ill.42

WINNER, Gerd (German, 1936-)
 Slow, 1972, col seri
 RC-2, p.69

WINTERSPERGER, Lambert Maria (1941
 -)
 Untitled, col ss
 Clark, no.113

WOEHRMAN, Ralph (American, 1940-)
 Attacus Edwards ii, 1975, intag
 Baro, p.128
 Henrietta, 1974, intag
 Baro, p.128

WOELFFER, Emerson (American, 1914
 -)
 Portrait of Max Ernst, 1970, col
 litho
 Tamarind-2, p.89
 Untitled, 1961, litho
 Tamarind-1, p.24

WOLF, Henry (American)
 Girl and Peonies (after I.R.
 Wiles), 1907, wengr
 Weit, opp.p.166

WOLS (Wolfgang Schulze) (German,
 1913-1951)
 Plate 3 for J.-P.Sartre, "Nour-
 ritures", 1949, dp
 RC-4, p.142

WOOD, Grant (American, 1892-1942)
 Honorary Degree, litho
 Craven, pl.93
 January, litho
 Craven, pl.92
 July Fifteenth, litho
 Craven, pl.94
 Midnight Alarm, 1939, litho
 Johnson-2, ill.46
 WISC, no.61
 Seedtime and Harvest, litho
 Craven, pl.97
 Shriners' Quartet, 1939, litho
 Craven, pl.96
 Eich, pl.585
 RC-1, pl.39
 Tree-Planting Group, litho
 Craven, pl.95

WOODBURY, Charles H.
 Easterly Coming, etch
 Laver, pl.LXXXIV

WOOLETT, William (1735-1785)
 The Destruction of the Children
 of Niobe (after R.Wilson),
 1761, etch and engr
 Godfrey, pl.40
 Judah and Thomas (after A.
 Carracci), etch and engr
 Hind, p.208 (det)

WORLIDGE, Thomas (English, 1700-
 1766)
 Sir Edward Astley as the Burgo-
 master Jan Six, 1765, etch and
 dp
 Godfrey, pl.38

WRAY, Dick (American, 1933-)
 Untitled, 1964, litho
 Tamarind-1, p.21
 Untitled, 1964, litho
 Tamarind-2, p.90

RM-2, pl.44
Sal, p.280
The Waltz, 1891, etch
 Knoedler, p.50 (3d st)
 RM-1, p.156
Wet, etch
 Knoedler, p.73 (3d st)
Zorn and His Model (2d plate)
 Knoedler, p.66 (V/VI)
Zorn and His Wife, etch
 Knoedler, p.48 (2d st)

ZORN and Co. (British, 19th c.)
 Landscape and Figures (ill.opp.
 p.242 of no.44, Jan.30, 1869
 of "The Chromolithograph, a
 Journal of Art, Literature,
 Decoration, and the Accomp-
 lishments"; after Claude Lor-
 rain), 1867-69, chromolitho
 Yale, pl.LXXII

PART II
Subject and Title Index

ing
De Martelly, J.S. Blue Valley
 Fox Hunt
Dufy, R. La Chasse
Howitt, S. An Etched Frieze of
 Hunting
Howitt, S. Pheasant Shooting
Huet, P. The Poacher
Latenay, G.de. Chasseresses
Leighton, G.C. The Hawking
 Party
Lewis, J.F. Buck Shooting
Munakata, S. Flower Hunting
 Mural
Nivisksiak. Man Hunting at a
 Seal Hole in Ice
Palmer, F.F.B. Wild Duck
 Shooting
Piloty, F. Boar Hunt
Reeve, R.G. Hare Hunting
Rowlandson, T. Tally-Ho
Soper, G. Full Cry
Stacpoole, F. English Game
 keeper
Tayler, F. A Day's Hunting in
 the Fens
Tayler, F. On the Scent
Tillemans, P. Hunting
Whiting, F. Hare-coursing--The
 Return
Hurrah for the Red, White and
Blue. Francis, S.

ICE
 Ford, L. Milton Pond, Thanks-
 giving Day
ILLNESS
 Gavarni, P. Avoir la Colique--
 le Jour de ses Noces
 Nolde, E. Sick Man, Doctor,
 Death, and the Devil
Imaginary Prisons. Piranesi, G.B.
INDIANS (AMERICAN)
 Adams, J.A. The Last Arrow
 Baskin, L. Crazy Horse
 Duveneck, F. Indians Warily
 Approaching Encampment
 Garcia, D. Indian Woman, Sit-
 ting
 Johnson, E. The Wigwam
 Sosamontes, R. Otomi Maid from
 the Mezquital
 Twohy, J. Indian Village
 Westermann, H. Big Red

Young, M. Navajo Watering
 Place
Young, M. Three Navajos
INDUSTRY
 Brammer, L.G. The Potteries
INSECTS
 Avati, M. The Butterflies of
 Nagasaki
 Klee, P. Giant Green-fly
 Picasso, P. Buffon...:The Wasp
 Priest, A. Libellula Depressa
 Redon, O. The Spider
 Ruscha, E. Swarm of Red Ants
 Sutherland, G. Bees
 Sutherland, G. Insect
INTERIORS See also names of indi-
 vidual rooms as titles; FURNI-
 TURE AND FURNISHINGS
 Anonymous British. The Earl of
 Derby's Drawing Room, Gros-
 venor Square, London
 Bourne, H. Watt's First Exper-
 iment
 Greene, B. Stan's House
 Haas, R. Great Hall, Kip Riker
 Mansion
 Haghe, L. North Transept--
 Waiting for the Queen
 Haghe, L. Private House at
 Antwerp
 Hamilton, R. Interior
 Milton, P.W. Card House
 Roberts, D. North Transept--
 Waiting for the Queen

January. Wood, G.
Jealousy. Munch, E.
JEWELRY
 Degas, E. The Jet Earring
 Margo, B. Jewels in Levitation
 Shaw, H. King Alfred's Jewel
 and the Ring of King Athel-
 wulf
Judgment Day. Barlach, E.
July Fifteenth. Wood, G.

Kilgaren Castle. Haden, F.S.
KING'S LYNN, England
 Brown, S. A Breezy Day, King's
 Lynn
 Daniel, H.W. The Old Customs
 House, Kings Lyn